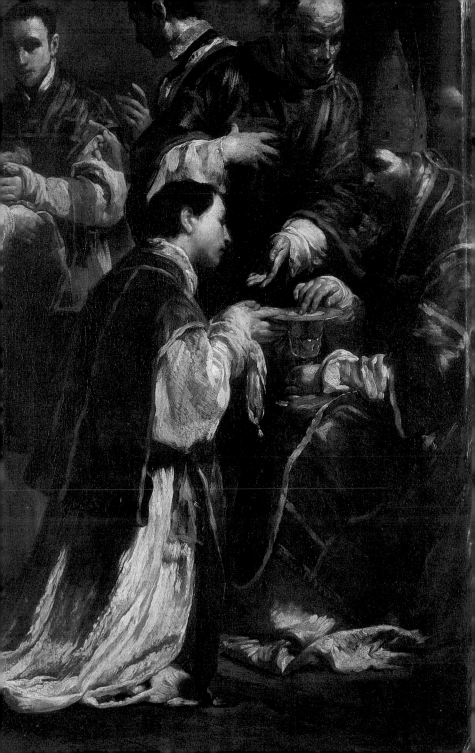

Rosa Giorgi

The History of the
Church in Art

Translated by Brian Phillips

The J. Paul Getty Museum
Los Angeles

A Guide to Imagery

Italian Edition © 2004 by Mondadori Electa S.p.A., Milan
All rights reserved. www.electaweb.it
© 2004 The Estate of Francis Bacon by SIAE

Series Editor: Stefano Zuffi
Original Graphic Design: Anna Piccarreta
Original Layout: Paola Forini
Original Editing: Maria Grazia Luparia
Original Image Research: Valentina Minucciani
Original Technical Coordination: Andrea Panozzo
Original Quality Control: Giancarlo Berti

English translation © 2008 J. Paul Getty Trust

First published in the United States of America in 2008 by
The J. Paul Getty Museum, Los Angeles

Getty Publications
1200 Getty Center Drive, Suite 500
Los Angeles, California 90049-1682
www.getty.edu

Gregory M. Britton, *Publisher*
Mark Greenberg, *Editor in Chief*

Ann Lucke, *Managing Editor*
Mollie Holtman, *Editor*
Robin H. Ray, *Copy Editor*
Pamela Heath, *Production Coordinator*
Hespenheide Design, *Typesetter*

Library of Congress Cataloging-in-Publication Data
Giorgi, Rosa.
 [Simboli, protagonisti e storia della Chiesa. English]
 The history of the church in art / Rosa Giorgi ; translated by Brian
Phillips.
 p. cm. — (A guide to imagery)
 Includes index.
 ISBN 978-0-89236-936-2 (pbk.)
 1. Christian art and symbolism—Handbooks, manuals, etc. I. Title.
 N7830.G5313 2008
 704.9'482—dc22
 2008020038

Frontispiece: Giuseppe Maria Crespi, *Cycle of the Seven Sacraments: Ordination* (detail), ca. 1712. Dresden, Gemäldegalerie.

Contents

Introduction

Much of the history of Western art coincides with the history of the Christian Church, and much of its iconography depends on and derives from the specific events, doctrine, influential figures, devotional movements, and trends of the Roman Catholic Church. The aim of this guide is to explain features and symbols in religious works of art as they relate to the history of the Church at the time these works were commissioned and created. Consequently, this is not a history book containing a catalogue of the important historical events but is rather a book of iconography that uses images, their history, and the frequency of their appearance to explore their iconological meaning—in other words, to explain them in terms of the devotional currents and doctrines of their time and place.

To achieve this end, we have thought it useful to equip the reader with certain helpful tools of investigation, such as keys to understanding signs and gestures. The aim of the first two chapters is to show the reader how to understand a religious image involving signs and symbols of the Catholic liturgy, which may be unfamiliar to people of other religious traditions and which, while they survive in some form within the Catholic Church, may not always retain their original meaning. In order to make it easier to recognize objects associated with religious rites and the liturgy, the first page of each entry provides an illustration of the object concerned as a work of decorative art admirable in its own right.

The monastic orders are among the principal players in the history of the Church's evolution and in its continual search for spiritual renewal and new forms of community. Because each of these orders made important contributions to the Church and hence appeared with great frequency in art, we decided to show the various offices and ranks of members of the Church and the clothing that characterize them. This is a case where you can indeed judge by appearances, since their garments are the primary attributes for identifying monks, friars, members of lay confraternities, and the clergy as they go about their business in works of art. Illustrations have been chosen

on the basis of their frequency in art, so more space has been devoted to the more frequently represented orders.

Before embarking on a chronological sequence of episodes and characters, which returns this guide to a more historical approach, our third chapter concentrates on the development of specifically Christian images. We shall find derivations from pre-Christian art and literature, as well as connections with developments in Christian doctrine, trends in popular worship, and the changing rhythms of religious rites.

The fourth chapter brings us to history proper, treating the iconography of episodes and events closely linked to Church history. Not surprisingly, given that the Roman Church was often art's patron, many of the less edifying episodes in Church history have evaded representation in art. This history must necessarily be as much a record of a spiritual journey as one of conflicts and excommunications.

And just as history is not always made up of great events, it may not always be acted out by great individuals, either. The Church's journey through two millennia was characterized by great and pious leaders along with their humble or, in some cases, debased fellows. These historical figures, the protagonists of the Roman Catholic Church, are the subject of the final chapter. The men, and sometimes women, who shaped the Church as it has come down to us may, alas, have been politically great but spiritually poor, or conversely, they may have been politically unskilled but spiritually very great. And perhaps it is the latter, the great saints, who have been chiefly acknowledged in worship and art.

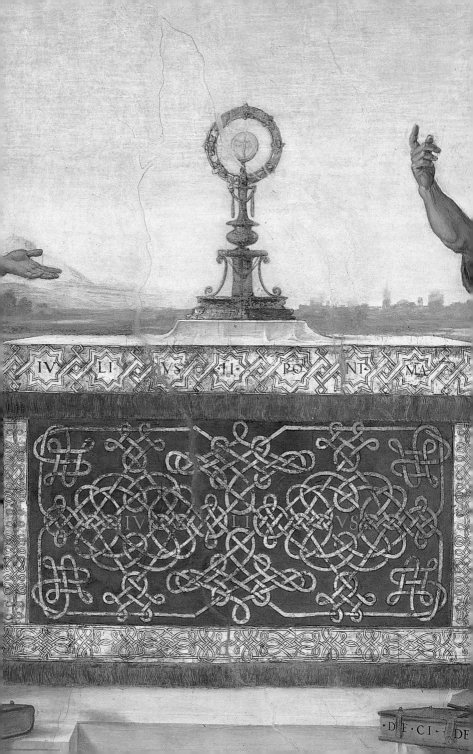

LITURGICAL OBJECTS AND FURNISHINGS

◄ Raphael, *The Dispute over the Sacrament* (detail), 1508. Vatican City, Palazzi Vaticani, Stanza della Segnatura.

In illustrations of the Old Testament, altars are depicted as prefiguring Christian altars. They are also found in scenes of the lives of saints and other Church figures.

Altar

Name
The word comes from a combination of Latin *alti* (high) and *ara*, from *arere*, meaning "to burn." Hence the altar is "(high) place of fire" where a burnt offering is made to God

Definition
The fulcrum of the whole liturgical setting, serving the dual purpose of altar and table

Purpose
The table at which the Eucharist is celebrated

Sources
Genesis 8:20–21; 12:7; 13:14–18; 26:24–25; 28:10–22; 1 Corinthians 10:21; Fifth Paschal Preface to the Roman Liturgy

Diffusion in art
Found in various forms throughout Christian art

There are references to Jewish altars in the Old Testament, but the Christian altar derives its shape not from these but from the table where the Last Supper was eaten. The earliest altars were family tables, where Christians originally gathered. It was when the first Christian communities were formed and the Christian feast was ritualized that the domestic table came to be used exclusively for religious rites and so became an altar. The earliest altars were small and wooden, either round, semi-circular, or U shaped. Stone came to be preferred later on, and there is evidence of its use everywhere during the 4th century, wood being used only for portable altars. At the time of the martyrs it became customary to celebrate the Eucharist upon their tombs, and the sacrificial aspect of the rite took precedence over its convivial element. In the 6th and 7th centuries, first in Gaul and then in Rome, the altar came to be placed against the wall so that the priest as well as the faithful could face east. Only after the Second Vatican Council was there a return to the original arrangement.

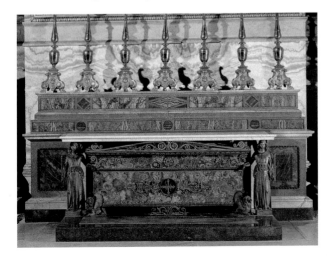

▶ Altar, 1854. Rome, San Paolo Fuori le Mura.

At the elevation of the host during Mass, a ball of fire appeared above Saint Martin's head. Simone Martini gives it a golden tail of light, which falls on Saint Martin's head.

According to Jacobus de Voragine's account in The Golden Legend, *Martin, on his way to church, had given his tunic to a beggar, putting on instead a garment with short sleeves. Two angels then descended and covered Saint Martin's bare arms with gold armbands decorated with precious stones.*

On the altar top we see a cross, candlesticks, the chalice covered by a paten and standing on a corporal, and the liturgical book resting on a cushion that acts as a lectern.

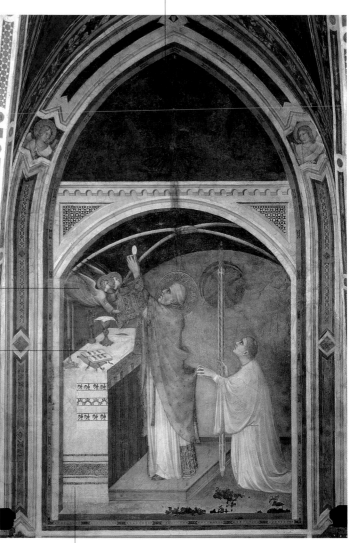

▲ Simone Martini, *Scenes from the Life of Saint Martin: The Miracle at Mass,* 1312–17. Assisi, lower church of San Francesco, chapel of San Martino.

In preparation for the religious rite, the altar has been covered with two cloths: a long one that reaches to the ground and a shorter one laid over it.

Altar

The first worshipers around the Altar of the Lamb are spiritual creatures: angels bringing the instruments of Christ's Passion, including a cross and a lance.

The mystic lamb is symbolic of Christ sacrificed on the cross for humankind: it stands on the altar, its head surrounded by light and its blood flowing into a chalice. This is a clear reference to the sacrifice of the Eucharist.

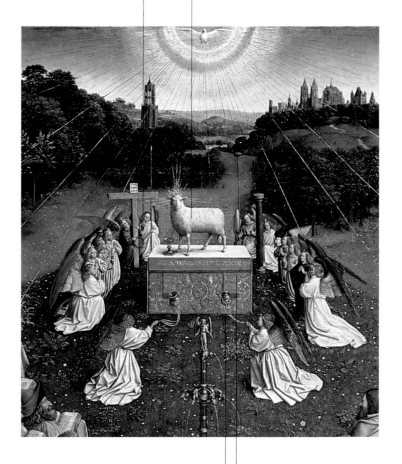

The use of incense is a ritual sign of worship. Here it is burned and sprinkled by angels with thuribles.

The altar is covered in a white cloth and has a frontal decorated predominantly in red—the liturgical color for feasts of the Eucharist.

▲ Jan van Eyck, *The Adoration of the Lamb Altarpiece* (detail), 1432. Ghent, Saint-Bavon cathedral.

That the blessing of church and altar is an extraordinary event is stressed by the fact that the bishop is assisted not by clergy but by angels, such as the one seen here carrying an incense boat.

Standing on the altar is a wooden panel with a picture of the Madonna and Child. This was a very widespread form of altar decoration during the 15th century.

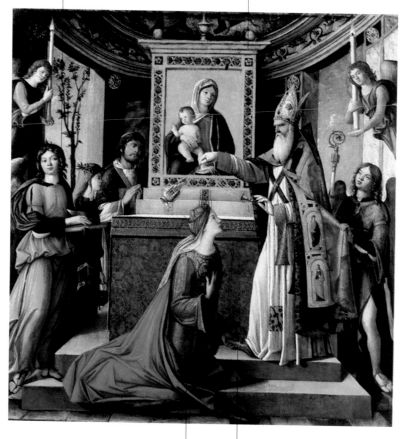

Galla Placidia, mother of the 5th-century emperor Valentinian III, kneels in prayer. She had a church built to honor Saint John the Evangelist as an ex-voto for having survived a shipwreck.

The woman touches the bishop's slipper as he sprinkles incense on the altar. This seems to be a representation of Saint John appearing to Galla Placidia and leaving her a relic for the new church dedicated to him.

▲ Niccolò Rondinelli, *Saint John the Evangelist Appearing to Galla Placidia*, ca. 1410. Milan, Pinacoteca di Brera.

The form and decoration of the chair on which the bishop sits during pontifical celebrations make it very like a throne.

Throne

Name
From the Greek *thronos*, a seat

Definition
The bishop's seat is the principal church of the diocese; the throne is his chair

Purpose
For the bishop to sit on

Diffusion in art
In early apse vaults Christ Pantocrator was shown seated on a throne, or the throne was shown empty. Later on, the throne appears in narrative scenes concerned with the activities of bishops

A bishop's seat or throne was originally made of wood and was portable, so that it could be moved to an appropriate position in church according to ritual requirements. While the seats of the Roman curia were presumably similar in shape to everyday chairs, the bishop's seat was different because it needed to stress the honor of his position, which was comparable to imperial dignity. The bishop's seat therefore had to have arms covered in rich materials as well as a back. Images of such thrones can be found in early representations of the Hetoimasia (Eternal Throne), or of Christ in Majesty or Christ Pantocrator, in paleo-Christian basilicas. At the time of Constantine, wood gave way to stone, as the latter proved more suited to the monumental dimensions of new churches. It was also then that the seat's position became settled: it preferably sat at the center of the semicircular apse and a few steps up. Later it was moved to the left and placed at the top of three steps, and its shape became more thronelike: the back became taller and was surmounted by a baldachin. It was from here that the bishop surveyed proceedings. On occasions when he was required to take a leading role, a portable chair called a faldstool would be used.

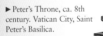

▶ Peter's Throne, ca. 8th century. Vatican City, Saint Peter's Basilica.

The cross is shown directly above the figure of Christ Enthroned as a cross in glory, encrusted with jewels and shining bright.

Around the representation of Christ's glory and his victory over death are the symbols of the four evangelists: the winged ox beside the cross represents Saint Luke, and the winged lion represents Saint Mark.

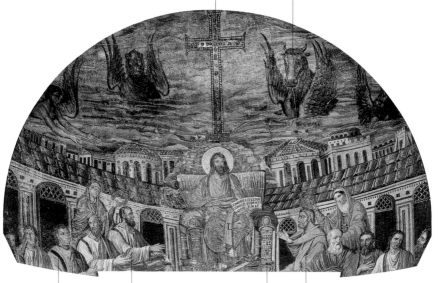

Saint Paul has an elongated face and a long beard and is almost bald. He partakes of the glory of Christ by sitting on his right and, like Peter, he is receiving a crown of glory.

Saint Peter is recognizable from certain physical features, including a short, square beard, that had become standard as early as the 3rd century. He occupies a position of honor close to Christ, who placed him in charge of the Church he had founded.

This representation of Christ's appearance is completed by the throng of twelve apostles.

The throne occupied by Christ Pantocrator (Almighty Ruler) probably reflects the earliest types of bishop's throne. It is made of stone, richly decorated, and upholstered with luxurious cushions and draperies that lend imperial dignity to whoever sits on it.

▲ *Christ Pantocrator*, early 5th century.
Rome, Santa Prudenziana.

15

Throne

The announcing angel represents the voice of the Holy Spirit, which, according to Tommaso da Celano's Vita seconda (Fonti francescane, 707), explained Saint Francis's vision to the friar who accompanied him.

Of the five shining thrones in the vision, the one in the middle is larger and more imposing than the others. The largest had apparently been reserved for the greatest of the angels, but that angel had rebelled and the seat was now reserved for the humblest of men, namely, Saint Francis. Giotto's depiction certainly reflects the typical shape of bishops' thrones at the time.

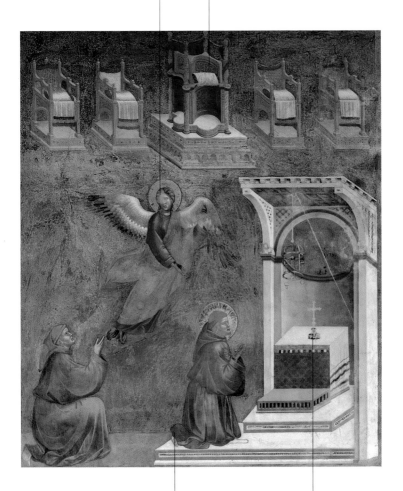

▲ Giotto, Scenes from the Life of Saint Francis: The Vision of the Thrones, 1297–99. Assisi, upper church of San Francesco.

Saint Francis piously kneels in deep prayer and is consequently unaware of his companion's vision.

Saint Francis's prayer is directed toward a cross, which constitutes the central feature on an altar in an architectural cross section revealing a vaulted apse with a coffered ceiling.

Two winged putti are carrying another attribute of Saint Peter: the keys that represent the keys of heaven promised by Jesus when he founded the Church on Peter.

The tiara, as the highest symbol of the pope's authority, crowns the throne of Saint Peter, designed by Bernini during the pontificate of Alexander VII and intended for the apse of Saint Peter's Basilica. The new throne was designed to contain the ancient one that was thought to have been used by Peter himself, but that was actually a gift from Charles the Bald to Pope John VI in the 9th century.

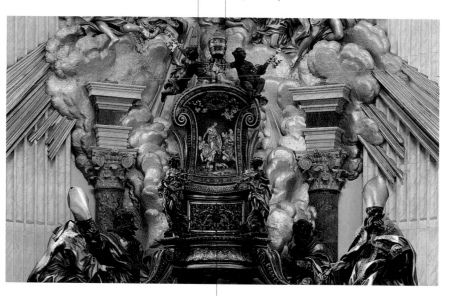

Beside the great bronze throne are the four fathers of the Church: the two Western bishops, Saint Ambrose and Saint Augustine, and the Eastern doctors, Saint Athanasius and Saint John Chrysostom.

▲ Gian Lorenzo Bernini, *The Throne of Saint Peter* (detail), 1657–66. Vatican City, Saint Peter's Basilica.

Ambo

An ambo is a raised platform with a parapet and often two flights of access steps. It stands outside the presbytery, to the right with respect to the altar.

Name
The etymology of the word *ambo* is uncertain. It seems to derive from the Late Latin *ambonem*, which in turn derives from the Greek *ámbonos*, meaning a curved surface—the original shape of an ambo. It is sometimes wrongly referred to as a pulpit

Definition
A tribune with a parapet, placed in an elevated position inside a church

Purpose
Used for reading and proclaiming the Word of God, for preaching and for reciting the creed

Sources
Apostolic Constitutions, Didascalia, the 4th-century Council of Laodicea (canon 15)

Diffusion in art
Found in scenes of liturgical rites

As early as the 4th century, Christian churches had a raised structure where the deacon and a reader would go to read and proclaim the Word. The earliest evidence of a disciplinary issue we have (the Council of Laodicea in A.D. 371) emphasizes that no one was allowed in the ambo unless specifically authorized. Ambos must originally have been made of wood, and consequently none of the early models has survived. The principal purpose of an ambo was to proclaim the Word of God through readings from the Old Testament, the Epistles or the Acts of the Apostles, the Psalms, and the Gospels. There is early evidence that an ambo could have more than one level, to be used according to the reading concerned. Such an ambo was built like a tower and might have a ciborium (canopy) at the top. It usually had two flights of steps, one facing east and the other west, for the same symbolic purpose as the orientation of the church itself.

▶ Ambo of Henry II, early 12th century. Aachen, cathedral.

The presence of a thurible carried by the clerk on the far right, preceded by another with an incense boat, demonstrates the solemnity of the occasion, when the Word of God will be visibly honored through the rite of incensation.

A clerk holds out a miter to the officiating priest, who is preparing to read the holy text.

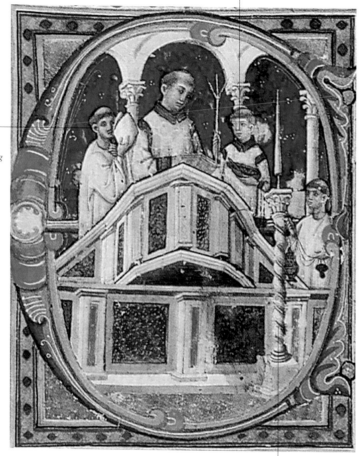

The candlestick with its paschal candle stands beside the ambo, having been placed there after the blessing at the beginning of the Easter Saturday celebrations.

▲ Illuminated initial, *Exultet*, late 13th–early 14th century. Vatican City, Biblioteca Apostolica Vaticana.

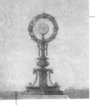

It is an architectural canopy, supported on four columns and placed over the altar. In some cases, this little shrine above the tabernacle is called a baldachin.

Ciborium

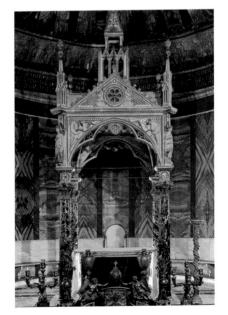

Name
Derives from the Chaldean word *kiborion*, meaning "ark of fire," "ark of light"

Definition
Generally an architectural baldachin placed as a protection over certain parts of a church, particularly the altar

Purpose
Symbolic and protective

Diffusion
From paleo-Christian times, found chiefly in Italy, especially in the Rome area, from which it spread to Latium, Tuscany, Romagna, and Veneto. With the advent of Charles the Great it spread throughout Europe until the Renaissance, and enjoyed a substantial revival in the Baroque period

Diffusion in art
Found in representations of liturgical rites

▶ Arnolfo di Cambio, Ciborium, 1293. Rome, Santa Cecilia in Trastevere.

By the 4th century, the altar had acquired a fixed position within churches and basilicas; in the same period, a baldachin or ciborium was raised above it. This was originally a temporary wooden structure, often richly decorated with silver, but it was later transformed into a key architectural feature, which evolved from its first interesting early medieval forms to the grandiose constructions of the Baroque. There is no evidence from early sources that it came into being as a liturgical feature linked to religious rites, nor do we know of any regulations requiring a ciborium for any ritual, so it must simply be an altar accessory. The ciborium originally had a secular purpose: it was a kind of shrine that stood over the emperor's throne both inside the royal palace and in public places, acting as a sign of imperial dignity. It was soon taken up by the Church to honor the place where divine sacrifice was enacted. Just as the divine figure of the emperor was shielded from the public gaze, so curtains could be drawn across the sides of the ecclesiastical ciborium to conceal the culminating moment of the liturgy from the faithful.

The stone ambo with fine inlaid decoration stands to the left of the altar above the rood screen, which separates the presbytery from the part of the church intended for the congregation.

A wooden cross, painted on the front, stands on the rood screen and is tilted slightly forward, as was customary at that time: this way, the painted figure of Christ on the cross, presented for worship, seemed more realistic and affecting.

A ciborium-baldachin raised on four columns protects the altar. For the solemn Christmas services, it is decorated with garlands.

The friars accompany the Christmas celebrations with singing.

▲ Giotto, *Christmas Creche at Greccio*, 1297–1300. Assisi, upper church of San Francesco.

At Christmas 1222, Saint Francis wanted to set up a creche to evoke the nativity of Jesus. At the time, he was a deacon and is therefore shown wearing a dalmatic.

Gian Lorenzo Bernini's imposing ciborium-baldachin rests on four twisted columns. It takes up much of the vast space below the dome and draws attention to the confessional altar.

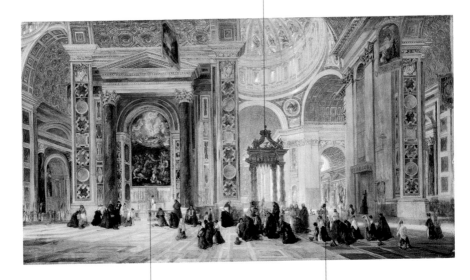

In accordance with the liturgy that was in use until the Second Vatican Council, the altar stood against the wall, and so the priest celebrated Mass with his back to the congregation.

Among the various pilgrims kneeling at Mass and paying careful attention to the proceedings, one can see Swiss guards with their halberds.

▲ John Scarlett Davis, *Interior of Saint Peter's, Rome*, 1842–44. Cardiff, National Museum and Gallery of Wales.

A small shrine with a door, it may stand on or be suspended over the high altar, or—especially north of the Alps—be mounted on the wall beside the altar in cornu evangelii.

Tabernacle

The requirement of keeping the pyx containing the consecrated hosts on the altar goes back to the 9th century. In 1215, the Lateran Synod ordered that the pyx be kept in a closed container, and as a result wall-mounted tabernacles became common, especially in Italy and Germany in the 15th century. They were attached to the wall beside the altar *in cornu evangelii* (that is, on the side where the Gospel is read), with a lockable door and a kind of frame (normally of marble) decorated with reliefs alluding to the mystery of the Eucharist. But north of the Alps the custom was usually different. From the late 14th century to the 18th century, the preference there was for vertical architectural structures inside which the monstrance with the consecrated host could actually be seen. A fixed tabernacle in the middle of the altar became established in the 16th and 17th centuries and was definitively prescribed by Paul V in the *Rituale Romanorum* of 1614. Finally, in 1863, it was decreed that the only tabernacle be that on the high altar. When the sacrament is in the tabernacle, it is to be covered with a tabernacle veil, or else a lighted lamp is placed beside it.

Name
From the Christian Latin term *tabernaculum*, meaning "tent"—a diminutive of *taberna*, a hut made of wooden planks

Definition
An enclosed shrine

Purpose
To hold the pyx with the consecrated hosts

Sources
Rationale divinorum (5.1.15), prescriptions of the Lateran Synod, *Rituale Romanorum*, Decree of the Congregation of Rites (1863)

Diffusion in art
Found in scenes of liturgical rites

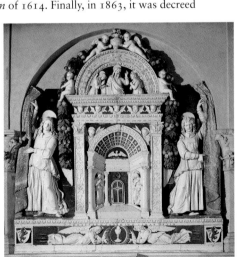

◄ Giovanni della Robbia, Tabernacle, late 15th–early 16th century. Florence, Santi Apostoli.

The tabernacle is protected by a tall ciborium. Both are classical in form, reflecting late-16th-century Roman taste.

This tabernacle is of an architectural type and takes the form of a small ancient temple surmounted by a statue of Christ in Benediction. It was a gift to Milan cathedral from Pope Pius IV, and the artist has taken certain liberties in depicting it.

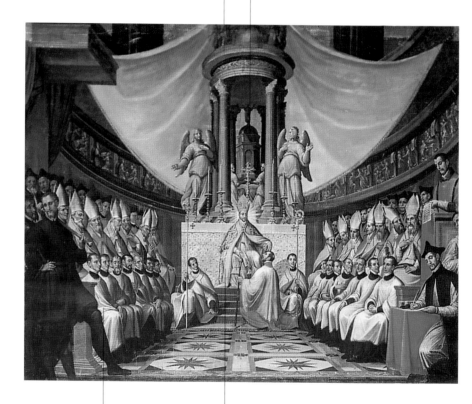

Among the clergy summoned by the cardinal we can distinguish numerous auxiliary bishops, priests, and other clerics.

Cardinal Saint Charles Borromeo sits on a faldstool in front of the altar, wearing the distinctive, sumptuous bishop's cope and miter. He is presiding over a council or synod.

▲ Giovanni Battista della Rovere and Giovanni Mauro della Rovere (called the Fiamminghini), *Saint Charles Borromeo Holding Six Provincial Councils and Eleven Diocesan Synods*, 1602. Milan, cathedral.

Juliana is gazing at a particular type of tabernacle, probably one of early design that is suspended close to the altar.

Juliana had a repeated vision of a stain on the moon, which represented the loss of splendor by the Church Militant through its failure to maintain the feast of Corpus Christi.

A lamp shining near the tabernacle indicates that the latter contains the consecrated sacrament.

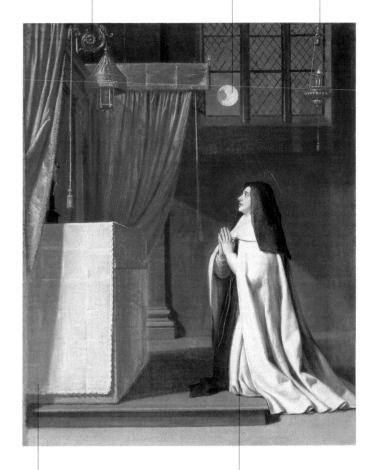

The altar at which Saint Juliana is praying has a simple white cloth cover. The ironing folds show that even this simple cloth has been prepared with care.

▲ Philippe de Champaigne, *The Vision of Saint Juliana of Liège*, ca. 1650. Birmingham (U.K.), The Trustees of the Barber Institute of Fine Arts, University of Birmingham.

Saint Juliana of Liège was a Cistercian nun in the 13th century. She is shown worshiping the Blessed Sacrament at the very moment when she realizes the profound meaning of a vision that had appeared to her on a number of occasions.

25

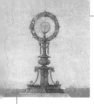

A covering for the side of the altar facing the congregation, it could be made of wood, cloth, precious metal decorated with jewels and gemstones, marble, or scagliola (stucco work).

Altar Frontal

Name
Also called antependium
from the Latin *ante*
(before) and *pendere*
(to hang)

Definition
Portable altar covering

Purpose
Decoration

Diffusion in art
Found in scenes of liturgi-
cal rites

It is likely that even when an altar was still a portable structure, users would cover it with a cloth for practical reasons. The cloth covering soon acquired symbolic value linked to the solemnity of the meal and the honor due to those involved. From the simple tablecloth used in the beginning developed the custom of covering the front of the altar, even when, after the Second Vatican Council, the priest faced the congregation. The altar frontal could be changed for different seasons of the liturgical calendar or according to the type of celebration. These decorative items developed particularly up to the 11th century and for a short while thereafter, until the orientation of the altar was settled; it was finally moved to the back of the presbytery or choir, so that the celebrant's body shielded the altar from the view of the congregation. In post-Tridentine times it was decreed that altar frontals cover only the side facing the congregation. Different materials were used to make a great variety of altar frontals: embroidered or painted fabrics, panels with narrative paintings, sheets of metal that might be gilded, embossed, or engraved, and colored scagliola or marble.

► Paolo Uccello, *The Miracle of the Desecrated Host*, predella detail, 1465–69. Urbino, Galleria Nazionale delle Marche.

An angel descends toward the altar to deliver a written message. It conveys that the great sin for which Saint Giles is celebrating Mass has been forgiven.

The splendid altarpiece, shown as a piece of precious goldwork, has an embossed image of Christ Pantocrator in the middle.

King Charles, in ermine cloak and royal crown, had asked Abbot Giles to celebrate a Mass for him in order to obtain forgiveness for a very grave sin. He piously takes part in the Mass with his own missal, but looks rather startled.

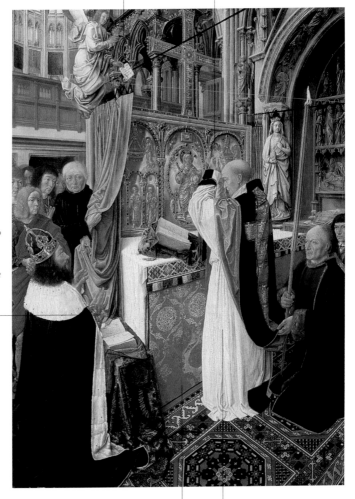

▲ Master of Saint Giles, *The Mass of Saint Giles*, ca. 1500. London, National Gallery.

The front of the altar is covered and ornamented by a precious altar frontal in worked red fabric.

Saint Giles raises the consecrated host in both hands as he reads the canon containing the prayer of consecration from the liturgical book on the altar.

These decorated and illustrated books were included in paintings of liturgical ceremonies, or shown as attributes of religious figures.

Liturgical Books

Name
Missal, prayer book, lectionary, evangelary

Definition
Books for liturgical rites

Purpose
Sacramentary: a book for the celebrant containing formulae for the sacraments; lectionary: readings for Mass; antiphonary: hymns; *ordines*: organization of the rite; pontifical: bishop's formulae and rites; missal: complete instructions for celebrating the Eucharist: prayer book: prayers for the canonical hours

Sources
Didache; the writings of Clement of Rome; the First Apology of Justin; the Apostolic Tradition of Hippolytus of Rome

Diffusion in art
Very widespread in scenes of liturgical rites

► *The Expulsion of the Merchants from the Temple and the Canon of the Gospels*, miniature from *Codex purpureus*, 5th–6th century. Rossano, Museo Diocesano.

For the first three centuries of the Christian Church, the only liturgical book was the Bible. But there were other texts in circulation that, although not strictly liturgical, provided information of a liturgical kind. The Apostolic Tradition, which appeared around the year 215 and provided suggestions for rites and formulae, may be considered the first liturgical text. At the time, a great deal of liberty and creativity were allowed, but after the 4th to 6th centuries, they were gradually lost as each church developed texts to establish its own liturgical forms, albeit unofficially. The first official liturgical books appeared in the 7th century: sacramentaries, lectionaries (supplanting continuous readings from the Bible),

and antiphonaries, initially without musical notation. As the year 1000 approached, books were joined together into a single volume containing liturgical formulae and instructions as well as readings. At this stage we also find pontificals, missals (complete instructions for the Mass, as well as hymns and readings), and breviaries, which brought together previously separate books such as psalters, homiliaries, antiphonaries, and prayer books.

This is a kind of frame into which a written text is inserted. It was used on altars starting in the 16th century. In the next century, three texts were fused together.

Altar Card

From the 17th century until the liturgical reforms of the Second Vatican Council, it had become common practice during Mass for the celebrant to use written texts placed on the altar to assist his memory. There were three texts, each containing fixed elements of the rite, set in frames and placed at the center and at each end of the altar. It appears that initially only the written text of the Gloria was used (hence the name *cartagloria* in Italian), and it was placed in the middle of the altar. Other prayers were added later, namely, the Canon and Offertory, called the "Canon minor," and the formulae to be recited in low tones; hence the altar card was sometimes described as "tabella secretarum." At a later stage, and commonly from the 17th century onward, two more tablets were added, one at each end of the altar. They might be the same size as the central tablet or smaller. The prayers they contained were the Lavabo text—the formula for blessing water—*in cornu epistulae* and the beginning of John's Gospel *in cornu evangelii*. Before the reform, the priest made the sign of the cross on the altar or the altar card after reading from the last Gospel.

Name
The Italian term *cartagloria* is made up of the two words *carta* and *gloria* and only came into use in the 19th century

Definition
A framed tablet containing parts of the liturgy

Purpose
A memory aid for celebrants

Sources
The Synod of Milan 1576 (quoted by Saint Charles)

Diffusion in art
Found in scenes of liturgical rites

◀ Luigi Valadier, Altar Card, 1762. Rome, Santa Maria Maggiore, Borghese chapel.

Altar Card

A German priest had doubts about the real presence of the
body of Christ in the host as stated in the doctrine of tran-
substantiation, but on raising the host immediately after
the consecration he saw blood issuing from it. This was the
Miracle of Bolsena in 1263.

The presence of six candle-
sticks on the altar (we can
see three in their entirety
and symmetry demands that
there be three on the other
side) means that this may be
the solemn celebration of
sung Mass.

The altar card frame, with the
prayers for the fixed parts of
the Mass, stands on the altar.

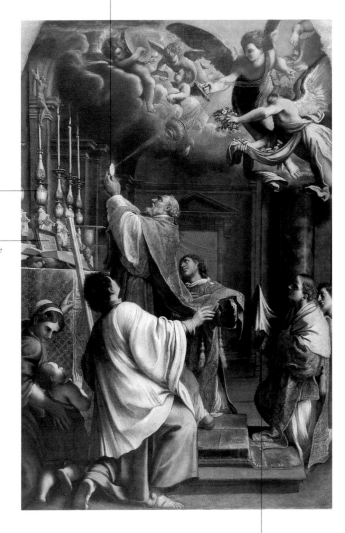

▲ Antonio Maria Panico,
The Mass at Bolsena, ca. 1600.
Farnese, San Salvatore.

The subdeacon kneels
behind the celebrant and
holds the paten under the
humeral veil.

Candlesticks were placed on or near the altar and near the ambo. At funerals they were placed close to the body. They were particularly important for use with paschal candles.

Candlesticks

The brightness and vibrancy of fire makes it a symbol of life and a place where the divine is manifested, as related in the episode of Moses and the burning bush (Exodus 3:1–6). In the liturgy, candle flames retain this symbolism: the blessing of new fire on Easter night, the paschal candle that is lit from that fire, and the placing of the paschal candle beside the ambo as a visible announcement of Christ's resurrection. The candlesticks used in Christian churches echoed the motifs and materials (marble) used by the Romans. During the Middle Ages, the true *candelabrum* was used almost exclusively for religious services. It was often made of bronze and its preferred position was on the altar, but there is evidence that marble candlesticks persisted in the Roman tradition. In the Gothic and Renaissance periods, increasingly sophisticated motifs were used in candlestick design. At first they took inspiration from architecture, with elaborate frameworks and colonette forms, until eventually the candlestick became an art object in its own right.

Name
The Latin word
candelabrum means
"candlestick"

Definition
To hold candles, including
paschal candles

Purpose
A symbol of divine
manifestation

Sources
Exodus 3:1–6; *Liber
pontificalis* 1.173–81

Diffusion in art
Found in scenes of
liturgical rites

◄ Candlestick, 18th
century. Rome, San
Giovanni in Laterano.

Candlesticks

During a service at which Gregory the Great has prayed for a miracle to convince a doubting woman of the real presence of the body of Christ in the consecrated sacrament, a tiny image of Jesus becomes visible above the chalice at the moment of consecration.

The figure of the risen Christ with the cross is part of the sculptural decoration of the altar. It serves to reemphasize his presence in the sacrament.

During the 17th century it became customary to use candlesticks during Mass, preferably on the altar. Their number was also established: six for a sung Mass, four or two for a read Mass, and seven for a pontifical High Mass.

Gregory's magnificent papal tiara is his attribute in art.

The picture of the Crucifixion in the celebrant's missal on a lectern underscores the significance of the miracle.

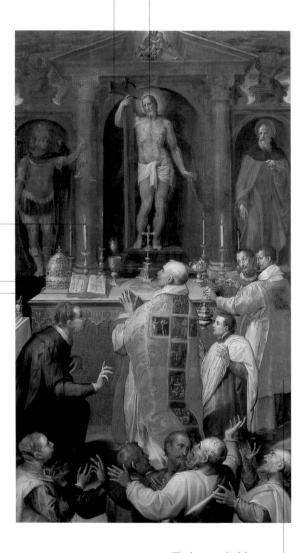

▲ Cesare Aretusi and Gabriele Fiorini, *The Miraculous Mass of Saint Gregory the Great*, 1580. Bologna, Santa Maria dei Servi.

The deacon and subdeacon are approaching the altar with the thurible and incense boat to cense the area during consecration of the bread and wine.

Even precious candlesticks are given away by Deacon Lawrence to alleviate the poverty of the desolate population.

Over his tunic Lawrence wears a deacon's dalmatic with wide sleeves.

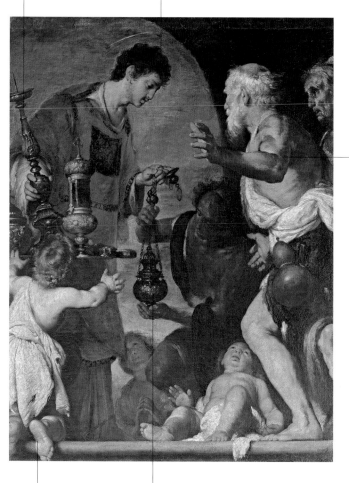

It was part of a deacon's job to succor the poor and widows in need. According to Ambrose, Lawrence was brought before the emperor, who demanded the Church's riches. Lawrence replied by bringing in the poor, among whom he had distributed the goods, saying that the poor were the Church's treasure.

A child stretches out his arms to take a tall monstrance.

Among the items of Church treasure that Lawrence had been told to distribute to the poor, we recognize a thurible.

▲ Bernardo Strozzi, *Saint Lawrence Distributing Alms*, ca. 1638–40. Venice, San Nicola di Tolentino.

Its dimensions may vary and it may or may not include an image of Christ. Since a processional cross is raised on a staff, it is ornamented on both sides.

Cross

Name
From the Latin *crux*

Definition
The chief symbol of the Christian faith

Purpose
Widespread liturgical use from the 9th century. An image of Christ Crucified obligatory from 1570

Sources
Saint Paul (1 Corinthians 1:23); Roman missal of Pius V

Diffusion in art
Throughout the history of Christian art

▶ Unknown Venetian artist, *The Cross of Saint Theodore*, 15th century. Venice, Gallerie dell'Accademia.

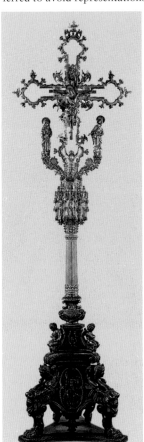

Christians were slow to accept the earliest representations of the cross because, as Paul wrote, it was "a stumbling block to Jews and folly to Gentiles" (1 Corinthians 1:23). They preferred to avoid representations of the instrument of torture or the suffering to which Christ was subjected, focusing instead on the cross's glory as an instrument of redemption. The veneration of the cross became more widespread after the Peace of Constantine (313), when Christians were allowed freedom of worship, and after the finding of the True Cross by Saint Helena, Constantine's mother. With the reform of the Roman missal (1570), it became obligatory for an image of Christ Crucified to appear on the altar cross. Because they were seen from all angles, processional crosses had to be decorated on both sides. From medieval times onward, large crosses painted on wood panel became very common, both for use as altarpieces and for placing on the rood screen that divided the church.

It is the bishop who conducts the funeral, wearing alb, cope, and miter. In accordance with the custom of the time, he also wears prelate's gloves.

The altar is prepared for a read Mass with two candlesticks, between which there stands a gold cross.

The numerous tall towers are a distinctive feature of the little town of San Gimignano, where Saint Fina lived and died.

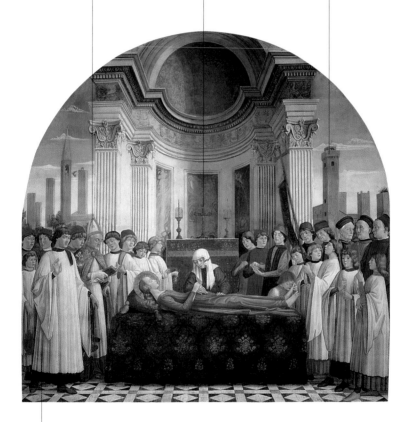

The clerk wears a very long surplice with very wide sleeves. As time went on this garment gradually became shorter and was decorated with elegant lace along the hem and sleeves.

▲ Domenico Ghirlandaio, *The Funeral of Saint Fina*, 1475. San Gimignano, collegiate church.

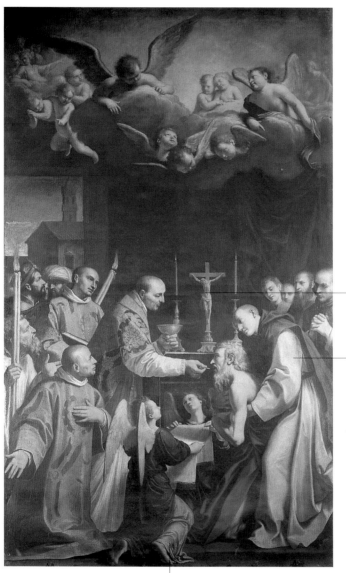

A crucifix stands out between the two lighted candles on the altar. The well-defined body of Christ on the cross at the moment of his death reminds us of the impending death of Saint Jerome.

A young monk tenderly supports the elderly Jerome as he receives his last communion. The Cistercian habits are anachronistic, but are intended to recall the long period Jerome spent at a monastery near Bethlehem.

▲ Lucio Massari, *The Last Communion of Saint Jerome*, 1625. Bologna, San Paolo Maggiore.

The exceptional nature of the event is stressed by the presence of two kneeling angels bearing a cloth. They are acting as acolytes at the distribution of the holy sacrament.

*Among the most important items of altar goods are the chalice,
in the form of a stemmed goblet, and the small plate that
always accompanies it.*

Chalice and Paten

The chalice was probably chosen as the holy vessel for the celebration of the Eucharist because it was the most common type of drinking vessel at the time when Christian worship was taking shape; the Eucharist at that time was a meal taken in private houses and ordinary objects were used. In time, the sacred nature of the consecration of the wine in the chalice was emphasized by beautifying the chalice itself. The shape of the chalice has remained practically unchanged, except for the proportions of bowl and stem. The hemispherical shape of the former has varied in width, and the latter has been embellished with a polygonal pommel that helps the priest hold the cup. Chalices were decorated according to contemporary taste, using costly materials to stress the precious nature of their contents, and the decorative motifs on the bowl, base, and pommel were symbolic of the Eucharist itself. This was especially the case when (from 1286 onward) the rite of *elevatio calicis* was defined, requiring the celebrant to raise the chalice so that the faithful could see it. The chalice is gilded at least on the inside. It is always accompanied by a paten, a small plate used to hold the host.

Name
Chalice comes from the
Latin *calix* (cup), and *paten*
from the Latin *patena*
(plate)

Definition
Holy drinking vessel for
liturgical use; small plate

Purpose
The chalice is used to
consecrate the wine and
distribute the Eucharist;
the paten is used to hold
the host

Diffusion in art
Throughout the history of
Christian art

◀ Lübeck manufactory,
Chalice, 18th century.
Milan, Museo Poldi
Pezzoli.

Chalice and Paten

The laying of hands on the head of the ordinand as he kneels before the bishop is a significant feature of priestly ordination. It is already mentioned in the Acts of the Apostles and is the means by which the Holy Spirit is bestowed.

A portable polyptych stands on the little altar. It can be identified by the hinged side panels, which fold in on the central panel, making it easier to carry and protecting the painted surfaces.

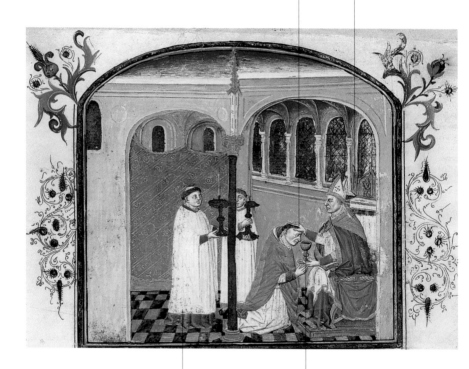

Two clerks, with evident tonsures and full-length habits under surplices with very wide sleeves, are holding candlesticks as they watch the ordination.

The bishop gives the new priest a chalice as a sign of his ministry. The gold chalice has a hemispherical bowl and a large pommel in the stem.

▲ Roman School of the quattrocento, *The Laying On of Hands and the Delivery of the Chalice*, miniature from *Trattato sulla Dignità Episcopale* by Domenico Dominici, ca. 1460. Milan, Biblioteca Ambrosiana.

Pope Saint Sixtus is ordaining a deacon. His face is in fact a portrait of Nicholas V, who commissioned the decoration of the Nicolina chapel, which takes its name from him. He is wearing a tall, conical tiara in which the three superimposed crowns can clearly be seen.

A deacon approaches the pope and offers the book of prayers to be said for the new deacon. The end of his maniple can be seen protruding from his wide left sleeve.

A minister approaches behind the celebrant. He stands ready with a diaphanous humeral veil to take the pope's tiara, for the latter does not wear it during the celebration of the Eucharist.

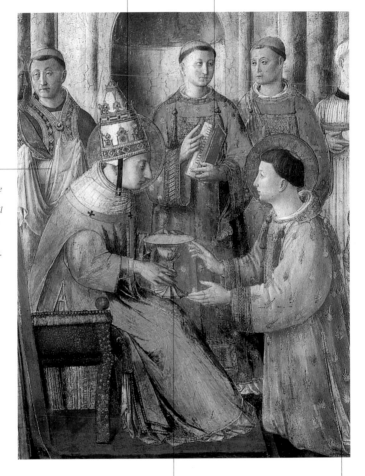

▲ Fra Angelico, *Saint Lawrence Ordained Deacon by Pope Saint Sixtus*, 1448–49. Vatican City, Palazzi Vaticani, Nicolina chapel.

As part of the ordination, the new deacon is given a chalice and paten. The pope offers the chalice, holding it by the pommel, but one can nevertheless make out the precious decoration on its stem.

The pope is seated on a faldstool, and Lawrence kneels before him in the act of being ordained deacon. He is still wearing the tunic of the subdeaconate, the order immediately below that of deacon. Deacons have slightly wider sleeves on their tunics.

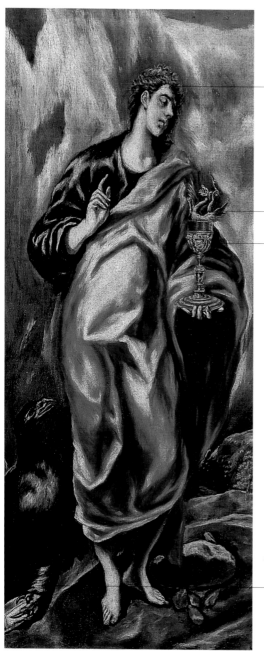

Saint John the Apostle and Evangelist is generally portrayed as a young man because, according to tradition, he was the youngest of the twelve chosen by Jesus.

A monstrous creature—a small dragon—emerges from the chalice. This is to remind us of an apocryphal story, related in Jacobus de Voragine's Golden Legend, in which a priest of Diana dares John to drink from a poisoned cup. The saint not only survives but restores life to two others previously poisoned.

The chalice ought really to be a simple drinking cup to fit the apocryphal story, but it has been painted with precious stones and enameling to resemble some of the most beautiful liturgical chalices of the early Spanish Baroque.

The eagle beside Saint John is his chief attribute as evangelist. It was paired with him because the text of his Gospel was seen as one of lofty spirituality and hence reminiscent of a bird that flies higher than any other.

Christ takes communion with the apostles by giving them the sacrament to eat, that is to say, his own body in the guise of consecrated bread.

Jesus uses a paten to distribute the Eucharist. It is very likely that the artist is imitating the gesture of a priest here.

Saint Peter assists Jesus in distributing the Eucharist, accompanying him with a gold chalice of wine.

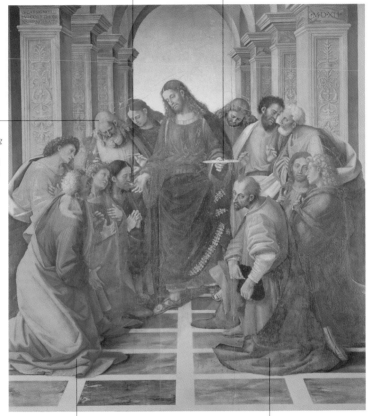

The apostle who gazes absentmindedly out of the painting and lacks the delicate gold-ringed halo is Judas. Although kneeling like the others, he is busy opening his money bag—an indication that he is in charge of the group of twelve's money, and also a symbol of his betrayal.

◀ El Greco, *Saint John the Evangelist and Saint John the Baptist* (detail), 1600–1607. Madrid, Prado, on loan to the Santa Cruz Museum in Toledo.

▲ Luca Signorelli, *The Communion of the Apostles*, 1512. Cortona, Museo Diocesano.

The apostles receive the sacrament with pious devotion. They are arranged in a semicircle around Jesus in accordance with Renaissance geometrical ideals.

It looks like a chalice with a wide bowl, but it has a lid, which is often topped by a small cross. On special occasions it may be covered with a rich cloth.

Pyx

Name
From the Greek *pyxis* (bowl), which derives from *pyxos* (box) because it was originally a bowl made of boxwood

Definition
Sacred bowl with a lid

Purpose
To hold the consecrated hosts

Diffusion in art
Rare

At an early stage, a pyx was used for the same purposes as a tabernacle—to store the host—but later it came to designate a vessel for the host within the tabernacle, or a portable container to take the Eucharist to the sick. From the late 16th century, after the Council of Trent, the shape of the pyx was fixed: it had a pedestal base with a stem supporting a bowl with a lid. The bowl might be tall and cylindrical or like that of a chalice, but was generally hemispherical and fairly broad. The lid had a cross on top, and the whole pyx was to be made of precious materials. At one time, when it contained the consecrated hosts, it was customary to cover the pyx with a veil (the Italian term *conopeo* for the veil comes from the Greek word for mosquito, because the veil was made from mosquito netting) in order to indicate the presence of the consecrated sacrament. The shape of the veil could vary. It was normally round, but could also be semicircular or rectangular or could be made up of four pieces of cloth sewn together to form a cross. It was preferably made from white or embroidered silk or other fine fabrics.

▶ Venetian manufactory, Pyx, late 15th–early 16th century. London, Victoria and Albert Museum.

The resplendent pyx is covered in a white veil with gold decoration. It contains the Blessed Sacrament and is an object of veneration by the faithful because of the saint's ecstatic levitation.

Saint Joseph of Cupertino wears the Franciscan habit of the Conventuals. He has been taken up in ecstatic levitation at the sight of the pyx containing the sacrament.

The tabernacle is covered with a veil made of gold fabric decorated with bands and fringes. Its door has been opened in order to extract the pyx for display during the Quarantore (Forty Hours' Devotion).

The priest leading the procession displays the pyx without touching it with his bare hands, using instead a humeral veil of the appropriate liturgical color.

The altar is also decorated with cloths that conform to the color of the Quarantore.

▲ Marco Caprini, *Saint Joseph of Cupertino in Ecstasy*, 1776. Modena, private collection.

The processional umbrella in liturgical white conforms to the regulations issued by Pope Clement XII in 1730. Hence its form belongs to the artist's era rather than that of the episode, which occurred in the second half of the 17th century.

The second king brings his gift of incense, a symbol of divinity, in a container shaped like a precious liturgical pyx.

The heads of the ox and the ass can be seen emerging from the little shed behind Mary. They are always present in scenes of the Nativity and Adoration because they appear in ancient prophesies and apocryphal texts.

The first gift—gold in a small casket—is a symbol of royalty.

▲ Albrecht Dürer, *The Adoration of the Magi*, 1504. Florence, Uffizi.

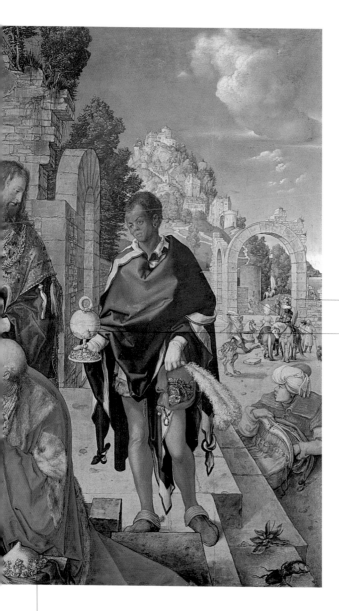

Especially during the Renaissance, one often finds the Magi processing through a ruined arch, a symbol of the passing of the pagan age with the advent of Christ.

The third king pays homage to the Child by bringing myrrh, a precious ointment used in preparing the dead for burial. It indicates the true humanity of Christ and is kept in a pyx consisting of a large hemispherical bowl with an equally large lid, the two forming a perfect sphere.

The headdress of the first of the Magi, doffed in respect, is decorated to look like a crown. This accords with the tradition that the wise men who came from the East to worship Jesus were kings.

Containers for liquids of varying shape, they are normally quite small and a set of two are placed on the altar ready for Mass.

Cruets

Name
From a diminutive of Old French *cruye* (jar)

Definition
These containers figure among altar goods and are also used for holy oils

Purpose
They are used at Mass to bring water and wine for consecration. Since the time of Pius V, the water has also been used for hand washing

Diffusion in art
Found in scenes of liturgical rites

Originally, when Mass was being celebrated and water and wine were being prepared for the chalice, a fairly large container was used, because it was the faithful who brought wine in their own containers called ampulae, and when empty they were returned to their owners. It was only from the 13th century that the use of small twin containers became common. At the Synod of Würzburg in 1298, the first regulations about cruets were issued. They were preferably to be made of glass, pewter, gold, or silver. They were sometimes also called jugs, probably because they often had narrow necks; and their small dimensions were due to the fact that from the 11th and 12th centuries the faithful took communion with bread alone. In the course of history they have been made of various materials, with a preference for glass, and their shape has varied as well. Examples without a handle can be flask shaped, with a long neck for pouring, while those with a handle may be jug shaped, tankard shaped, footed, or not. The upper rim sometimes opened out for pouring. There is nearly always a lid with something to indicate the contents. The cruets stand on a small cruet tray.

▶ Venetian manufactory, Pair of Cruets, 17th century. Milan, Museo Poldi Pezzoli.

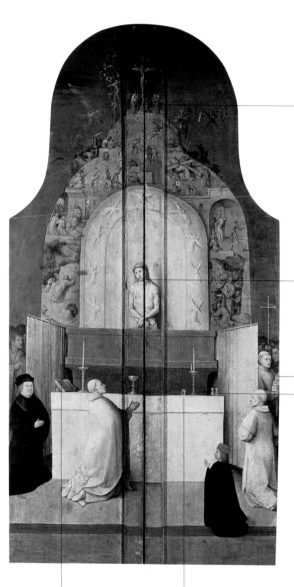

The representation of the Crucifixion at the pinnacle of this great altarpiece seems to bring to a conclusion the narrative of the Passion, though in fact it is completed by the appearance of Christ lower down.

In order to combat the incredulity of a member of the congregation as to the real presence of Christ in the consecrated sacrament, Saint Gregory requested a miracle during Mass. At the moment of consecration, Christ was seen to appear as man of sorrows, with blood gushing from his wounds into the chalice.

Beyond the hanging that acts as a rood screen (or iconostasis when there is no clear spatial demarcation of the sanctuary), a subdeacon waits with Pope Gregory's tiara.

A pair of cruets sit on the edge of the altar at the side where a deacon is kneeling, ready to serve at Mass.

The missal required for the service rests on a lectern on the altar, to the left of the celebrant. There is no altar card—evidently they were not yet in common use in the early 16th century.

A small pax, perhaps with embossed decoration, stands on the altar.

▲ Hieronymus Bosch, *Triptych of the Adoration of the Magi*, side panels closed, *The Mass of Saint Gregory*, ca. 1510. Madrid, Prado.

Similar in shape to a reliquary or pyx on a base, it is used for showing the consecrated host. It is made of precious metals or, on rare occasions, of inlaid and gilded wood.

Monstrance

Name
From the Latin *monstrare* (to show)

Definition
A container for displaying the consecrated host

Purpose
Displaying the consecrated host for worship

Diffusion in art
In scenes of liturgical rites, and in certain scenes from the lives of saints

The earliest monstrances were adaptations of other liturgical objects, such as reliquaries or pyx, to which lunas (nearly always made of gold) were added to hold the host. The use of reliquaries made it clear that the consecrated host was seen as a relic of Christ, whereas the use of a pyx as a monstrance was an extension of its primary use for keeping consecrated hosts. The shape of a monstrance thus derived from the established type of reliquary on a base. The need for a specific liturgical object in which to present the consecrated host began to be felt only in the 15th century, thanks to Blessed Sacrament processions and the institution of Forty Hours' Devotions. It was in this context that the four basic monstrance shapes were established: tower, disc, cross, and figured. As time went by, other variations appeared, leading to architectural monstrances, either cup shaped or with rays. The exuberance of Baroque art and the pressing need for symbols at the time of the Counter-Reformation led, in the 17th century, to monstrances whose stems were richly decorated with vegetal motifs and allegorical scenes.

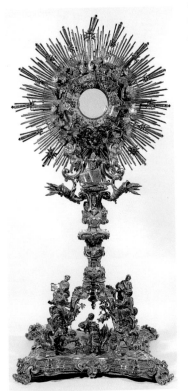

▶ Monstrance with grape harvest, silver, enamel, gems, 18th century. Caltagirone, cathedral treasury.

The monstrance carried by Saint Clare derives its form from the reliquary and the tower pyx. The host rests on a gold lunette.

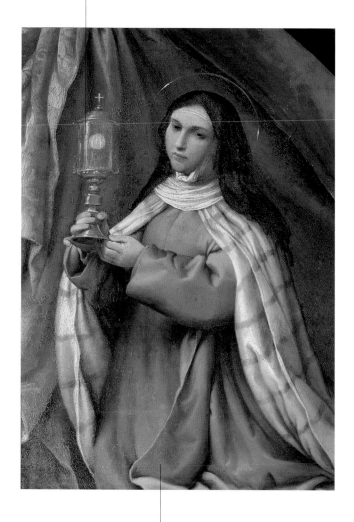

▲ Lorenzo Lotto, *Saint Francis and Saint Clare* (detail), 1526. Jesi, Pinacoteca Civica.

Saint Clare wears the brown habit and black veil of the Poor Clares. Her attribute in art is a monstrance to recall the episode in her hagiography in which she kept the Saracens away from Assisi by praying at the town gate, having taken with her an ivory casket containing the Blessed Sacrament; but the art tradition has always preferred to show the sacrament in a monstrance.

Monstrance

Christ's appearance is confirmation of the true substance of the host. He appears in triumph, bathed in light, and with the stigmata and crown of thorns as signs of his sacrifice.

The column, rope, and bundles of rods symbolize the Flagellation.

To Jesus' right we see the chief instruments of the Passion: the lance that pierced his side and the stick with a sponge soaked in vinegar, both tied to the cross.

This kind of monstrance, with refined Gothic architectural forms, was particularly widespread in the Milan area, thus reflecting the origin of the commission for the altarpiece and its intended destination.

Saint Bartholomew the Apostle gazes at the vision of Jesus with hands together. At his feet is his attribute in art: a knife, with which he was skinned alive.

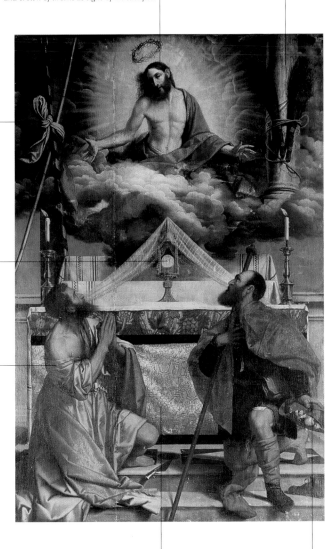

▲ Moretto da Breschia, *Christ of the Eucharist with Saint Bartholomew and Saint Roch*, ca. 1550. Castenedolo, San Bartolomeo Apostolo.

The magnificent white altar frontal completes the simple furnishing of the altar, which concentrates attention on the displayed sacrament.

The crumpled stocking allows us to see signs of the plague, which struck Saint Roch on a pilgrimage to Rome. On the hat are symbols of pilgrimage destinations.

These small panels of various shapes and materials, bearing a Passion scene, stood on the altar. Saint Charles prescribed that they be made of gold, silver, or bronze and show a Pietà.

Pax

Pax is the name traditionally given to the small panel with a Pietà or other scene from the Passion, which was offered to the priest for the kiss of peace before communion, especially in the choir at low conventual Masses, or to a bishop or other prelate if they were formally involved in a read Mass. The kiss of peace was a custom taken from Jewish tradition and adopted by Christians for use during the liturgy of the Eucharist as a gesture of fraternal communion before approaching to receive the body and blood of Christ. According to the words of Jesus while praying at the Last Supper, the kiss of peace was a sign of the pacification of minds, and it remained in use until the early decades of the 20th century. The pax could be made of various materials, from wood to silver and gold, and it could be square, oval, of irregular form, architectural, or round. The holy scene in the middle was usually a Pietà, either with Christ alone or with the Virgin and Saint John at either side, but other scenes, such as the Madonna and Child or Christ Crucified, were also used. There were also cases in which the plate included a small pinnacle and showed more than one holy scene.

Name
From the Latin
instrumentum pacis

Definition
A small Pietà scene

Purpose
It was kissed by the priest
as a sign of pacification
before communion

Diffusion in art
Found in scenes of
liturgical rites

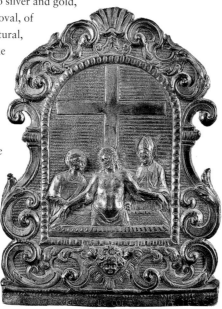

◀ Italian manufactory,
Pax, 1680. Milan,
Museo Diocesano.

51

The clerk holds the bishop's crosier, using a sudarium to avoid touching it.

Bishop Macaille is wearing his pontifical robes and reading from a lectionary the formulae for the vesting of Brigid, at the same time holding the white robe that will be given to her.

The cross in the large fresco of the Crucifixion behind the altar is exactly in line with the precious gold cross on the altar itself.

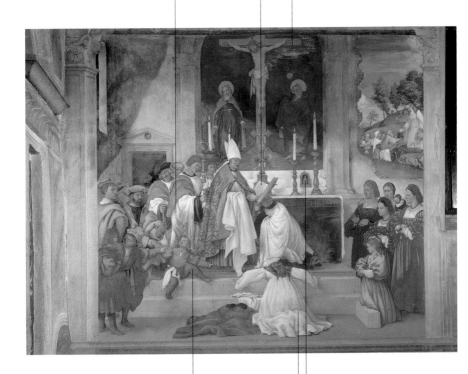

The wooden altar plinth on which Brigid rests her head has miraculously burst into flower as a sign of her sanctity.

Brigid's worldly clothes have been removed and set down on her left. She kneels before the altar steps with her head bowed to the ground to signify her total abandonment to the Lord.

The small pax on the right has an arched top and bears an image of the dead Christ in imitation of embossed work.

▲ Lorenzo Lotto, *The Consecration of Saint Brigid*, 1524. Trescore Balneario, Suardi oratory.

A cup-shaped container with a lid controlled by four chains, it is used with a smaller container in the shape of an open boat. Both are made of precious metals.

Thurible and Incense Boat

The custom of sprinkling rooms with incense was common during the Roman Empire but entered the Christian liturgy only after the age of persecution, because it was too closely tied to pagan rites. Incense sprinkled in a room was a sign of veneration and was first introduced solely for honoring the dead. Later it came to be used at important church services, being directed toward the sacrament, the altar, the Word, the celebrant, the clergy, and the congregation. The true thurible, in use since the 7th century, has a perforated lid so that air can promote combustion, and a hollow pan on which incense grains are burned. At first it was a simple round or hexagonal box, but in Gothic times it took on architectural forms to symbolize the church building itself, and from the 17th century onward it acquired freer forms. An incense boat, or navicula, is a container from which the incense is transferred to the thurible with a spoon. Its shape, like the hull of a boat on a small base, became common in the 14th and 15th centuries and symbolized the Church carrying the faithful to salvation. For processions of the Blessed Sacrament, two thuribles are specifically required.

Name
From the Latin *turibulum* (censer)

Definition
Container for burning incense and container for holding incense grains

Purpose
For incensation at certain liturgical rites

Sources
Dionysius the Areopagite, *De ecclesiastica hierarchia* 2.4

Diffusion in art
Found in scenes of liturgical rites

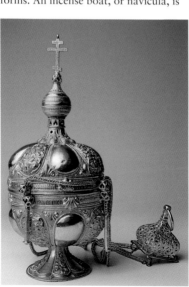

◄ Thurible, 1674. Moscow, State Historical Museum.

53

Although King Solomon recognized the Lord, "he sacrificed and burnt incense at the high places" to idols (1 Kings 3:3).

The statuette of a human figure is an imaginary representation of the idols to which Solomon was sacrificing, even though he had recognized the God of Israel.

The presence of the thurible close to the image of the pagan god acknowledges that the rite of honoring with incense is very ancient. But the object painted by Abbiati is in the style of contemporary liturgical thuribles.

▲ Filippo Abbiati, *Solomon Sacrificing to Idols*, ca. 1690. Milan, Quadreria Arcivescovile.

An angel, accompanied by the heads of winged putti, has come from heaven and with an eloquent gesture promises Saint Palatias the glory of paradise.

According to her hagiography, she used this wonderful silver thurible to honor the Trinity; but in this painting she kneels in prayer, preparing for imminent martyrdom.

In the shadow close to Palatias's cloak one can also make out the incense boat, thanks to a few reflections of light from its silver surface.

Because he needed to place the story of Saint Palatias, a martyr from Ancona, in context, Guercino decided to dress her in the fashion of his own day. The only historical element may be her sandals.

▲ Guercino, *Saint Palatias*, 1658. Ancona, Pinacoteca Civica.

It consists of a water vessel and an instrument either like a paintbrush or in the form of a small perforated globe with a handle, containing a sponge.

Aspergillum Set

Name
From the Latin *aspergere* (to sprinkle)

Definition
A set consisting of a water vessel for holy water and an aspergillum

Purpose
For blessing with water

Sources
Genesis 1:2

Diffusion in art
Found in relation to certain ceremonies and as an attribute of a few saints

The act of blessing with water is very ancient, and Christianity took its water symbols from the language of the Old Testament. We read in the book of Genesis that water indicated the certainty of the divine presence: "The Spirit of God was moving over the face of the waters." Water is also full of life symbolism in the rite of baptism. Aspersion was originally carried out using a twig of laurel, hyssop, myrtle, or olive. There is evidence of aspergilla made with bunches of bristles from the 12th century, their use spreading chiefly in the Ambrosian Church. The perforated globe, sometimes shaped like a pinecone or acorn and often with a ring at the end of the handle, came into common use in the 15th century and was the preferred aspergillum of the Roman Church. The sponge inside the aspergillum was soaked in holy water carried in the companion vessel. The earliest water vessels were ivory *situlae* dating back to the 10th century. For blessing purposes, water is sprinkled on the surface of the object concerned, as special prayers are recited.

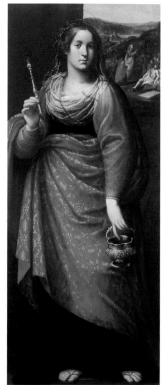

► Giuseppe Cesari (called Cavalier d'Arpino), *Saint Martha*, ca. 1610. Rome, Santa Maria in Vallicella.

The liturgical objects, such as this architectural thurible and accompanying incense boat, stand out against the vaguely rendered setting, with few recognizable features.

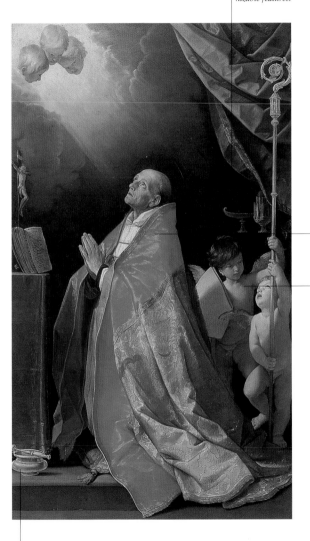

The bishop is Saint Andrew Corsini. He is shown kneeling with hands together before the crucifix, but he gazes upward in a deep ecstatic vision of three cherub heads representing the Trinity.

Behind the saint are three cherubs carrying his attributes in art: the miter and crosier. Notice that the top of the crosier staff has a structure with niches containing images of saints, and that the crook with its elaborate plant motifs terminates in a cross.

A water vessel and aspergillum stand at the foot of the altar. Their presence is not justified by any episode in the saint's hagiographies, but they are probably there because they were used at the altar in the 17th century even in private devotions.

▲ Guido Reni, *The Ecstasy of Saint Andrew Corsini*, ca. 1629–33. Florence, Uffizi.

Generally shown as a jug and basin set, and most likely to be found in scenes of the Passion, the lavabo set is also found in some liturgical scenes.

Lavabo Set

Name
From the Latin *lavabo* (I shall wash), that being the first word in the formula used by the priest when washing his hands during Mass

Definition
Jug and basin set; or two basins, ewer and dish

Purpose
Used for pontifical liturgical ablutions

Diffusion in art
Found in scenes of special liturgical ceremonies from the 16th century onward, and also in Gospel scenes such as the washing of feet, since the action is similar to liturgical ablution

The jug and basin were in use long before they became a set in the sense of being two receptacles made of the same material with matching decoration. It was in the Renaissance that the jug and basin set was established and the various objects previously used were abandoned. Since the 4th century, the basin had been used to hold the water to be poured over the celebrant's hands during the ablution ceremony. From the 17th century onward it was accompanied by a jug. Very costly sets were made—mostly for the use of senior prelates, but also for priests on special occasions. Because these objects were so frequently used, they were not decorated with symbolic details, but over the course of the Renaissance their shapes became standardized, reflecting the contemporary passion for the classical world. The form of the jug was influenced by the amphora, and its decoration was enriched with embossed work in the 16th century. In paintings dating from the 16th to 18th century, lavabo sets also appear in New Testament scenes in which depicted events are related to liturgical ablution.

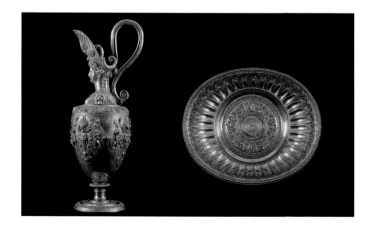

▶ Master W. N., Lavabo Set, ca. 1525–50. Milan, Museo Diocesano.

Judas stands apart from the other apostles and is already heading for the exit. With his money bag in hand, he is on his way to betray Jesus.

In addition to a few items for the paschal dinner, such as bread rolls, bottles, and a saltcellar, a magnificent chalice, its pommel decorated with enamel, stands out in an elevated position.

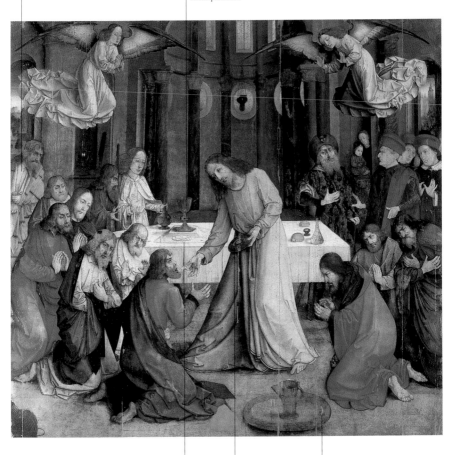

The dining table is shown as though it were an altar for Mass: the consecrated bread is laid out on a corporal.

Jesus uses a paten to distribute his body to his disciples in the guise of bread.

The circular composition is completed by the lavabo set at Jesus's feet. The jug and large basin are there to remind us that the Lord began the paschal feast with his disciples by washing their feet.

▲ Justus of Ghent, *The Communion of the Apostles*, 1473–75. Urbino, Galleria Nazionale delle Marche.

Just visible in the darkness of the middle ground is the figure of Christ. He has been sentenced and crowned with thorns, carries the cross, and is making his way to Calvary.

Pilate is illuminated by strong artificial light whose source is hidden by the back of a chair on his left. He is dressed as an Eastern dignitary and wears a cloak that is very much like a liturgical cope.

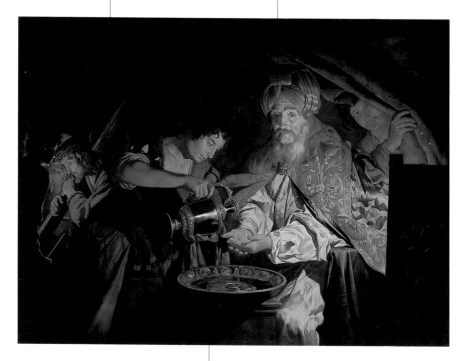

The famous episode of Pilate ridding himself of all responsibility for Christ's fate shows him using a jug and basin—objects that later acquired liturgical use.

▲ Matthias Stom, *Pilate Washing His Hands*, ca. 1650. Paris, Louvre Museum.

A faldstool is a folding seat without a back. A gestatorial chair has a back and arms as well as bars that can be used to lift and carry it.

Faldstool and Gestatorial Chair

Faldstools came into use when the position of the bishop's throne was moved from the center of the semicircular apse to one side, and, though the honor due to his dignity and authority continued to be acknowledged, he was now watching rather than presiding over most celebrations. But when it was his role to participate in a rite, he was given a portable chair without a back that could be placed in front of the altar if required, thus putting him in charge of the proceedings. In some cases he used it to support his arms when kneeling. The gestatorial chair was reserved for the pope. It was used to carry him through crowds in an elevated position on solemn occasions, so that he could be seen and impart his blessing. Since he was accorded the greatest dignity, the chair was carried by four to twelve papal bearers. The gestatorial chair was richly decorated, upholstered in silk, and equipped with rings on each side to hold the wooden bars used to carry it. Its use began in the 5th or 6th century, in particular at a new pope's coronation or installation, and on other special occasions. It ceased to be used after the pontificate of Paul VI.

Name
Faldstool is related to the Frankish *faldistòl* (folding chair). *Gestatorial* is related to Late Latin *gestatorium* (for carrying)

Definition
Two special chairs used during liturgical rites or events involving bishops or the pope

Diffusion in art
Found in scenes concerning bishops and popes

◄ Lombard manufactory, Faldstool, mid-19th century. Milan, Castello Sforzesco, Museo d'Arti Applicate.

*The architectural features of the triptych on the altar look
Gothic. The simulated niches with inlaid statues reflect the
Spanish tradition of inlaid retablos.*

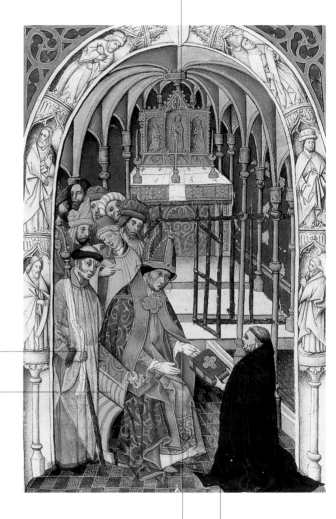

*One of a bishop's principal
insignia is the crosier. Here it is
held for him by a clerk in a
red habit and an almost trans-
parent white surplice. He is
not allowed to touch the
crosier and therefore holds it
with a special white cloth
called a sudarium.*

*For the donation and dedica-
tion of the book, the bishop
sits on a faldstool not far from
the altar.*

▲ *Fra Alfonso Giving His Work to
the Bishop of Toledo, miniature
from the codex* Lumen ad
Revelationem Gentium, *1464–68.
Milan, Biblioteca Ambrosiana.*

*The bishop receives the book
wearing white gloves. These
gloves were used in important
ceremonies and were indicative
of episcopal status.*

*Fra Alfonso da Propesa was a
member of the Congregation
of Hermits of Saint Jerome and
had written this work at the
request of the bishop himself.*

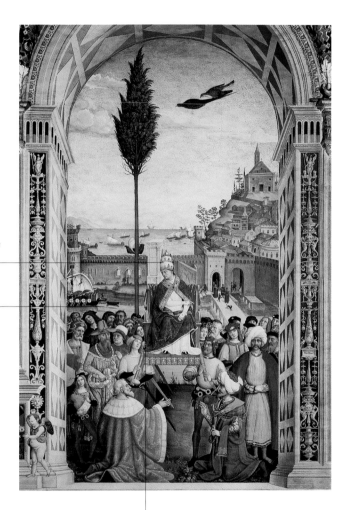

Pope Pius II, in papal robes and tiara, arrives at Ancona for the departure of a crusade against the Turks. His chief political concern was to stem the tide of Islamic expansion in Europe.

Ships can be seen preparing for departure in the harbor by the walls of the town perched on the Monte Conero promontory.

▲ Bernardino Pinturicchio, *Pius II Arrives in Ancona for the Departure of the Crusade*, 1503. Siena, cathedral, Libreria Piccolomini.

The gestatorial chair on which the pope sits is an upholstered wooden throne carried by four bearers.

A portable canopy made partly of stiff or soft fabric and supported on four or more poles, it could be decorated in a variety of ways.

Processional Baldachin

Name
Baldachin is a corruption
of Baldacco (Baghdad), the
source of the fabric from
which it was made

Definition
A portable canopy

Purpose
Originally a protection but
subsequently conferred
dignity

Diffusion in art
Found in scenes of liturgi-
cal rites, especially where
processions are involved

A processional baldachin, or baldacchino, is an item of Eastern origin, but it was in use in the West by the time of the Roman Empire. Its original purpose was surely to protect an honored person from rain and sun, but it soon acquired symbolic significance, conferring special dignity on whatever it protected, whether a person or object, and it gradually came into liturgical use. The architectural form of the ciborium over the altar probably derives from this baldachin, but the latter retained its portable nature for use in special celebrations, especially processions. Its structure has remained virtually unchanged since antiquity. It was a piece of cloth with lappets

along the edge decorated with gold braid, tassels, and fringes, supported on poles (four or more), which may be decorated with inlay, painted, covered in fabric, or gilded. The finials at the ends of the poles could take many forms, including flames, fir cones, pomegranates, and vegetal shapes.

► Guido Cagnacci,
*Procession of the Blessed
Sacrament*, 1628.
Saludecio, San Biagio.

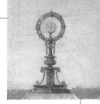

A processional umbrella looks just like an ordinary umbrella, the principal difference lying in the fine fabric from which it is made.

Processional Umbrella

The original purpose of a processional umbrella was to protect the pope or senior prelates from the rain or sun as they moved from place to place. It also came to be used as a decorative feature in liturgical rites, but that use has now been abandoned. As time went by, it became an item for use in processions, especially when the eucharistic sacrament was displayed or moved into or out of churches. There is evidence in medieval paintings that the earliest umbrellas could be flat or slightly conical, and sometimes the shaft of the handle could be bent at a right angle. In more recent times, it became much more like an ordinary umbrella, the difference lying solely in the use of rich fabrics for the cover and for the decoration of the rim, which was influenced by earlier models and always had fringes and trimmings. Time of use and the liturgy dictated the colors of these processional umbrellas: white when used in eucharistic processions (red in the Ambrosian rite), white or red for the pope, red or violet for cardinals, and red or green for bishops. Some dignitaries of the papal court were allowed to use pale blue.

Name
An object for providing shade

Definition
A small umbrella for use in processions

Purpose
Protection and a sign of reverence for the priest when carrying the sacrament

Diffusion in art
Found in early scenes from the lives of popes and later scenes of eucharistic processions

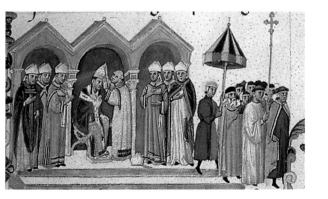

◀ Jacopo Stefaneschi,
De coronatione,
13th–14th century.
Vatican City, Biblioteca
Apostolica Vaticana.

This special type of fan has a long handle. The most striking ones are those made of ostrich feathers, while others are made of metal and decorated with pearls, jewels, or enameling.

Flabellum

Name
From the Latin *flabellum* (fan); the terms *muscarium* and *muscatorium* are also used

Definition
A type of fan

Purpose
Originally for keeping insects away; later acquired a symbolic significance

Diffusion in art
Very occasionally found in scenes of particular liturgical rites

The fan was an attribute of honor in ancient Eastern cultures, and the flabellum soon came to be used in the Eastern liturgy, from which it passed into the Latin liturgy. It originally had a double function: it had a symbolic and honorific purpose in relation to the celebrant, who was kept cool by these elegant fans, and it also had the important practical purpose of keeping insects away from the bread and wine awaiting consecration. The flabellum must have been widely used in Rome and the West from as early as the 6th century until about the 16th. Flabella could be made of various materials and have various shapes. The more practical models were circular or semicircular, made of fabric, paper, parchment, or feathers, and had a long handle. The flabella used for purely decorative purposes seem to have been made of metal and decorated with jewels, enameling, or gemstones. From these there developed others made of dyed ostrich feathers. These were the last to fall into disuse.

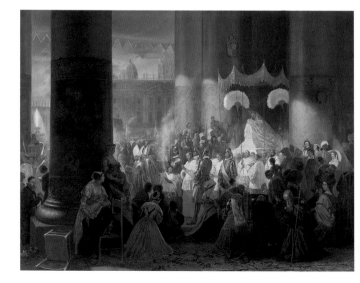

▶ Egron Sellif Lundgren, *The Feast of Corpus Domini in Rome*, ca. 1845. Stockholm, Nationalmuseum.

Bishop Basil carries on with Mass despite the emperor's sudden intrusion into the church. The bishop had been threatened by one of the emperor's senior officials and ordered to accept Arianism, but he had refused to appear before the emperor.

The bishop is placing the chalice in the hands of a priest. On either side of him, two young men are waving long-handled flabella.

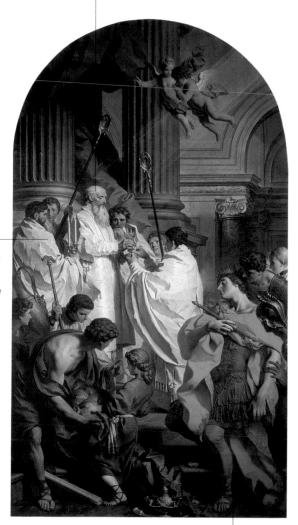

▲ Pierre Subleyras, *The Mass of Saint Basil*, 1743. Saint Petersburg, Hermitage.

The emperor Valens, clad in armor with crown and scepter and escorted by his soldiers, nears the bishop but then staggers and faints.

CLOTHES, VESTMENTS, AND STATUS

◀ Benozzo Gozzoli, *Scenes from the Life of Saint Francis: The Meeting of Saint Dominic and Saint Francis* (detail), ca. 1450–52. Montefalco, San Francesco.

The colors of Roman liturgical dress and vestments are white, red, violet, green, rose, black, and gold. These colors, with certain variations, are also used in other Church rites.

Liturgical Colors

Definition
Colors prescribed for vestments according to the time of the liturgical year

Purpose
They provide a symbol of the liturgical time concerned

Diffusion in art
Found in scenes of various religious rites

Five principal colors, plus gold, are used to emphasize the particular characteristics of the mystery being celebrated, and the individual significance of each provides a visual message as to the time in the liturgical year and the nature of the rite. White is the color of light and life and conveys the joy of Easter: it is used at Easter and Christmastime, at festivals and commemorations of the Lord and the Virgin and of angels and saints, and in celebrations linked to the mystery of the Eucharist and the Sacred Heart. Red is the color of blood and denotes the gift of the Holy Spirit, which makes witness of faith possible: it is used on Palm Sunday and Good Friday, at Pentecost, for celebrations of the Passion of the Lord, and on the feast days of evangelists, apostles, and martyrs. Violet (almost black in the Ambrosian rite) indicates penitence, expectation, and mourning: it is used during Advent and Lent as well as in services for the dead. Green is the color of hope, of beginning a new life, and of the youth of the Church; it is used at ordinary times. Rose (Roman rite only) is used on the third Sunday in Advent and the fourth in Lent as a sign of the approaching celebrations. Black is not much used today, but was formerly the color for funerals. At all times in the liturgical year gold can be substituted for the other appropriate color on solemn occasions.

► Romanino, *The Mass of Saint Apollonius*, 1520–25. Brescia, Santa Maria Calchera.

The Blessed Philip has a vision of the Madonna with the Child in her arms, accompanied by the heads of three winged putti representing cherubs.

The priest is shown dressed for Mass. He is wearing a red chasuble, chosen as a visible sign of the gift of the Holy Spirit.

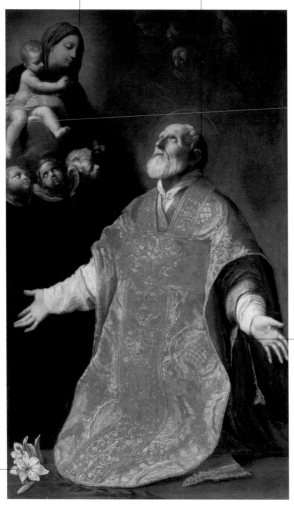

By the time this painting was made, the maniple (a narrow cloth hanging from the left arm) had become a decorative feature in the dress of all the major orders, deriving from a napkin used in ancient Roman etiquette.

The lily at the saint's feet is a symbol of purity.

▲ Guido Reni, *The Vision of Saint Philip Neri*, 1614. Rome, Santa Maria in Vallicella.

Violet is the liturgical color for Advent, signifying expectation. It can be seen in the humeral veil that the subdeacon is using to conceal the paten—a gesture required in the Tridentine Mass as long as the relevant canon remained in force.

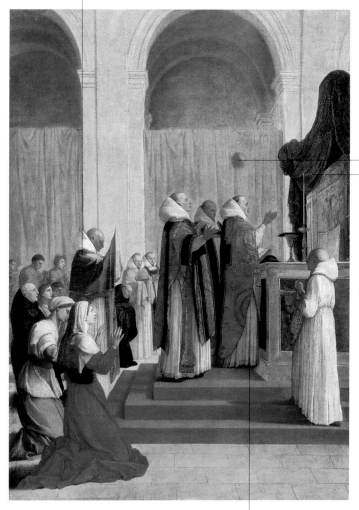

While Saint Martin is celebrating Mass, a ball of fire appears above his head as an extraordinary manifestation of the divine.

Over the altarpiece is a rich baldachin decorated with green draperies. There is no prescribed color for a baldachin, and indeed green is not the prescribed color for Advent, when the ball of fire episode took place, according to The Golden Legend.

The celebrant is wearing a splendid gold chasuble. Gold may be used at any time in the liturgical year as a substitute for the prescribed color.

▲ Eustache Le Sueur, *The Mass of Saint Martin of Tours*, 1654. Paris, Louvre Museum.

The consecrated
host can be seen
in the tower
monstrance.

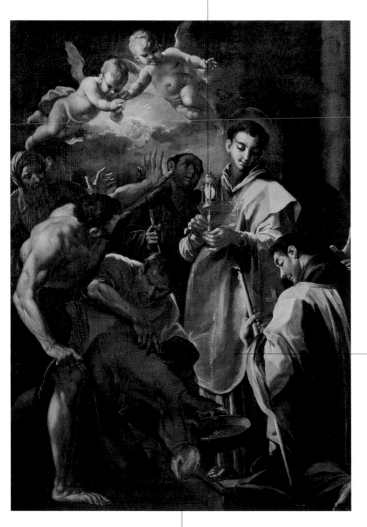

The liturgical white
of Saint Anthony's
chasuble predomi-
nates in spite of the
gold embroidery.
White is chosen for
this painting because
it is the color of
the mystery of the
Eucharist, which is
the true protagonist
of the miracle.

▲ Filippo Abbiati, *The Miracle of
the Mule*, ca. 1700, cycle of the
Arciconfraternità del Santissimo
Sacramento. Milan, Museo Diocesano.

The mule has been left without food for
several days, but when the sacrament is
displayed it miraculously kneels and
refuses the fodder.

73

He is sometimes tonsured and wears a short white tunic with wide sleeves over a black cassock. In late-16th-century paintings he is shown without a surplice.

Clerk in Minor Orders

Function
He is a consecrated minister attached to a particular church or with a personal prelacy, or attached to a religious institution or an ecclesiastical organization involved in the apostolic life

Special dress features
Tonsure, cassock, and surplice

Diffusion in art
In scenes of religious ceremonies

A clerk, or cleric, in minor orders is a minister consecrated into one of three ranks: subdeacon (until the Second Vatican Council), deacon, or presbyter. In earlier times his hair was shaved into a circle as a sign of his status and in order to appear like Christ with the crown of thorns. As time went by, the title came to designate a member of a religious order or congregation. His cassock is intended to show that he has cast off the vanity of the world and that his position has a certain gravitas. During religious ceremonies he wears a surplice over his cassock. The surplice is a white garment that first appeared in England, France, and Spain around the 11th century and was later adopted in Rome, where it was called a *cotta*—a term deriving from Low Latin. It is a loose tunic that was originally full length but was progressively shortened until it reached only to the knees. Its use was widespread from the 17th century onward. The hem and sleeves (normally of medium width) are decorated with lace. Because a priest may also wear a surplice when administering the sacraments, as well as at blessings, processions, funerals, and sermons, the difference between priest and clerk in art is to be judged by the action being performed.

► Arnolfo di Cambio, *Procession of Clerks*, Annibaldi Monument, ca. 1276. Rome, San Giovanni in Laterano, cloister.

The city of Perugia is being
besieged by the Ostragoth
Totila and is represented much
as it really was.

Totila besieged and
ultimately sacked the
city of Perugia in
A.D. 547.

The clerk being led to the barbarian king is
wearing a long, loose, sleeveless surplice and
has a prominent tonsure. He has betrayed the
ruse by which Bishop Herculanus, later the
city's patron saint, sought to save the city.

▲ Benedetto Bonfigli, *Totila and the
Traitor Clerk*, ca. 1454. Perugia,
Palazzo dei Priori.

Saint Peter stands on one side with a crowd of saints on the other. Together they represent the communion of saints in the glory of heaven.

An angel is carrying the dead man's soul to heaven.

A Dominican friar can be seen here. The Dominicans, Franciscans, and Augustinians were the three orders that normally took part in funerals in the 16th century.

Some knights of the Order of Santiago, their red crosses standing out against their black clothes, display measured amazement as they perceive the miraculous appearance of the two saints at the count's burial.

An Augustinian monk in black talking to a Franciscan friar in a dark habit seems to be remarking upon the great distinction being accorded to Count Orgaz; thanks to his charitable life, Saint Stephen and Saint Augustine have intervened to help bury him.

▲ El Greco, *The Burial of Count Orgaz*, 1586. Toledo, San Tomé.

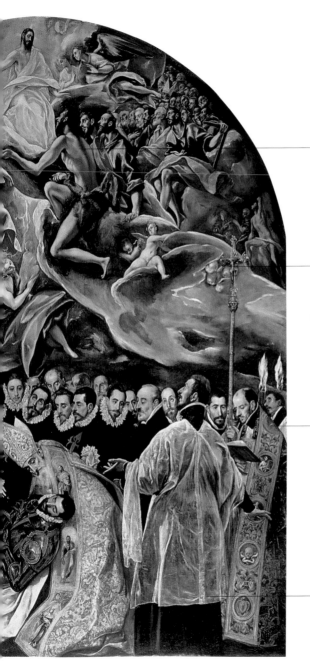

Saint John the Baptist and the Virgin Mary pray to Christ for the salvation of Count Orgaz's soul.

A cross on a staff normally accompanied a funeral cortege. The usual six candles can also be seen here, though not all are close at hand because the funeral cortege has now broken up.

The celebrant is wearing a splendid cope.

A clerk with his back to us gazes at the glory of heaven as the count's soul is carried up by an angel. The clerk is wearing a full-length black cassock under a white, almost transparent surplice with a maniple of the same fabric.

A deacon is normally a young man and wears a dalmatic, or an alb with a stole across it. He may be tonsured.

Deacon

Name
From the Greek *diakonos* (servant)

Duties
To assist the bishop and priests in Church affairs

Sources
Acts 6:1–6; 1 Timothy 3:8–13; the Apostolic Tradition of Hippolytus of Rome

Diffusion in art
In scenes of liturgical rites and in those involving various men who served as deacons

The Acts of the Apostles describe the appointment of the first deacons, who were chosen from the community to assist widows and to serve at table, so that the twelve apostles could devote themselves to prayer and the ministry of the Word. The same source specifies that they were entrusted with responsibility for this work by the laying on of hands. The first juridical and theological statute concerning deacons (3rd century) includes them in the group of those ordained by a bishop with the laying on of hands. That document clarifies the breadth of the deacon's duties, for he was required to carry out any of the bishop's orders, though he was excluded from the council of presbyters. The deaconate existed throughout Church history from the early 2nd century onward, and became firmly established in the 4th century when it was recognized as constituting a rank in the ecclesiastical hierarchy below bishops and presbyters. The deacon's duties included serving at the liturgy, preaching the Gospel, catechizing, charitable works, and administration as required by the bishop. As time went by, his role was reduced until it became simply a temporary step on the ecclesiastical ladder. The distinctive dress of the deacon is the dalmatic, derived from a secular garment worn by the Roman nobility. Deacons can also be distinguished by the stole, which was worn over the alb, crossed the left shoulder, and was tied at the right hip.

▶ Bergamesque artist, *Saint Stephen Martyr*, late 15th century. Milan, Castello Sforzesco, Museo d'Arte Antica.

The deacon wears a white amice and surplice under his dalmatic. The amice is visible as a kind of cloth collar folded under the neck of the dalmatic.

Youthfulness and a tonsure are characteristics of the deacon in art.

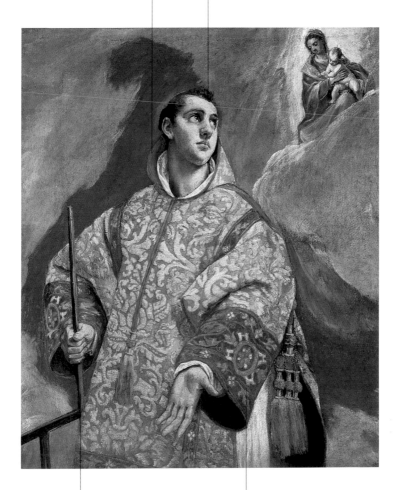

The gridiron used as the instrument of Lawrence's martyrdom can just be seen attached to a long handle. According to tradition he was burned alive before being decapitated.

▲ El Greco, *The Virgin Appearing to Saint Lawrence*, 1578–80. Monforte de Lemos, Fundación de Nuestra Señora la Antigua.

The dalmatic was originally a secular garment worn by Roman nobles. It was a tunic made of white cloth with wide sleeves and a split at each side. El Greco takes pains to describe in detail this very rich, worked fabric. It is suggestive of Venetian manufactories.

Deacon

Stephen gives his sermon close to the city of Jerusalem, which is represented by the artist as surrounded by walls, with large buildings arrayed up the hill.

In addition to the dalmatic, a deacon wore a maniple carried over the left forearm, but only during rites involving chasuble, dalmatic, and cord, the latter being insignia of subdeacons (a title abolished by the Second Vatican Council) and the major orders.

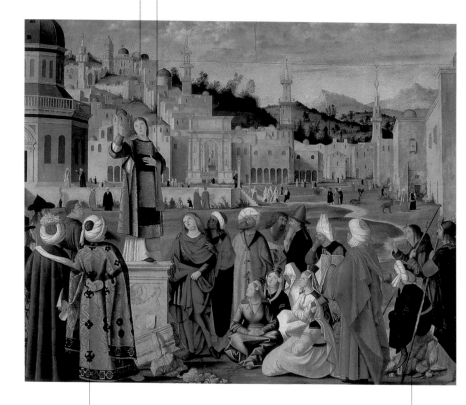

It was Vittore Carpaccio's custom to identify as pagan anyone of his own day who was not a Christian. Hence his choice of Easterners and Muslims, whom he represents with characteristic costumes in rich, embroidered fabrics and damasks, with turbans on their heads.

Among those listening to the young deacon's sermon, we can identify some pilgrims by their walking sticks, which have a characteristic hook from which to hang a gourd that serves as a water bottle.

▲ Vittore Carpaccio, *The Sermon of Saint Stephen*, 1514. Paris, Louvre Museum.

He will be seen wearing a cassock, or an alb and stole, or perhaps a chasuble; he may be shown at the altar or administering the sacraments.

Priest

A priest is an elder in the community both in age and in maturity in the faith. *Priest* comes from the Greek word for presbyter, or church official. Priestly ordination gives him the power to administer the sacraments instituted by Christ. The garment that makes him recognizable in art is the one he wears for liturgical rites, namely the chasuble, an outer garment in the shape of a scapular. Like other liturgical garments, the chasuble derives from an everyday secular item of clothing: the *paenula*, which was used throughout the Graeco-Roman world, where it served as protection from the rain and cold. In Gaul and Africa the word *casula* (hut) was used because of its shape, and *paenula* gave way in Italy to *pianeta* around the 5th century. The first evidence of its use in a liturgical context comes from 4th-century Spain, and in art we see evidence in various mosaics of the same period of a very wide bell-shaped garment with a hole for the head. A total change to the scapular shape was completed in the 16th century, the use of heavy fabrics making it more practical. Recently there has been a return to the so-called Gothic chasuble.

Name
From the Greek *presbyteros* (elder)

Duties
From earliest times the role of the priest has been to administer the sacraments and preach

Special dress features
Stole, chasuble, and cope

Diffusion in art
In scenes of liturgical rites and in the portrayal of various persons who had a priestly role in life

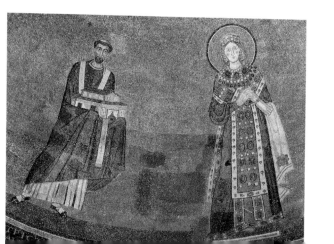

◄ *Pope Honorius Offering the Church to Saint Agnes, 625–638. Rome, Sant'Agnese.*

81

The Virgin Mary is giving a chasuble to Ildephonsus. According to tradition, the gift was a reward to the abbot for his zealous support of the Virgin Mary in his writings.

The crosier and miter on what is presumably an altar help to identify the saint as Ildephonsus, abbot and bishop of Toledo.

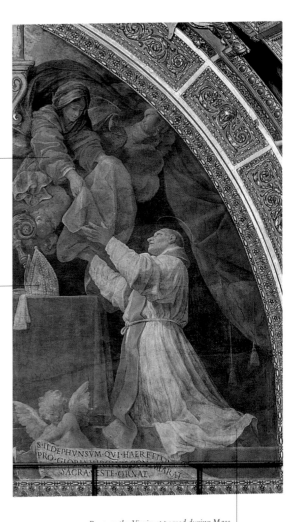

▲ Guido Reni, Cycle of *The Triumph of the Virgin: The Donation of a Chasuble to Ildephonsus*, 1611–12. Rome, Santa Maria Maggiore, Cappella Paolina.

Because the Virgin appeared during Mass, Ildephonsus has on the "inner garments" worn under the chasuble. Over the amice, which can be seen emerging around his neck, is a white alb, and over that is the stole, another characteristic feature of priestly dress; a cord is tied around his waist.

Assisting at the Mass for souls in purgatory is a deacon, whose tonsure can be distinguished. He is wearing a dalmatic over his cassock and alb. The thurible swaying beside him shows that he is the incense bearer.

The chasuble worn by Pope Gregory the Great is of the Gothic type, but it is still not very full. In accordance with liturgical custom, a clerk is holding up the draping end. The tiara—papal headdress and attribute of Saint Gregory—stands on the altar.

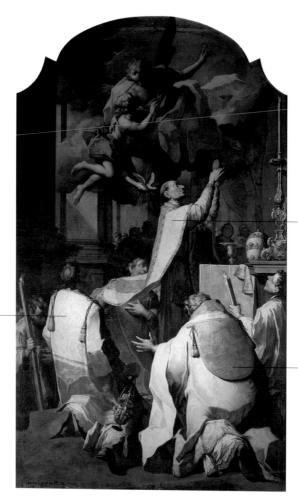

The ample cope worn by the religious attending the Mass is decorated with a shield that was originally a hood. At the bottom of the picture one can see the cassock and alb under the cope.

▲ Pietro Ligari, *The Mass of Saint Gregory*, 1720. Sondrio, Collegiate Church of Santi Gervasio e Protaso.

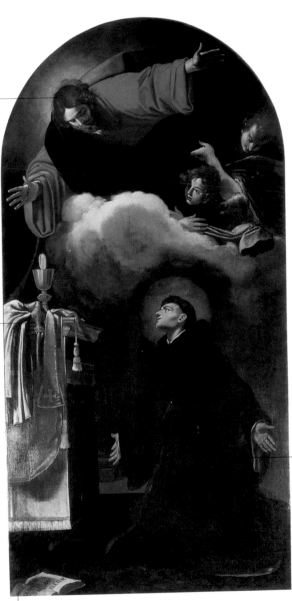

The appearance of Christ confirms the saint's ecstatic encounter. Christ spreads his arms in a welcoming gesture in response to the saint's open arms, which convey his amazement and self-offering.

The various garments on the altar—amice, alb, stole, cord, and chasuble—are for the priest to put on before Mass. They serve to emphasize his basic duty of celebrating the consecration of the host.

John of Sahagun is a monk wearing the black Augustinian habit. He kneels in contemplation of the consecrated host.

The significance of the scene is revealed by the words written in the open book: "Vidi Dominum facie ad facies." The saint had the ecstatic experience of seeing the face of Christ in the host.

▲ Giacomo Cavedone, *Christ Appearing to Saint John of Sahagun*, ca. 1614–20. Bologna, San Giacomo Maggiore.

A vision of heaven with its bright light and host of angels appears to Saint Andrew Avellino at the moment of his death, the night after his stroke.

Andrew Avellino was a saintly priest. At the age of eighty-seven, he was about to begin Mass one evening when he suffered a stroke and died shortly afterward.

The lighted candle indicates that the altar is ready for Mass to begin, as is emphasized by the words carried by the angel: "introibo ad altare dei." These are words from Psalm 43 (I will go to the altar of God, to God my exceeding joy; and I will praise you with the harp, O God, my God) recited by the priest at the altar before celebrating Mass.

The young clerk with his little tonsure and wide-sleeved surplice is rendered speechless with surprise and is unable to come to the aid of the priest; but an angel steps in to do so.

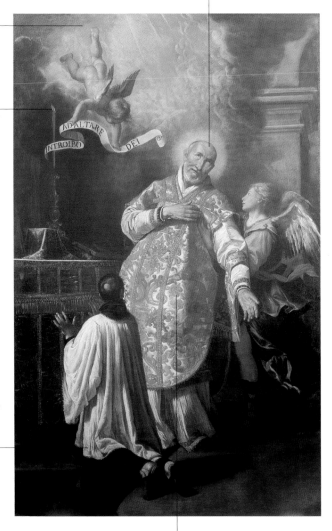

The rich chasuble worn by this elderly priest is of the scapular type that was in use up to the 20th century. Medieval liturgists (among whom Rabanus Maurus was a leading figure) initiated the view that it was a symbol of charity as an outer garment covering all the other garments, which were symbols of virtues.

▲ Domenico Fiasella, *The Death of Saint Andrew Avellino*, ca. 1630–40. Genoa, San Siro.

He is an ecclesiastic whose liturgical dress includes a cope over his shoulders and a miter on his head. He carries a crosier and may wear a pastoral ring on his finger.

Bishop

Name
From the Greek *episkopos* (overseer)

Duties
As successors of the apostles, the bishops are to teach, sanctify, and govern the people of God

Special dress features
Cope, chasuble, and miter; the pastoral ring came into general use in the mid-12th century specifically for bishops; they also have their own gloves and special footwear

Diffusion in art
Found throughout art history

▶ Francisco de Zurbarán, *Saint Ambrose*, 1626. Seville, Museo de Bellas Artes.

In the original Church, bishops were appointed by the apostles and placed in charge of communities of the faithful to carry on the apostles' work. In the course of history, bishops came to acquire a high rank in the Church hierarchy and were appointed by the pope. Among the characteristic outer garments of the bishop—those worn over his robe, cord, and stole—are the chasuble and cope for solemn ceremonies, just

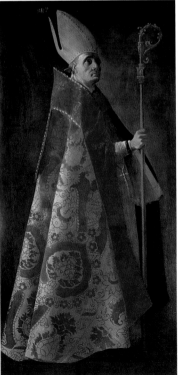

as for a priest, but the bishop wears a miter on his head as well. The miter is bellows shaped, with two halves in the form of a pentagon coming to points called *cornua*, and with two ribbons that fall onto the bishop's neck. This headgear is used not just by bishops, but also by cardinals and the pope and, on special occasions, by other prelates. When a bishop is ordained, the miter is placed on his head as a defense against the enemies of truth. As a liturgical ornament, it is worn during religious ceremonies, but is removed for prayers at Mass, for consecration rites, and when the bishop is at prayer. The ring and crosier are also appurtenances of the bishop.

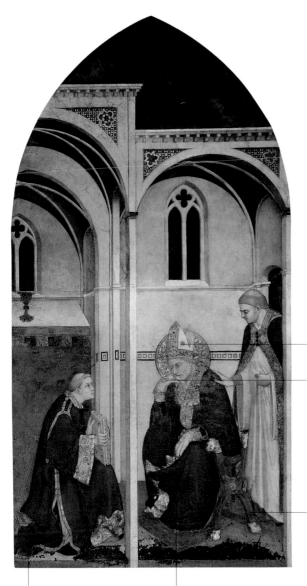

The bishop's special headdress is the miter, meaning "bonnet" or "cap" in Low Latin. According to a prayer in use from the 15th and 16th centuries, it was granted to the bishop as a helmet in defense of the truth.

The episcopal ring derives from a custom that was already common among the first Christians and acquired specific liturgical use from the end of the 6th century. In the following century it became an emblem of episcopal dignity. Some rings were large enough to be worn over gloves, and the gem could be a topaz, amethyst, or ruby.

Saint Martin sits in deep meditation on a portable faldstool, which has been placed close to a chapel on this occasion.

A deacon, who can be identified by his ample dalmatic, has approached the bishop with a missal to remind him that he has to celebrate Mass, for which the altar is already prepared.

Pontifical gloves were used only at pontifical masses. In the Middle Ages they had the moral significance of purity of action.

▲ Simone Martini, *Saint Martin of Tours in Meditation*, ca. 1315–16. Assisi, lower church of San Francesco, chapel of San Martino.

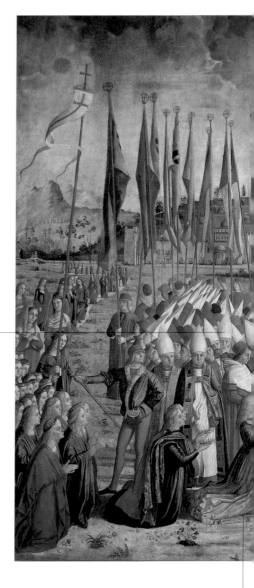

The tall white miters of the group of bishops standing on the esplanade have a very attractive effect. In only a few cases is it possible to distinguish the characteristic ribbons that fall onto the back of the bishop's neck. According to Ursula's legend, this meeting took place sometime around the 3rd or 4th century.

▲ Vittore Carpaccio, *Scenes from the Life of Saint Ursula: The Pilgrims Meet Pope Ciriacus at the Walls of Rome*, ca. 1495. Venice, Gallerie dell'Accademia.

Ursula and her pagan fiancé (who is willing to convert to Christianity) kneel before the pope. The young maidens behind them are wearing crowns as an indication of their royal status.

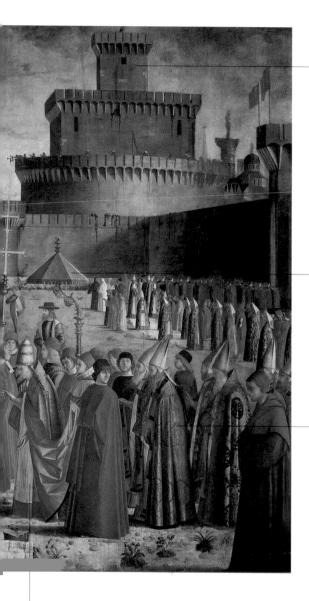

Saint Ursula went on a pilgrimage to Rome and allegedly met Siricius, who was pope at the time. The artist imagines the meeting as having taken place close to the imposing bulk of Castel Sant'Angelo.

The chief purpose of the processional umbrella was to protect the pope from the sun or rain. At the time when this scene was painted it had already acquired a symbolic value, which is emphasized by its papal red color.

The bishops accompanying the papal procession are wearing rich, heavy copes.

The pope has come to the meeting with a procession of prelates, but he can be distinguished from the other figures by his headgear, the papal tiara.

Bishop

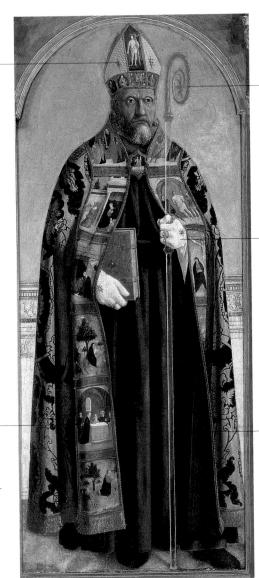

The embroidery on Bishop Augustine's precious miter completes the narrative sequence on the cope by presenting an image of the risen Christ surrounded by pearls and precious stones.

The crystal crosier ends in a crook with floral decoration. The crosier was in use as an item of episcopal insignia from at least the 11th century and probably derived from the staff used by evangelizers.

The white gloves are decorated on the back, with rings fitted over the fingers. They are used to hold the crosier and holy book respectfully.

The wide border of the cope is decorated with embroidered rectangles containing scenes from the life of Christ, to be read from the top downward. The final scene of the Resurrection is on the clasp.

Underneath the cope he wears not priestly garments but the dark habit of the Augustinians, the order he founded.

▲ Piero della Francesca, *Saint Augustine*, ca. 1464. Lisbon, Museu Nacional de Arte Antiga.

His dress is characteristically red. In early paintings he has a broad-brimmed hat or sometimes a kind of fur-lined hood.

Cardinal

Cardinals have a very long history, going back to at least the pontificate of Sylvester I in the 4th century. *Cardinal* was at first a term used to refer to an ecclesiastic placed in charge (*incardinatus*) of a church or deaconry. The title gradually became restricted to those ecclesiastics who were in the service of the pope in Rome; hence by the mid-15th century it had acquired great prestige. As time went by, the cardinals—whose difficult task it was to elect a new pope—increased in number as the Church increased in size, diplomatic relations, and ecclesiastical bureaucracy. In 1586, Sixtus V fixed their number at seventy, echoing the number of *seniores* (elders or presbyters) of Israel. The cardinals' most important work was carried on in the College of Cardinals, a legal corporation whose purpose was to assist, act on behalf of, and elect the pope. The chief characteristic of a cardinal's dress is the red color (Latin *purpurea*), and the hat granted by Innocent IV at the Council of Lyons (1245) as a badge to distinguish them among prelates.

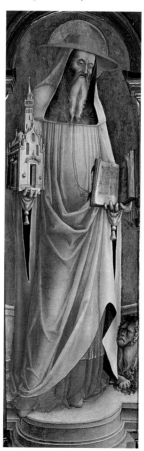

Name
One who is *incardinatus*, i.e., acts as a *cardo* (hinge)

Duties
The highest ecclesiastical rank, with the duty of collaborating closely with the pope in the government of the universal Church

Special dress features
Red, cardinal's hat, black three-cornered hat, cardinal's coat of arms

Diffusion in art
Fairly widespread: in scenes of church history, portraits of cardinals, and scenes from the lives of cardinal saints, including the iconographical error of representing Saint Jerome in cardinal's robes even though there is no historical evidence that he was ever appointed cardinal

◀ Antonio Vivarini, *Saint Jerome*, detail from the triptych *Saint Jerome, Saint Bernardino of Siena, and Saint Louis of Toulouse,* 1458. Venice, San Francesco della Vigna.

91

Cardinal

The red outer garment may be an early form of the cappa magna, the flowing ceremonial hooded robe.

The characteristic hat was granted to cardinals in 1345 as a sign of their elevated rank.

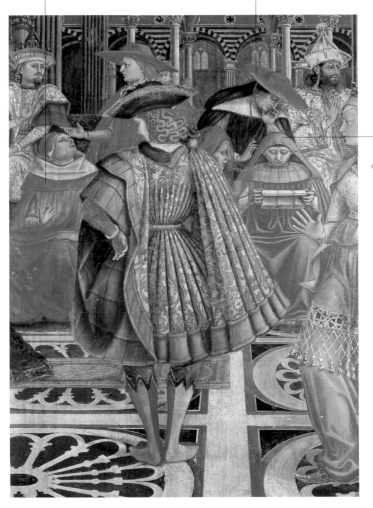

The almuce was a sort of lined hood, originally worn as a choir vestment but later adopted by cardinals.

▲ Domenico di Bartolo, *Pope Celestine III Granting Privileges to the Hospital* (detail), 1441–44. Siena, Santa Maria della Scala.

The red biretta was granted to cardinals by Pope Paul II in 1464. By about the mid-16th century its shape had settled permanently into one with three or four corners. It was customary to put stiff cardboard inside in order to maintain its shape.

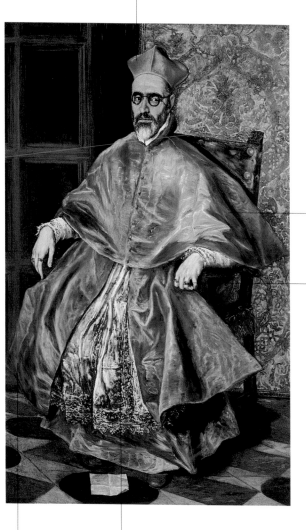

The mozzetta is worn only by cardinals and popes. It is a kind of short cape with buttons at the front and a tiny hood at the back.

The cardinal's ring is a characteristic feature of his dress as a dignitary of the Church.

In official portraits, a cardinal had to be shown seated.

Over his robe the cardinal is wearing a rochet: a full but fairly short alb, which in the 16th and 17th centuries began to be ornamented with lace. It was not strictly speaking a liturgical garment but was reserved for certain ecclesiastical ranks.

▲ El Greco, *A Cardinal, Probably Cardinal Niño de Guevara*, ca. 1600. New York, Metropolitan Museum.

Cardinal

The mozzetta, a garment characteristic of cardinals and popes, is a short cape with buttons down the front. In accordance with the fashion of the time, the cardinal's white collar is showing at the top.

The unfolded sheet of paper in the cardinal's hands may be a letter reminding him of his long residence at Antwerp as papal nuncio for the Low Countries.

The rochet seems rather short and thus in its original form, but it is richly ornamented with lace on both hem and sleeves.

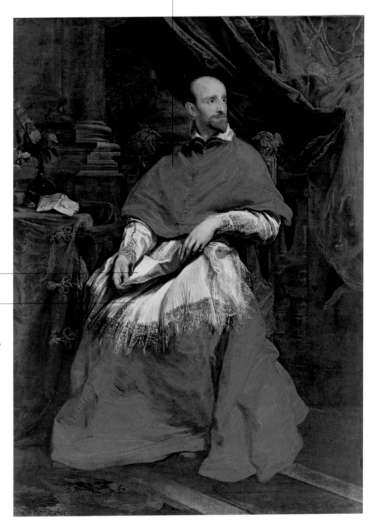

▲ Anthony van Dyck, *Cardinal Guido Bentivoglio*, 1623. Florence, Palazzo Pitti.

A small crucifix on the altar is the source of inspiration for the saint's ecstatic prayer.

The cardinal is wearing a very full cloak with a shearling almuce much in evidence.

The cardinal's biretta is an attribute of Saint Charles. It is laid on the floor at the moment of worship.

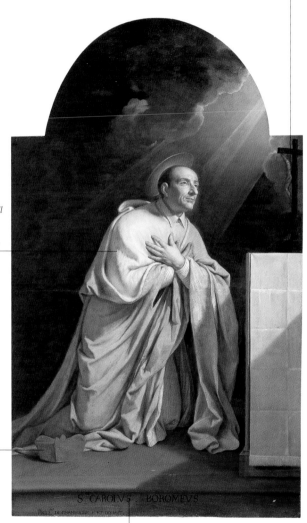

▲ Philippe de Champaigne, *Saint Charles Borromeo at Prayer*, ca. 1666. Orléans, Musée des Beaux-Arts.

According to the artist's own inscription, the painting was to be a gift to the community of Ursuline Bourniquettes at Orléans, whose patron saint was Charles Borromeo.

This severe and silent figure, called a cardinal, has only the cope and miter to identify him. Based on his dress and without color to assist us, we could just as well mistake him for a bishop or abbot.

▲ Giacomo Manzù, *Large Standing Cardinal*, 1960. Ardea, Museo Artistico "G. Manzù."

He is shown in papal robes with the characteristic tiara and keys. He may be wearing a pallium—a white woolen band decorated with six crosses.

Pope

As Peter's successor, the pope is the supreme head of the Church and Vicar of Christ on earth. His name derives from an ancient affectionate term for father. The pope may wear papal liturgical robes or a simple white robe, but his primary emblem is the tiara, sometimes called the *triregno*, the most illustrious of ecclesiastical ornaments. It is an extra-liturgical headdress, being worn only on very solemn occasions and formerly in processions, but the latter use was abandoned after the pontificate of Paul VI (1978). The tiara probably derives from something similar to the Phrygian cap, which had been used in Persia and became a symbol of the Byzantine emperors. Popes seem to have adopted it from the early 7th century. It must have been in the form of a tall, pointed cone with a gold band that became a crown in the 10th century. In the 13th century, the crown was decorated with lacework and called a *regnum*, and then Pope Boniface VIII (r. 1294–1303) added another crown as a consequence of the bull *Unam Sanctam*, in which he declared his temporal sovereignty. By the first half of the 14th century a third crown had been added.

Name
From a familiar form of address for a father

Duties
Supreme head of the Catholic Church

Special dress features
Tiara, fisherman's ring, pontifical robes, the color white, keys

Diffusion in art
Found in rare scenes from the lives of historical popes. Images of popes who were saints are more common. God the Father is often depicted in papal robes

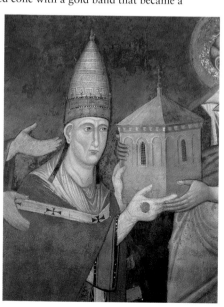

◄ *Pope Nicholas III Offering a Model of the Sancta Sanctorum*, 1275–1300. Rome, Santuario della Scala Santa.

The tiara worn by Saint Sylvester conforms to a type used before the second crown was added by Boniface VIII. By painting a conical tiara with infulae (the descending ribbons or lappets) and a dentellated crown, the artist was depicting a tiara that was historically accurate neither for his own age nor for that of Pope Sylvester.

Saint Helena, queen and mother of Constantine, is flanked by two learned and highly regarded pagan judges, Crato and Zenophilus, who are to judge in a dispute between Sylvester and the Jews.

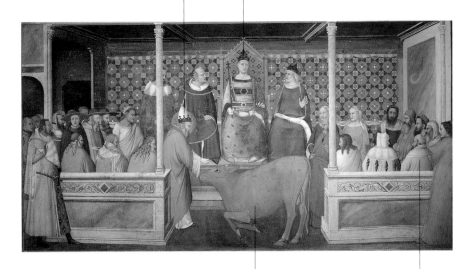

The bull had been killed by the twelfth wise Jew, who claimed he had whispered the name of God in its ear, but Sylvester maintained that God does not kill but gives life, and after praying, he restored it to life. This caused the queen, the Jews, and the pagan judges to convert to Christianity.

Helena had come to Rome, bringing 141 Jews, including twelve of the wisest.

▲ Maso di Banco, *Scenes from the Life of Pope Sylvester and Constantine: The Miracle of the Bull* (detail), ca. 1337. Florence, Santa Croce, chapel of San Silvestro.

God the Father is shown wearing a papal tiara consisting of three superimposed crowns surmounted by a cross, with two infulae (lappets). This was its usual form from the 14th century.

God the Father is seated on a throne and raises his hand in blessing.

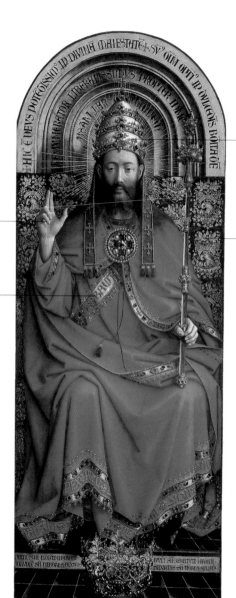

The brocade fabric behind the throne has a repeated design of a pelican pecking its own breast to feed its young. This is an allusion to Christ's sacrifice.

The words "San Bavone" appear on the border of his robe—a reference to the fact that this painted panel was to be part of the great altar made for the cathedral of Saint-Bavon at Ghent.

▲ Jan van Eyck, *God the Father*, central part of the Ghent altarpiece, 1432. Ghent, Saint-Bavon.

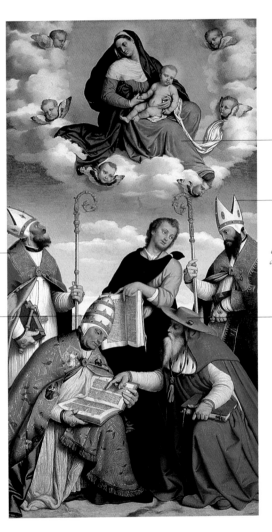

The Virgin and
Child are seen on a
throne of clouds
surrounded by the
heads of winged
putti representing
cherubs.

Saint Ambrose is in
bishop's attire and can
be identified by his
crosier and the book
denoting a doctor of
the Church.

Augustine is in
bishop's robes. He is
holding a book (one
of his attributes as a
doctor of the Church)
and a precious crosier.

Of the four doctors of
the Western Church,
only Saint Gregory
the Great was a pope.
He can be identified
here chiefly by the
tiara with three super-
imposed crowns (the
triregno).

The cardinal's hat
worn by the elderly
figure of Saint
Jerome sits on top of
an almuce, of which
we can see the
ermine lining.

▲ Giovanni Battista Moroni, *The Virgin
in Glory with the Doctors of the Church
and Saint John*, ca. 1551. Trento, Santa
Maria Maggiore.

Male or female, hermits can be identified by the extreme poverty of their clothing, usually rags or animal skins. They have no particular headgear and no shoes.

Hermit

Since hermits lived in solitude and did not consider themselves to have any particular status or to belong to any particular religious community, it was never possible to ascribe a single form of dress to them. However, those whose ascetic aspirations caused them to retreat into the desert and about whom we know something from the writings of the Church fathers, or from the Gospels themselves in the case of Saint John the Baptist, were often depicted wearing distinctive garb. According to the Gospels, Saint John the Baptist dressed in camel hair in order to demonstrate that he had chosen a hermit's life. Hermits appear often in the history of art: not only Saint John the Baptist, Saint Paul the Hermit, and Saint Anthony, but also women such as Mary the Egyptian and Mary Magdalene, as well as Saint Jerome during his periods of meditation in the desert. Art has given them a kind of penitential garb to convey the utter poverty in which they lived. According to the *Fonti francescane*, even Saint Francis originally used hermit's garb, with a leather belt, staff, and sandals, before choosing a habit for himself and his friars.

Name
From the Greek *eremos* (solitary)

Special dress features
Extreme poverty of dress

Diffusion in art
Throughout art history, in paintings of hermit saints and scenes from their lives

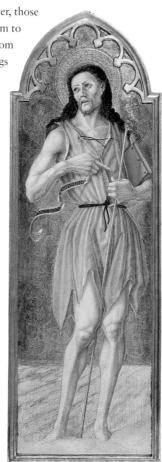

◄ Nicola di Maestro Antonio d'Ancona, *Saint John the Baptist*, late 15th century. Baltimore, Walters Art Gallery.

A crow has brought the two hermit
saints a loaf of bread, but out of
mutual respect neither wishes to be
the first to eat.

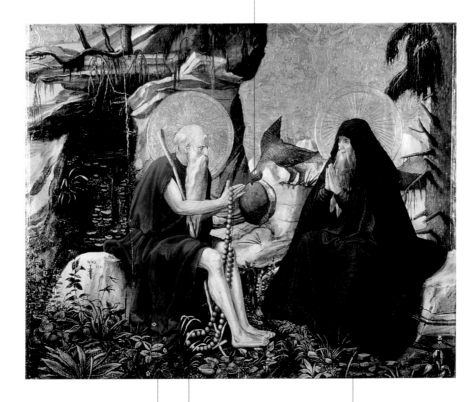

Saint Paul is wearing
a wretched hermit's
garment: drawn in at
the waist, no sleeves,
and made of very
simple fabric.

The long string of beads
reflects the very ancient
custom among Eastern
anchorites (it began around
the 3rd century) of counting
their prayers.

Saint Anthony is wearing
a habit corresponding to
that of the monks who
followed his example.

▲ Manuel Deutsch Nikolaus, *Saint
Anthony and Saint Paul,* ca. 1520.
Bern, Kunstmuseum.

A monk's habit always reached his feet; it might have a hood or a scapular. It could be plain black (Benedictines), plain white (Carthusians), or black and white (Cistercians).

Monk

The life of prayer and solitude led by 4th-century anchorites fascinated some of their disciples and made them desire a similar path to God, with the result that the first communities of monks came into being. Pachomius (290–394), an Egyptian, was the first to set down rules for community life, being convinced that brotherly example and assistance could facilitate spiritual growth. The experiment spread rapidly in the West, thanks to Saint Martin and especially Saint Benedict. Monasteries arose for both men and women, and as different charismas became clear, different rules were set up. Over time, monastic life underwent complications and reforms: after the Benedictines, who followed the rule of Benedict of Nursia, came the Camaldolese (1012), the Vallumbrosans (1036), the Carthusians (1084), the Cistercians (1098), the Sylvestrines (1232), and the Olivetans (1313). In the West today, there are three types of monasticism: Benedictine, Carthusian, and Cistercian. Originally, monks wore a sleeveless linen tunic, a goatskin, and a short hooded cloak, but subsequently the habit took different forms depending on the order.

Name
From the Greek *monos* (alone)

Special dress features
The habit could be white, black, or white with a black scapular. Sometimes there was a hood

Diffusion in art
In scenes of monastic life and of monk saints

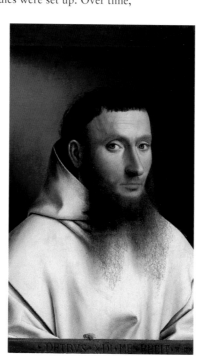

◀ Petrus Christus, *Portrait of a Carthusian*, 1446. New York, Metropolitan Museum.

Monk

Saint Romuald had a vision while he was surrounded by his disciples: he saw his monks ascending a ladder toward heaven, each reaching a height corresponding to his degree of perfection.

Saint Romuald (ca. 950–1027) founded the Camaldolese congregation within the Benedictine Order, thereby bringing together two forms of contemplative and monastic life.

The Camaldolese habit derived from that of the Benedictines and consisted of a scapular, tunic, and hooded cuculla. The use of white instead of black may reflect the low cost of undyed cloth and the possibility of weaving it in the monastery.

▲ Andrea Sacchi, *The Vision of Saint Romuald*, 1631. Vatican City, Pinacoteca Vaticana.

The scapular is a typical item
of monastic clothing for both
men and women.

A nun's dress always involves
a head covering, sometimes
with a veil drawn tightly
around the face.

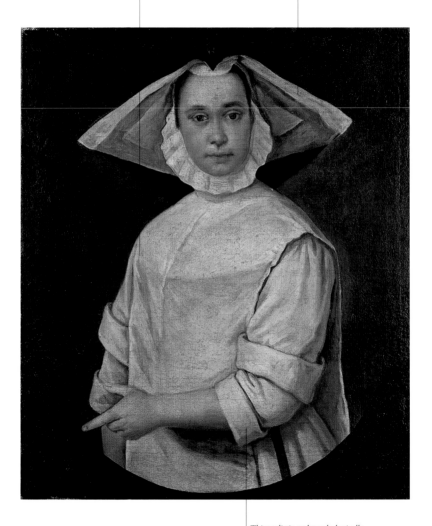

▲ Giacomo Antonio Ceruti, *Portrait
of a Young Nun*, ca. 1730. Milan,
Museo Poldi Pezzoli.

This realistic and psychologically
penetrating portrait of a young nun
of the Order of Humiliati shows that
she is wearing a shirt with rolled-up
sleeves under her habit—probably to
make her work in the convent more
comfortable.

Elizabeth Throckmorton was a
young Augustinian nun, following
the Rule of Saint Augustine in
Paris. She wears a white habit and
black veil.

ELIZABETH DAUGHTER OF Sᴿ ROBᵀ THROCKMORTON BARᵀ

▲ Nicolas de Largillière, *Portrait of
Elizabeth Throckmorton*, 1729.
Washington, National Gallery.

Portraits often show the subject holding a book,
with a finger between the pages to indicate a
dedication to culture. In this case the book is
probably a prayer book, which becomes the
young nun's attribute.

The rich throne with its variety of decorative architectural features has allegorical figures of the cardinal virtues at the bottom and the theological virtues higher up. Their movement and the rich range of colors break up the monochrome gold of the panel as a whole.

From the second half of the 11th century, abbots were given papal permission to wear miters as a sign of their position in charge of communities of monks.

Along the border of the cope are rectangles embroidered with highly realistic images of virgin saints and apostles. Saint Dominic, who founded the monastery at Silos, is shown in bishop's attire, so no monastic habit is visible under his cope.

The crosier is part of the abbot's insignia. The crook has been ornamented with a scene—in this case, a small Virgin and Child—in accordance with Gothic tastes. The sudarium, or pannisellum, was a narrow linen ribbon, attached here to the knob on the staff. It was used in particular by abbots from the 13th to the 18th century, perhaps in order to avoid directly touching the crosier. The elaborate architectural decoration just above the point where staff and crook meet is most impressive.

▲ Bartolomé Bermejo, *Saint Dominic of Silos in Glory*, 1474–77. Madrid, Prado.

Habits worn by mendicant friars can be identified by their color and shape. They are always full length and hooded, but may be white, brown, or black, with or without a scapular.

Mendicant Orders

Name
From their choice of poverty

Special dress features
For the Dominicans: a white habit with scapular and hood and a black cloak; for the Franciscans: a dark habit (black if they were Conventuals) with a hood (very long if they were Capuchins), and a white cord at the waist; for the Servites: a black habit with a scapular or cloak, a hood, and leather belt; for the Carmelites: a brown habit with scapular and hood

Diffusion in art
In scenes from the lives of saints belonging to mendicant orders

The mendicant (begging) orders came into being in the 12th and 13th centuries as individuals, disenchanted with the increasingly worldly values of the Church, sought spiritual renewal. The attraction to evangelical spirituality had led to an explosion of heretical movements, such as those of the Cathars and Joachimites, which were vigorously attacked by Pope Innocent III; but at the same time, thanks to Francis of Assisi and Dominic de Guzmán, new reforming fraternities appeared. They sought a return to the roots of the Gospel without withdrawing from the world, their lifestyle being neither anchoritic

▶ Sandro Botticelli, *Saint Dominic*, 1498–1505. Saint Petersburg, Hermitage.

(reclusive) nor monastic but fraternal and poor; they preached the Gospel among ordinary people. The particular vision of Saint Dominic (d. 1221) involved careful theological preparation for combat against heretical arguments. Soon thereafter, seven Florentine noblemen, known as the Seven Founding Saints, founded the Order of the Servants of Mary (the Servites). The Carmelites were penitent pilgrims who had gathered on Mount Carmel in the late 12th century to live like hermits in imitation of the prophet Elijah; they formed an order in 1247.

Catherine of Siena and her sister nuns wear the white
habit and black cloak of the Dominican Order. The
white comes from the white habits worn by the canons
regular of Osma (Spain). Dominic was one of these
canons before founding his new order.

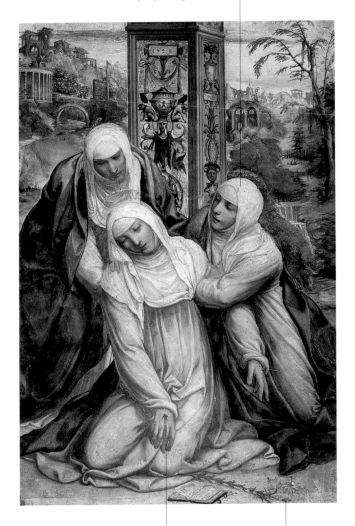

▲ Sodoma, *Saint Catherine Fainting*,
1526. Siena, San Domenico.

The wounds in Saint Catherine's
hands are a sign of her bond
with the suffering of Christ, and
the stigmata draw her even
closer to him.

The stem of flowering
lily is a symbol of purity
and hence of the offer-
ing of virginity that
Catherine made when
she was still very young.

At the top of Saint Francis's habit is a hood whose broad neck spreads over the habit. This neck, sometimes called a capperone, is not sewn on to the habit and is a characteristic of the Franciscan families of Minors and Conventuals.

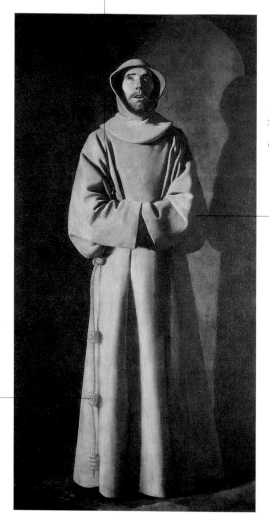

The garb first chosen by Saint Francis was that of peasants: a dark habit, belted at the waist. With the passage of time the color has changed to brown for the Minors and Capuchins, and black for the Conventuals.

The cord at the waist has remained a feature of all Franciscan dress. The three knots are intended to symbolize the three vows of poverty, chastity, and obedience.

▲ Francisco de Zurbarán, *Saint Francis of Assisi*, ca. 1640. Barcelona, Museo Nacional de Arte de Catalunya.

This Franciscan bishop saint is Louis of Toulouse. His identity is confirmed by the fleurs-de-lis of France on his cope.

The elderly friar with a worn expression is Saint Bernardino of Siena.

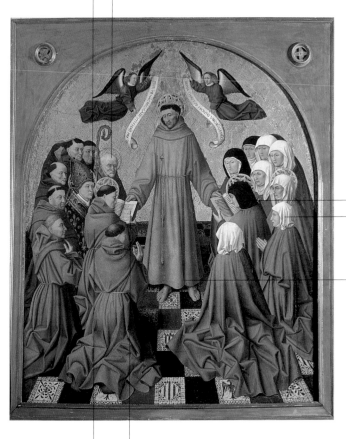

The nun in a brown Franciscan habit, with a black abbess's veil and a halo, is Saint Clare, who founded the female branch of the order. She is receiving the rule from Saint Francis.

Other nuns who succeeded her as abbess are shown behind her.

Saint Francis is wearing a long brown habit. Hoods of the type shown here have persisted in the dress of Friars Minor.

The holy Friar who receives the rule is Saint Bonaventure.

The words of the text were written by the prophet Ezekiel (9:4): "Put a mark on the foreheads of those who sigh and groan."

▲ Colantonio, *Saint Francis of Assisi Giving the Rule to the Franciscan Orders*, ca. 1445–50. Naples, Capodimonte.

The Virgin and Child appear on a throne of clouds accompanied by angels playing musical instruments.

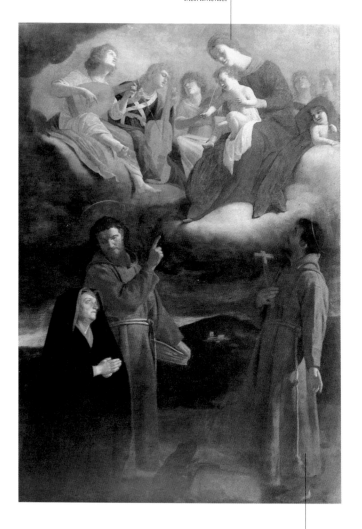

▲ Gerrit van Honthorst, *The Virgin in Glory with Saint Francis, Saint Bonaventure, and the Donor, Flaminia Colonna Gonzaga,* 1618. Albano, Capuchin convent.

Saint Francis holds a cross and is wearing the dark habit of the Capuchin friars, with its long hood without the broad collar and a white cord at the waist. He is wearing Capuchin dress because the painting was a gift to a Capuchin church.

A black veil (white for novices) was worn, long enough to cover the tunic hood.

Saint Clare is carrying a monstrance as a reminder of the occasion when she caused a Saracen siege of Assisi to be raised by praying at the gates of the town, taking with her a casket containing the Blessed Sacrament.

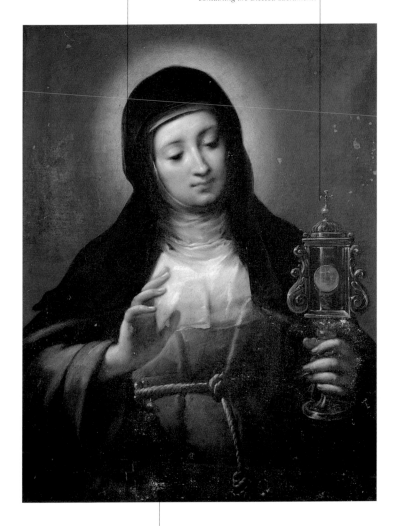

▲ Carlo Francesco Nuvolone, *Saint Clare*, 1640–49. Milan, Quadreria Arcivescovile.

The Poor Clares originally wore a dark habit like that of the Franciscans. According to the Rule of Saint Clare, they also had to wear a scapular. Their heads had to be covered "uniformly and modestly" with a white veil that hid forehead, cheeks, neck, and throat.

This is a portrait of a nun who, at the age of sixty-five, left Spain to found a convent of Poor Clares at Manila. It is absolutely realistic in conveying her age and iron will.

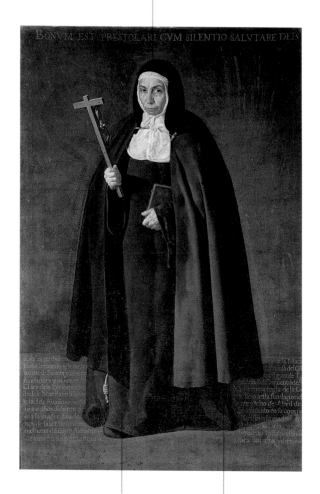

A distinctive item of Franciscan dress is the cord: the last of its three knots peeks out from under her cloak.

The cloak she is wearing over her habit is an indication that she is about to leave on her mission, a fact that is emphasized by the large crucifix in her right hand.

▲ Diego Velázquez, *Sister Jerónima de la Fuente*, 1420. Madrid, Prado.

The head veil is
always characteristic
of a nun's attire.

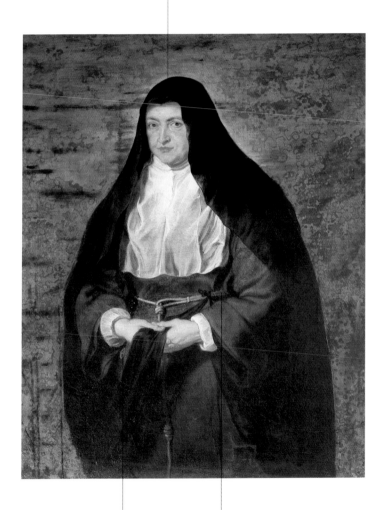

▲ Peter Paul Rubens, *Isabella Chiara Eugenia, Governor of the Low Countries, in Nun's Attire*, ca. 1630. Florence, Palazzo Pitti.

Her crown rosary can just be made out, hanging from her cord. It is indicative of her devotion to the Virgin.

The cord at her waist is of Franciscan type. She was the daughter of the emperor Philip II and became governor of the Low Countries after the death of her husband, Archduke Albert, in 1621. She enjoyed wearing a nun's austere attire.

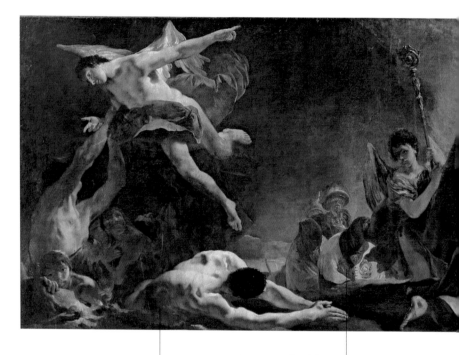

Thanks to the interces-
sion of the Virgin, the
souls in purgatory—
represented here by the
bodies being dragged
from the fire—are freed
from their torment.

A procession of hooded men is
advancing from the back-
ground. They are members of
the Confraternita del Suffragio
del Carmine, who symbolize
the Church Militant as
opposed to Simon's vision,
representing the Church
Triumphant.

▲ Giambattista Tiepolo, *The Madonna
of Carmel with Carmelite Saints and
Souls in Purgatory*, 1721–27. Milan,
Pinacoteca di Brera.

Jesus is holding out a little scapular—also known as an *abitino* or *pazienza*—reserved for members of the pious confraternities.

The Virgin herself is handing a scapular to Saint Simon Stock. According to tradition, the Virgin appeared to Saint Simon around 1250 when he was praying for protection, and promised salvation of the soul to anyone of sound faith who wore the scapular.

Saint Simon Stock is shown wearing the habit of the Carmelite Order with a small cape and hood. He is clutching the book of the rule as a symbol of his efforts to obtain tolerance for the Carmelites on the part of other mendicant orders.

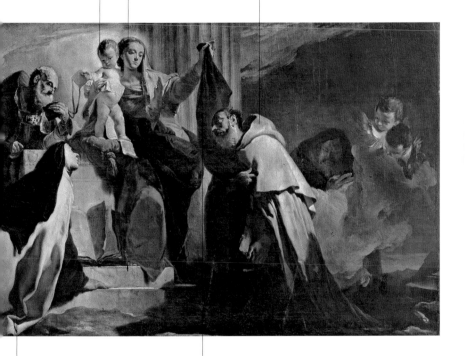

Kneeling at the Virgin's feet and gazing at the baby Jesus is Teresa of Avila, the reformer of the Carmelite Order. Hence the large open book beside her.

The scapular was originally intended to protect the wearer's habit when he was working, being designed to cover the shoulders and chest. But it was also interpreted as the "sweet yoke" of Christ and hence was a sign of adherence to the religious life.

Members are shown in aristocratic dress with insignia of their order, usually a cross of a particular shape and color.

Military Orders

Name
Indicative of a link with the world of soldiers and knights

Special dress features
They wore the attire of noble knights with cross emblems that varied according to the order

Diffusion in art
Mostly portraits of noble-men belonging to a military order

The first military orders emerged in the Holy Land in the 12th century, propelled by fervid support for the Christian cause. They aided soldiers who were fighting in the crusades, cared for the wounded, and provided shelter for pilgrims. These were genuine orders of consecrated men of religion who followed a rule and lived a monastic life under a superior. Like the lay brothers of monastic orders, they renounced property and honors, prayed several times a day, and were obliged to carry out works of mercy in accordance with the rules of community life. Certain orders linked to the Cistercians were inspected periodically by an abbot, kept faith with their rule, and preserved their original ardor. However, most orders strayed from their original aims: they became secularized, turning into corporations

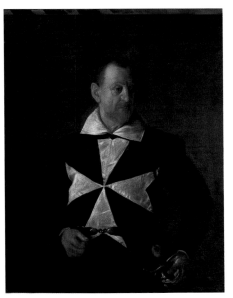

▶ Caravaggio, *Portrait of a Knight of Malta*, ca. 1607. Florence, Palazzo Pitti.

of noblemen who retained no more than a few symbols of their ancient past. Among the most important were the Order of Knights of Saint John of Jerusalem (now the Sovereign Military Order of Malta) and the Poor Knights of Christ, called Templars because their headquarters were at the ancient temple of Jerusalem.

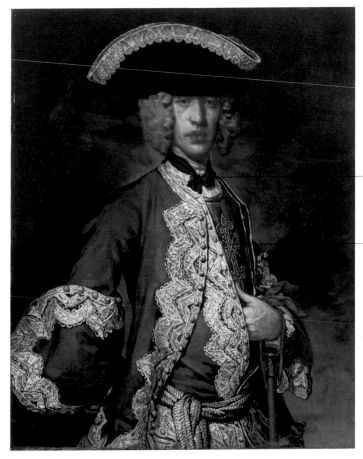

In accordance with a fashion that derived from military circles in England, the knight's wig under his three-cornered hat is tied around his neck with a ribbon.

The deep-red cross on his metal breastplate has arms of equal length with fleurs-de-lis at their ends. This is the emblem of the Sacred Military Constantinian Order of Saint George, which enjoyed a brisk revival in northern Italy in the 18th century.

▲ Giuseppe Ghislandi (called Fra Galgario), *Portrait of a Knight of the Constantinian Order*, 1745. Milan, Museo Poldi Pezzoli.

A cloak thrown over one shoulder completes the uniform, in accordance with contemporary fashion. The great red cross of Santiago stands out on his chest.

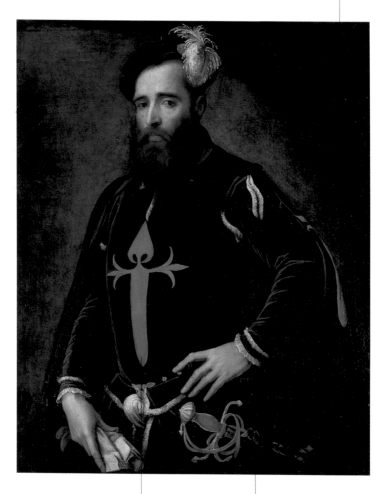

The great red cross sewn on the front of his uniform takes the form of a sword with a cross-shaped hilt—emblem of the Knights of Santiago, otherwise known as Knights of the Sword.

The sword is placed in a prominent position in the knight's portrait as a specific attribute of military nobility, but his identity is not known.

▲ Niccolò dell'Abate, *A Knight of the Order of Santiago*, ca. 1540. Berlin, Gemäldegalerie.

The Spanish Military Order of Calatrava is represented here by Saint James the Apostle, who can be identified by his pilgrim's staff and the small shell on his shoulder strap.

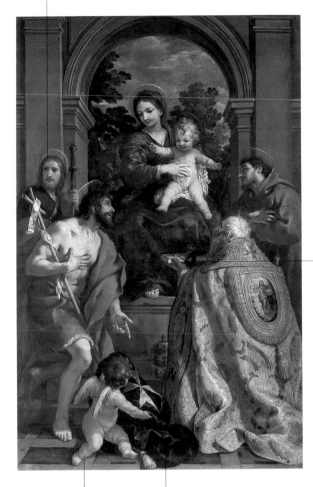

Pope Stephen is offering the Virgin a red Maltese cross and a book— probably the rule of the order. The same type of cross is embroidered on the pope's cope.

Saint John the Baptist kneels at the Virgin's feet and is assisted by a cherub who presents on his behalf a black cloak with a white silk cross sewn on it. This is the emblem of the Knights of Saint John, also known as the Knights of Malta.

The richly ornamented tiara on the step next to the pope is his specific attribute in art.

▲ Pietro da Cortona, *The Virgin and Saints*, 1626–28. Cortona, Museo dell'Accademia Etrusca.

121

Confraternity members can be identified by their garb, which is based on the habits of the religious orders. They are often shown kneeling at the Virgin's feet or with patron saints.

Lay Confraternities

Name
From the Latin
cumfraternitas

Special dress features
They wore a garment
similar to the hooded habit
of the religious orders. It
might have an opening at
the back, and the hood
might cover the face

Diffusion in art
Most likely to be found in
devotional images

Associations of lay members of the Church began to form in the 12th century, their purpose being to pray and carry out works of charity. These confraternities did not demand vows or life in a community, but were regulated by a statute approved by the ecclesiastical authorities. Confraternities could own property and take part in town life, and they also had spiritual guides. They played an active part in town life—building hospitals, their own chapels, or churches—and they also provided charitable assistance to the poor and needy both inside and outside their own confraternity. One of the earliest confraternities in Italy was that of the Flagellants. Founded in 1260, its characteristic activities were flagellation of the body and public penitence, with the aim of achieving spiritual elevation. As these activities waned, members instead cared for the sick. At meetings and religious services, confraternity members wore habits whose design and color were based on those of the religious orders.

▶ Domenico di Michelino, *Saint John the Baptist with Two Members of a Confraternity*, ca. 1450. Milan, Castello Sforzesco, Museo d'Arte Antica.

122

The frontal pose of this
Virgin enthroned with
angels makes her
decidedly statuesque
and archaic.

The lay brothers' habits
have hoods intended to
cover their faces and so
conceal their identities.

The knotted cord derives
from the dress of the
religious orders. In this
particular case, it echoes
the Franciscan cord.

The whip, also known as a
disciplina, *provides further
evidence that these are
members of a confraternity
of flagellants known as the
Disciplini Bianchi.*

▲ Giovanni Antonio di Gaspare da
Pesaro, *The Virgin and Child*, ca. 1450.
Urbino, Galleria Nazionale delle
Marche.

The dove represents the Holy Spirit and is shown in this vision of the Trinity at the point where the light is brightest. The light breaks through the clouds in the direction of the worshiping flagellants.

Two persons of the Trinity, Father and Son, are given the same facial features in order to stress, as the doctrine demanded, the begetting of the Son by the Father, and to remind us of the words of Jesus: "As you, Father, are in me and I am in you, may they also be in us, so that the world may believe that you have sent me" (John 17:21).

▲ Giovanni Paolo Cavagna, *The Trinity of the Disciplini Bianchi*, ca. 1595. Alzano Lombardo, Museo della Basilica.

The lay brothers' habit included a hood that was normally pulled over the face when charitable works were being carried out. This ensured that they would not be recognized and would not gain reward for their good deeds.

The heavy white cloth habit has an opening at the back so that the lay brothers can flagellate themselves for the expiation of sins.

Scenes show monks and nuns praying, studying, or working, in accordance with the special rules governing their life. Sometimes the monastery environment itself is depicted.

Monastery Life

The earliest monasteries go back to the 4th century (the first was founded by Saint Pachomius in 320), and were very different from the later forms into which they developed. They were groups of poor dwellings—sometimes abandoned villages— where monks lived their new lives in isolation but in close proximity to one another. By the time of Saint Benedict about two centuries later, the monastery type that had developed in the East in the 5th century had migrated to the West. Certain features were quite settled: the monastery was a fully autonomous organization, with its own water, mill, kitchen garden, workshops, library, school, church, and so on. The rhythm of monastic life, then as now, was marked by community prayer, communal life, and work. In monasteries, abbey complexes, and Carthusian houses, there would be a large choir in the church for communal prayer, a cloister with doors to community rooms, a chapter house, and a refectory. Benedictine cells were small, whereas the Camaldolese or Cistercians had separate huts or fairly large cells, each with a little garden, a separate bedroom, and a study.

Name
From the Greek
monastèrion, originally a
hermit's cell (from
monastès, a monk)

Special features
In accordance with the
Benedictine requirement
ora et labora, there was a
cycle of prayer, community
life, and work

Diffusion in art
Found throughout the
history of art

◄ Scriptorium, *Lectionary of Henry III*, ca. 1039–40. Bremen, Staats- und Universitätsbibliothek.

125

A solitary monk kneels in
prayer among the rocks. He
is wearing the earliest
"habit" of the hermits,
namely a simple goatskin.

A man praying in
solitude is granted
the privilege of a
visit from an angel
sent from Heaven.

A number of people gather around the body in a
scene depicting the death and funeral of a saint.
The fact that various different habits can be
identified is evidence that the various medieval
monastic groups were all originally derived from
anchorites living in the desert of Thebes.

Two monks are working in a
kitchen garden surrounding
a cell. This is an indication
of the original self-sufficient
organization of monasteries.

▲ Gherardo Starnina, *The Thebaid*,
ca. 1410. Florence, Uffizi.

This may be a scene of temptation: a woman in a fashionable red gown is seen approaching a monk's cell and then hurrying away.

A monk rather near the edge of the broad citadel takes refuge in a hermit's cave.

Two monks sit opposite each other outside their cells on a protruding rock, carrying on a fraternal conversation.

This painting of the hermitage at Camaldoli—the first to be founded by Saint Romuald—shows in very schematic form a life that is communal while not renouncing hermitage: hence the separate and independent cells.

The large church at the center of the hermitage looks like a Palladian temple. It is probably an invention on the part of the artist, since it is not referred to in any contemporary document.

Saint Benedict was the founder of Western monasticism. He is shown wearing the black Benedictine habit (chosen for reasons of austerity, according to tradition), and holding his abbot's crosier and the book of the Benedictine rule.

▲ El Greco, *An Allegory of the Camaldolese Order*, 1600–1607. Valencia, Museo del Patriarca.

This wooden structure, painted to look like an altar, is richly ornamented with imitation inlay and sculptures. In the central panel is a Latin verse text containing a description of a hermit's life.

Saint Romuald, who founded the Camaldolese Order, is wearing the heavy white cloth habit of the new order. He is holding a model of the monastery at Camaldoli.

It is not uncommon in 17th-century Spanish art to find "a painting within a painting." Here we see a painting on a religious subject intended to inspire the monks gathered in their refectory. The Virgin and Child with Saint John the Baptist in the attire of a hermit reminds us of the Carthusian cult of the Virgin and their adherence to the solitary life.

The elegant facade of the Carthusian monastery church can be glimpsed through the refectory entrance.

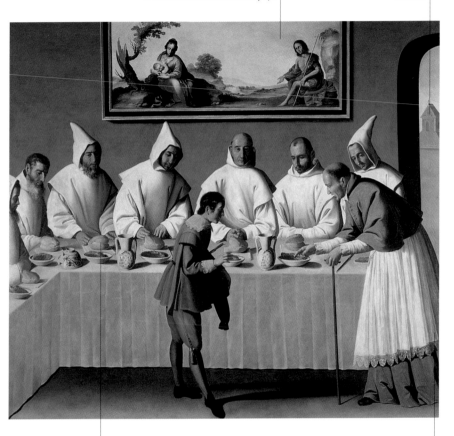

The still life of bread rolls and crockery on the table admirably conveys the frugality of the monks' meal.

Bishop Hugo of Grenoble, now a very old man, is visiting the Carthusians. He aspired to abandon his ecclesiastical duties and retire to the life of a monk, but no pope (Hugo lived through the reigns of six of them) was willing to release him from his episcopal duties, which he performed with great zeal.

▲ Francisco de Zurbarán, *Saint Hugo in the Refectory*, ca. 1625–65. Seville, Museo de Bellas Artes.

Monastery Life

The funeral cortege of Trappist monks is led by a monk with a cross and two others with tall candles.

The monastery cemetery is surrounded by an arcade with pairs of columns. The busts in the tondi between the arches probably represent abbots or saints of the order.

A monk at the rear of the cortege is carrying an aspergillum and water vessel for blessing the monk who has died.

The simple crosses in the cemetery area are an indication of the extreme poverty of the place.

▲ Alessandro Magnasco, *The Burial of a Trappist Monk*, ca. 1700. Bassano del Grappa, Museo, Civica Biblioteca e Archivio.

Saint Brigid can be identified by her white
habit and darker abbess's veil. She
founded and was abbess of the Kildare
convent in Ireland (5th–6th century).

Large numbers of the poor
relied on the ministrations
of Saint Brigid. Here they
are especially fortunate: she
has turned their buckets of
water into beer.

The hagiographic tradition
of Saint Brigid tells us that
distributing food to the poor
was part of everyday life for
monks and nuns.

▲ Lorenzo Lotto, *Scenes from the Life of
Saint Brigid, Charitable Works in the
Countryside: Water Turned into Beer*,
1524. Trescore, Oratorio Suardi.

Monastery Life

A sister warms herself at the fireside in this nuns' common room.

A precious 18th-century gold jug has been inserted anachronistically into this attractive communal scene.

A moment in the life of Saint Clare. Until the 19th century, all the female orders lived an enclosed life, more like that in a monastery than a friary.

▲ Francesco Unterperger, *Saint Clare Washing the Sisters' Feet*, 1731–32. Monguelfo, convent of Poor Clares.

The picture of the Virgin and Child, illuminated by a small lamp, is positioned near the parlatory. It is a point of focus amid the impoverished setting of this enclosed convent.

Among this group of nuns is one who is busy with embroidery, while two others have stopped working to listen to a fourth sister reading.

Most of the nuns are busy spinning.

One young nun is making some precious lace on top of a pillow covered in blue—one of only a few touches of color in the whole painting, whose diagonal composition is echoed in the wool fibers on the spinning wheels and yarn swifts.

One nun with her back to us has temporarily stopped work in order to read aloud some edifying matter to accompany the rhythm of her sisters' work.

▲ Alessandro Magnasco, *Enclosed Nuns*, ca. 1720. Darmstadt, Hessisches Landesmuseum.

Enormous books are used so
that everyone can see, read,
and sing the liturgy of the
canonical hours.

Seven times a day, at the canonical
hours, the monks are summoned by
a bell and gather in the choir of the
church for communal prayer.

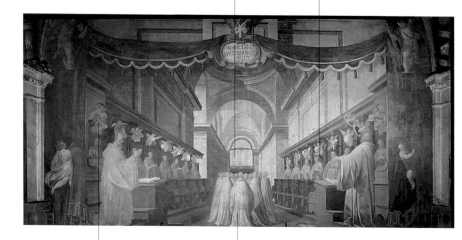

Beside each monk is a
cherub who takes notes
on a flimsy scroll of
paper, recording the
monk's zeal at prayer.

The monks who have recently
entered the community do not
yet know the prayers by heart
and do not have their own
prayer books, so they gather at
the great lectern.

▲ Bartolomeo Roverio, *Angels Note the
Zeal of Monks at Prayer*, ca. 1618.
Milan, Chiaravalle abbey.

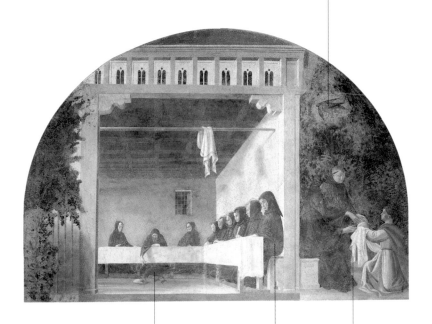

Saint Benedict gave the poisoned bread to a crow that ate from his hands every day, ordering it to take the bread far away where it would do no harm.

At first, the crow summoned by Saint Benedict to take away the poisoned bread flew up without the bread, indicating its refusal to comply, but later it did what was asked.

The "black" Benedictine monks are sitting at the bare refectory table in the monastery, waiting for their meal to be served.

According to The Golden Legend, the poisoned bread was sent to Saint Benedict by a jealous priest called Florentius.

▲ Giovanni di Consalvo, Scenes from the Life of Saint Benedict: The Miracle of the Poisoned Bread, 1436–39. Florence, Badia Fiorentina.

Pictured moments in the communal life of the mendicant orders include prayers in the choir, meals in the refectory, and brotherly encounters.

Convent Life

Name
From the Latin *convenire* (to meet together)

Description
Faithful reconstructions of communal living quarters in convents in accordance with the customs of each different age

Diffusion in art
Up to the 17th century they provided settings for scenes from the lives of saints; later they became settings for genre scenes

The communities of the mendicant orders lived in convents. Franciscans and Dominicans built them on the model of monasteries, but with the substantial difference that since their vocation took them out and about for the care of souls, the convents had to be situated near towns. As the Dominicans were preachers, they soon took to building their convents inside towns, whereas the Franciscans, being basically itinerant, had no fixed community buildings until 1221. The Dominicans needed above all a very large church, suitable for preaching to the faithful. But the two orders were much alike in how their convents were organized. Cloister, chapter house, parlor (the only area where speech was permitted), dormitory with friars' cells and bedrooms, refectory, library, and scriptorium: the sequence and proximity of these spaces allowed them to live according to their rule. Libraries and scriptoria were key components from the very beginning, even in Franciscan convents, where after 1240 they usually became places for study.

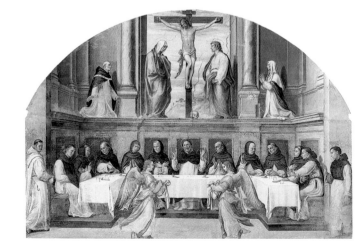

▶ Giovanni Antonio Sogliani, *The Miraculous Dinner of Saint Dominic*, ca. 1535. Florence, Museo di San Marco.

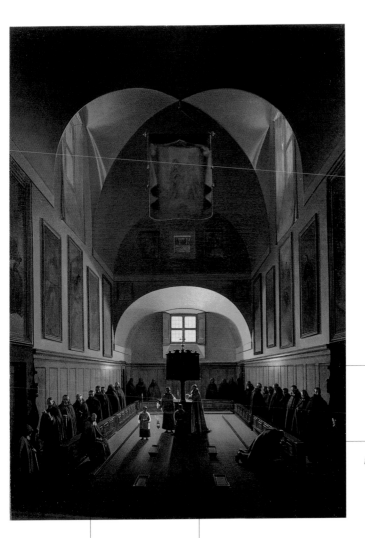

Because the younger friars have not yet learned their psalm singing by heart, a large lectern in the middle of the choir allows them to read from the great book and pray with the others.

The kneeling friar is probably carrying out public penance for having arrived late.

A friar is allowed to remain seated during preparations for Mass if he is sick.

Before the Sunday service takes place, there is a procession in which the celebrant is preceded by two altar boys carrying candles and a friar with a thurible.

▲ François-Marius Granet, *The Choir of the Capuchin Church in Rome*, 1814. New York, Metropolitan Museum.

The paintings on the walls of the friars' refectory depict scenes of religious devotion that contrast with the casual, irreverent supper under way below.

The fact that the doors are decorated with olive branches suggests that the scene is set after Palm Sunday and during Easter week. There is thus even stronger criticism implied in the artist's decision to paint a Lenten fast in this manner.

Far from observing the rule of silence at table in order to listen to the Word, the rule, or the constitutions of the order, these friars seem to be having a friendly chat.

The well-fed individual who is about to start eating from the large platter of fish may be the prior.

This Franciscan friar is a guest at the table and devotes himself to prayer.

▲ Walter Dendy Sadler, *Friday*, 1882.
Liverpool, Walker Art Gallery.

The convent superior is counting on his fingers the reasons for community contrition on the part of his friars.

In this dimly lit room, there is a small crucifix above a skull that is highly exaggerated in its proportions. This memento mori is probably intended more to emphasize the need for penitence than to reproduce the ancient iconographic motif of the cross of Jesus raised over the tomb of Adam.

At various points around the room there are warming dishes with hot ashes.

One friar expresses his penitence by kneeling with a noose round his neck. The noose was a common feature in penitential processions.

▲ Alessandro Magnasco, *Contrite Capuchins before Their Superior*, 1730–40. Madrid, Academia de Bellas Artes de San Fernando.

An elderly friar is approaching the central warming area. The difficulty of keeping warm is emphasized by the fact that he has pulled the characteristic long hood of his habit up over his head.

The inevitable cross appears on the chimney hood in the middle of the room. It is small compared to the gaping holes in the hood that allow smoke to escape, thereby emphasizing the friars' poverty.

Two friars sit apart from the rest. Rather than spending their recreation time chatting with their fellow friars, they are reading in silence.

One young friar does not seem to be concerned with warming himself by the fire. Instead he amuses himself by teasing a cat with the white cord of his habit.

▲ Alessandro Magnasco, *The Friars' Warming Room*, 1725–27. Pasadena, Norton Simon Art Foundation.

Priests, monks, and friars are shown at their various activities: assisting the sick, studying, praying, and administering the sacraments.

Priestly Life

The religious vocation involves a deliberate choice of lifestyle and occupation. Each of the numerous religious orders has its own individual characteristics, corresponding to the various personal gifts mentioned by Paul (1 Corinthians 12:4–11), which manifest themselves in the different activities of monks, friars, and priests. Christ's first disciples and the first Christian communities must at an early stage have organized themselves, hierarchies included, and each member had his duties, defined in consideration of his aspirations and abilities. Since then, those who have chosen the religious life have been able to express themselves in it through their own skills and gifts. It may be that priests are chiefly identified as the men who administer the sacra-ments, but they also administer to the sick, study, and preach. Even monks who promise always to remain in the monastery where they took their vows or who choose a life of enclosure are carrying on an active, dedicated life, albeit in silence and contemplation.

Description
Moments and activities in the lives either of priests expressing their personal gifts or of the religious orders to which they belong

Duties
When they administer the sacraments, they are instruments of the grace of God for the sanctification of the faithful

Diffusion in art
Found throughout the history of art

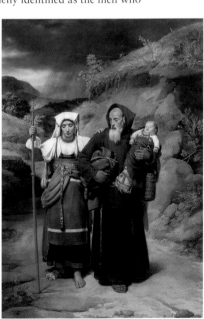

◀ Jean Victor Schnetz, *A Friar Helping an Injured Pilgrim*, 1826. Valenciennes, Musée des Beaux-Arts.

Saint Jerome was a hermit for whom the crucifix was a source of inspiration and prayer. In this scene the crucifix is placed so high up in his study that it loses its force as a primary attribute.

A wounded lion came to the monastery where Jerome was staying. After being cured and tamed by the saint, it remained with him for the rest of its life.

The cardinal's hat and red robe are attributes of Saint Jerome in art, despite the fact that he was never in fact a cardinal but was rather secretary to Pope Damasus.

Jerome was a man of great learning and a doctor of the Church. He is representative of the studious activities of monks and priests, having been responsible, among other things, for revising translations of the Bible from Greek into Latin.

The peacock is a symbol of new life and resurrection because it changes its feathers in the spring, around Eastertime.

▲ Antonello da Messina, *Saint Jerome in His Study*, 1474. London, National Gallery.

The hood, the rough, dark-
brown cloth of the habit, and
the beard suggest that this is a
Capuchin friar.

The friar's habit has
been patched and
repaired more than once,
an indication of his life
choice of poverty.

The artist achieves a wonderful lighting effect in the narrow
beam that touches only part of the sheaf of papers the friar
is holding. We are left to imagine the importance of the
mysterious document that requires such keen attention.

▲ Rembrandt, *A Monk Reading*, 1661.
Helsinki, Sinebrychoff Art Museum.

In the background of this complex composition, set inside a church, Mass is being celebrated behind a partition.

The sacrament of confirmation is being administered by the bishop, seen here in liturgical attire with cope and miter, as he anoints the foreheads of the candidates for confirmation with holy oil. To keep the holy oil in place, the clerk beside the bishop ties a strip of cloth around the forehead of each child as soon as he or she has been confirmed.

The priest is administering the sacrament of baptism to the newborn baby in the presence of parents and godparents. He is anointing the baby's forehead with holy oils, and the baby will then be sprinkled with holy water.

The sacrament of confession is celebrated with discretion and reserve by a priest wearing a hood. In those days it was more common for confessors to be members of the mendicant orders, and such members wore hoods.

Flights of angels devotedly watch over the activities below. They carry banners that provide a brief explanation in Latin of each of the sacraments being administered.

A bride and groom are entering into the sacrament of marriage. The priest blesses their union, making the significant gesture of binding their hands in his stole.

For the ceremony of ordination, the ordinand is already wearing his priestly attire, with a stole placed over his alb. The bishop joins his hands together, using a stylus to consecrate them.

A woman has drawn aside to read some prayers for the dying man. This is an act of private devotion rather than part of the sacrament of extreme unction, which is administered by the priest himself.

▲ Rogier van der Weyden, *Altarpiece of the Seven Sacraments*, 1439–43. Antwerp, Musée Royal des Beaux-Arts.

The sermon is delivered from a pulpit protected by an awning with a more ample canopy above it.

The crucifix seems to motivate the unidentified saint's words. Since his habit has a scapular, he may be a member of the Dominican Order.

Beside a religious who has fallen to his knees with a gesture of pain is a large open book with a skull on it. This symbol of the ephemeral nature of earthly things reminds us of the need for conversion.

Some young monks listen attentively to the sermon. The bright light that blankets them may be intended to indicate that they welcome the preacher's words.

The stirring words of the sermon arouse varying reactions among the listeners: this friar prostrates himself in an attitude of repentance.

▲ Michel-François Dandré-Bardon,
A Saint Preaching, 1734. Paris, Louvre
Museum.

▶ Pietro Longhi, *The Baptism*, 1755–57.
Venice, Pinacoteca Querini Stampalia.

At the top of the Baroque baptismal font is a statuette of Saint John the Baptist with a lamb at his feet and a shell in his right hand for sprinkling water.

A woman watches the ceremony from the wings, half hidden by a column. She is probably the mother, who, having not yet been purified after the birth, cannot be admitted to the church.

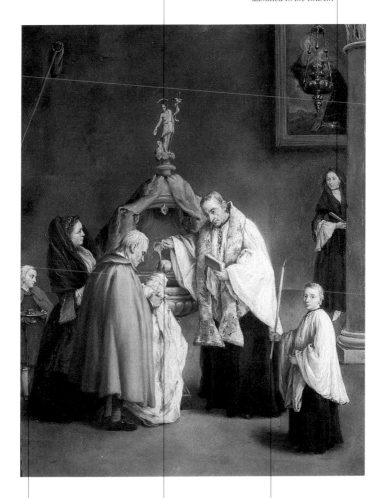

The baby will receive two oils: one is that given to a catechumen to exorcize the spirit of evil and aid in the struggle for faith before baptism with water, and the other is the confirmatory chrism that follows.

The newborn baby is swaddled in bands of cloth and cumbersome, precious white fabrics. Baptismal water is being sprinkled over its head.

The long candle is a gift to the newly baptized child. It is a symbol of resurrection and is linked to the paschal candle.

A penitent kneels in prayer at the confessional as he waits for the priest to become available to hear his confession.

We cannot see the face of the woman in shadow making her earnest confession, but she resembles the queen of Bohemia, who chose Canon John Nepomucene as her confessor and confessed to him very frequently.

The priest is listening to the confession with careful attention. He is wearing a surplice over his habit because the sacrament of confession does not require liturgical dress. Saint John Nepomucene lost his life because he refused to yield to the Bohemian king's implacable desire to learn the secrets of his wife's confessions.

▲ Giuseppe Maria Crespi, *Saint John Nepomucene Confessing the Queen of Bohemia*, 1743. Turin, Galleria Sabauda.

The Eucharist is one of the sacraments that can be received on more than one occasion in life. In art one often finds scenes of saints receiving their last communion shortly before their death.

The group of boys behind the Spanish saint reminds us that the order he founded was much concerned with the education of children.

The elderly saint's priestly black cap is close beside him.

The celebrant's chasuble is green, the color for everyday occasions: Saint Joseph died on August 25, i.e., an ordinary day.

Saint Joseph Calasanctius piously kneels, hands together and eyes shut, as he receives the consecrated bread. He is wearing his priest's stole over the black cassock of clerks regular.

▲ Francisco de Goya, *The Last Communion of Saint Joseph Calasanctius*, 1819. Madrid, Sant'Antonio Abate.

The bishop draws a cross on the child's brow with his finger dipped in holy oil— the same type of oil that was used at the child's baptism.

In this case, the child being confirmed is quite small and is therefore held in its mother's arms.

The sacrament of confirmation is administered by the bishop, who wears a loose cope and a miter.

▲ Maso di Banco, *The Sacrament of Confirmation*, 1338. Florence, Museo dell'Opera del Duomo.

As Hyacinth kneels before the father superior, the white habit of the Dominicans is drawn over his head. The black leather belt, still held by the friar on his left, will be fastened over the habit, as will the white scapular held ready by the friar on his right.

As he waits to receive the Dominican habit, the postulant lies prostrate on the ground as a sign of his total dedication to God.

When Saint Hyacinth arrived in Italy and asked to enter the Order of Preachers, he was a canon. He has now removed and discarded his canon's robes, among which can be seen his ecclesiastical cap.

A habit, scapular, and black cloak sit folded and ready for another of the postulants who will be received into the order together with Hyacinth.

▲ Federico Zuccaro, *The Clothing of Saint Hyacinth*, ca. 1599–1600. Rome, Santa Sabina, chapel of San Giacinto.

Although the school's primary purpose was to teach the catechism, care was also taken to impart a general education: hence the artist's insistence on the presence of books large and small. These are being used by the older children to learn their prayers and also to learn to read.

The strict discipline imposed by the School of Christian Doctrine is partly reflected in their methods: each teacher has a long cane that he can use to discipline unruly children, like the one who is seen here climbing on the altar gate.

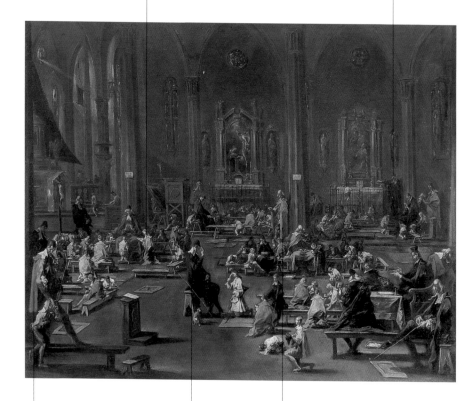

The organization of these schools for poor children was strict, and among its more important figures was the "fisherman," often a layperson, whose job it was to find children in need of education and bring them to the school.

Gestures and their meanings are among the first things to be taught. This priest is teaching the little kneeling boy to make the sign of the cross.

The compound pier and other details suggest that the scene may be set inside the Milan cathedral. Leaning against the pier is the "silencer," whose job it was to impose silence by ringing his bell.

The saint's hand pointing to heaven is in keeping with the serenity of his expression and the light around his head: the gesture promises eternal life for those who die in the grace of God. The background atmosphere seems to tell of life after death.

The rosary and holy picture on the wall are signs of the dying man's piety.

Saint Cajetan is wearing the habit of clerks regular. He is present at the last moments of a dying man and comforts him by holding his hand.

◄ Alessandro Magnasco, *Catechism in a Church*, 1725–30. Philadelphia, Museum of Art.

▲ Sebastiano Ricci, *Saint Cajetan Comforts a Dying Man*, 1725–27. Milan, Pinacoteca di Brera.

WORSHIP AND IMAGES

◀ Lorenzo Lotto, *Madonna of the Rosary*, 1539. Cingoli, Pinacoteca Civica.

Certain animals within the decoration of church buildings or in other religious contexts have symbolic meaning in relation to redemption.

Symbolic Animals

Name
Fish, lamb, leviathan, dove, peacock, pelican, stag, phoenix

Definition
Various creatures that acquire a religious meaning

Purpose
To convey the Christian faith in a symbolic way for the benefit of the initiated

Sources
Clement of Alexandria, *The Tutor* 3.11.59

Diffusion in art
Found from the time of paleo-Christian art onward

In the earliest centuries of Christianity, once the question of whether its art should be iconic or aniconic had been resolved, motifs were developed that gradually became specific to Christianity but drew partly on the bucolic forms and subjects of the existing art tradition. The early Christians initially employed artists who also worked for pagan clients; for their new patrons the artists adapted not only their style but also established subjects, presenting older motifs in a new context that endowed them with appropriate symbolism. Among the earliest creatures represented were fish, which gained a privileged position because the letters making up the Greek word for fish are also the initial letters of the Greek words in the phrase "Jesus Christ, Son of God." Then came the lamb, a sacrificial animal and a symbol of Christ himself. Saint John the Baptist described Jesus as the Lamb of God. Creatures such as the dove and the leviathan derive from Bible stories. The former appears in the story of Noah's ark and is then taken up in the Gospels as an image of the Holy Spirit descending on Christ at the moment of his baptism, and the latter is linked to the story of Jonah, which exegetical scholars interpreted as prefiguring the Passion. Various other animals were thought to recall the Resurrection or Redemption.

► *Fish and Communion Bread*, 3rd century. Rome, catacombs of San Callisto.

According to the Gospels, the Holy Spirit in the form of a dove descended upon Christ at the moment of his baptism.

Saint John the Baptist is shown wearing the very primitive costume of a desert hermit, a rough tunic of camel hair, as described in the Gospels.

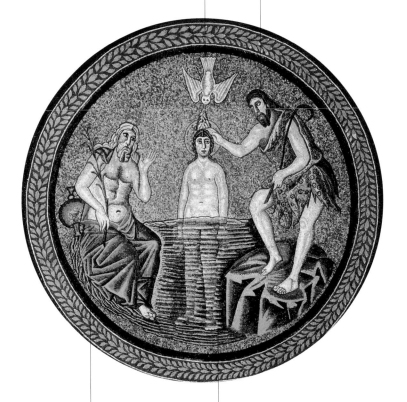

The personification of the Jordan River follows the traditional iconography of classical art: he is an old man with a beard and long hair sitting on the rim of an amphora from which water is pouring, and he holds a river reed.

In order to be baptized, Jesus has entered the water up to his waist. This scene follows the customary rite for adult baptism.

▲ *The Baptism of Christ*, 5th century.
Ravenna, Arian baptistery.

The white lamb with a halo is a symbol of Christ, sacrificed but living, and is placed at the center of the vault.

The four angels support the festooned tondo surrounding the image of the mystic lamb. They are wearing white tunics with a stripe, as did the Christians at that time.

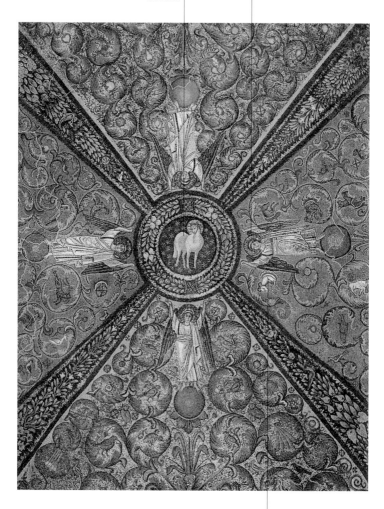

Various animals can be found among the vegetal and floral ornamentation of the vault. Some, like this sheep, allude to the animals used in ancient sacrifices, while others are the animals of paradise.

▲ *Haloed Lamb Carried by Four Angels*, 6th century. Ravenna, San Vitale.

The lamb's head resting on a plane surface defines the picture space, but it also attracts our attention because of its "expression" of abandonment and resignation.

With extreme realism, the lamb's four hooves tied together in the foreground seem to suggest sacrifice, and at the same time they remind us of the words of the prophet Isaiah: "Like a lamb that is led to the slaughter" (Isaiah 53:7).

▲ Francisco de Zurbarán, *The Lamb of God*, 1635–40. Madrid, Prado.

The bunch of grapes alludes to Christ as a vine and as a eucharistic offering. This kind of symbolic image is one of the first to appear in Christian art.

▲ Mosaic with peacocks and vines, 4th century. Rome, Santa Costanza, detail of the vault.

The peacock is rarely shown displaying its multicolored tail (that would be a symbol of pride). Instead the bird is a symbol of the Resurrection because it completely renews its plumage every spring, near Eastertime.

The stag drinking at a spring or stream is a direct reminder of Psalm 42: "As a deer longs for flowing streams, so my soul longs for you, O God." It thus represents the faithful seeking God.

A spring of flowing water represents Christ as one who quenches man's thirst.

▲ Mosaic with stags drinking (detail of the apse vault), 11th–12th century. Rome, San Clemente.

Vines and grapes are often found in Jesus' parables. Since wine is obtained from grapes, they are often used to allude to Christ's sacrifice and his offering of himself.

There are often doves among the creatures drinking at a spring. They symbolize the innocence and purity of the faithful who turn to Christ.

According to the Gospel of John (4:14), Jesus himself is a source of living water that gives life to men. In early images of paradise, there is always a fountain—the Fountain of Grace—which represents Christ as living water.

▲ Mosaic with doves drinking, 6th century. Ravenna, San Vitale.

▲ Francesco De Mura, *Charity*,
1743–44. Chicago, The Art Institute.

The pelican has become a sym-
bol of Christ's sacrifice.
According to medieval tradi-
tion, the pelican feeds its young
by piercing its own breast and
giving them its blood.

The legendary phoenix is actually mentioned in Exodus. It was supposed to live for a great many years, die in flames, and then re-emerge from the ashes three days later. For this reason it acquired a symbolic Christological significance, having earlier been a symbol of divine wisdom. The bird's return to life after three days became an allusion to the resurrection of Christ and at the same time a symbol of life after death.

▲ *Phoenix*, detail of a mosaic floor from Antioch, 5th century. Paris, Louvre Museum.

Objects such as crosses, jugs, anchors, and lighthouses took on symbolic meaning. They are found chiefly in paleo-Christian art, but a few kept their symbolic value in later ages.

Objects

The first important Christian symbol, one that has retained an immediately comprehensible meaning throughout the history of art, is the cross. But it was not the first symbol to be used by Christians, and in any case their attitude toward the instrument of Christ's death was quite varied. In the earliest days of Christianity, various objects were identified as capable of communicating the Christian faith and the way to salvation, such as jugs for drawing water, anchors as symbols of the strength of faith, lighthouses providing the light that leads to salvation, and boats. All these objects with their symbolic significance were first represented in the catacombs and in epitaphs on Christian tombs, and then in churches when freedom of worship was allowed, but few have retained their symbolic power into our own age. Only in the case of the cross can we say with certainty that it has always had the same clear significance, whereas the original meanings of the other objects have gradually been lost. They are often represented in a highly realistic manner, which makes it difficult to understand their symbolic significance.

Definition
Different objects that convey a religious meaning beyond their existence as objects

Purpose
To convey the Christian faith in a concealed way for the benefit of the initiated

Diffusion in art
Found ever since the time of paleo-Christian art

◄ *Birds beside a Jug*, mid-3rd century. Rome, catacombs of Santa Domitilla.

The head of Christ has been placed in a tondo where the arms of the cross meet.

The meaning of the image is made complete by the inclusion of alpha and omega, the first and last letters of the Greek alphabet, at either end of the transverse arm. They lead to Jesus: the beginning and end of everything.

A gem-encrusted cross, representative of the finest goldwork of the late antique period, was the only acceptable way of representing the instrument of Christ's death: it had to be a magnificent object that would convey victory over death.

An inscription at the foot of the cross refers specifically to the instrument of torture and death as SALVS MUNDI, the salvation of the world.

▲ *Transfiguration*, mid-3rd century.
Ravenna, Sant'Apollinare in Classe.

The cross conveys an invisible Christ in Majesty: Christ who reigns but does not appear here in person. In other examples of this iconographic type, there may be a crown or an open book instead of a cross.

Because the Book of Revelation describes the one seated on the throne as looking "like jasper and carnelian," it was decided to represent a cross on a throne ornamented with these widely used gemstones.

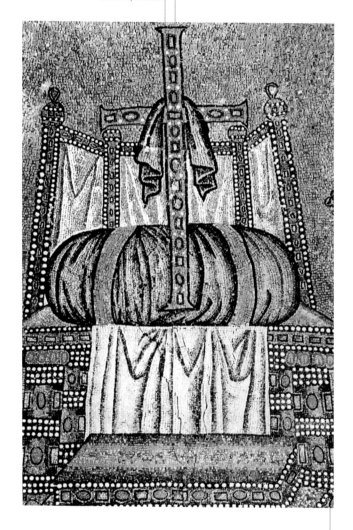

The hetoimasia (empty throne) awaits the parousia (arrival) of Christ, who will come and occupy it. The sumptuous imperial throne represented is decorated with gems, pearls, and precious stones.

▲ Hetoimasia, second half of the 5th century. Ravenna, Arian baptistery.

The anchor is one of the earliest symbolic objects in Christian art, representing the strength of faith in Christ. As time passed this meaning was lost, and in a number of cases it has been wrongly thought that it symbolized the suffering of the martyrs, because it appeared with epitaphs on many tombs.

The fish is one of the best-known symbols in early Christian art. It was chosen and given privileged status because the letters of the Greek word for fish are the initial letters of the Greek words in the phrase "Jesus Christ, Son of God."

▲ *Epitaph with Fish and Anchor*, 3rd century. Rome, catacombs of San Sebastiano.

At the helm of the ship stands Peter, the apostle on whom Jesus founded the Church.

The ship is a symbol of the Church sailing through the sea of history and encountering the storms of human events.

By depicting the episode of Jesus walking on the waters of Lake Tiberias, the artist draws the attention of the faithful to their trust in Christ, for Peter follows Jesus and only by believing in him can he too walk on water.

▲ Andrea da Firenze, *The Ship of Christ*, 1366. Florence, Santa Maria Novella.

Narrative scenes were often taken from mythology or biblical texts; figures of men or women were used to personify ideas, events, or places, identifiable by their specific attributes.

Allegorical Images

Definition
Complex scenes alluding to things beyond themselves

Purpose
To convey a concept or belief in a concealed way, so that it would be understood (during the early years of Christianity and the persecutions) by only a few, or to express a complex idea through simple images

Origin
Based at first on the classical tradition and then developing autonomously, using texts from scripture to create stable visual codes over the course of time

Diffusion in art
Found in paleo-Christian art, and gaining in popularity at various points in the history of art

From its earliest days, Christianity solved the problem of images, forbidden by God's commandment to Moses, by resorting to symbols and allegory. Before Christians became comfortable with representing episodes from the Old Testament and more particularly from the New Testament, the earliest solution was to adopt scenes from the pagan tradition that could be interpreted in a Christian light. Early on, for example, scenes of the labors of Hercules or from the myth of Orpheus, though apparently pagan, could be interpreted as expressing the power of the coming of Christ. Later, Old Testament scenes lent themselves to allegorical interpretations in relation to the life of Christ, and then bucolic images from the late antique tradition allowed the good shepherd to be interpreted as an image of Jesus, in the light of Gospel metaphors.

Allegorical scenes were never completely abandoned in later centuries but were adapted to Christian cultural requirements. The commonest scenes from the Middle Ages onward were representations of the cardinal and especially the theological virtues. This kind of artistic language was much developed in 17th-century Catholic art in scenes extolling a religion that had survived the storm of the Reformation.

▶ *Hercules and the Hydra,* mid-4th century. Rome, Via Latina hypogeum.

The leviathan here takes the form of an imaginary sea monster. It will swallow Jonah and spit him out three days later.

Jonah had embarked on a ship bound for Tarshish in order to avoid carrying out a task assigned him by the Lord. Being held responsible for the divine wrath of the storm, he was cast into the sea, whereupon the storm subsided.

Each of the sailors, terrified by the storm, has prayed to his own god, and then the crew have thrown everything into the sea to lighten the ship. Next they cast lots to identify the person responsible for the trouble, and the lot falls on Jonah.

▲ *Jonah Cast Out of the Ship*, first half of the 3rd century. Rome, catacombs of San Callisto.

Orpheus was a character from classical mythology. He was the first citharist and could use his music to attract and tame wild animals. For Christian artists he could be used as an image of Christ, whose Word brought men to goodness.

This bucolic scene has been packed not only with wild beasts such as the lion, bear, and boar, but also with tamer animals such as the horse, deer, and goat.

▲ *Orpheus among the Wild Animals,* ivory diptych, late 4th century. Florence, Museo Nazionale del Bargello.

The gesture of carrying the sheep on his shoulders recalls the parable of the lost sheep in the Gospel (Luke 15:4–7).

This image of a shepherd comes straight from the iconographic repertory of ancient bucolic art, because the short tunic, footwear, and pipes reveal that this is Pan.

The earliest images of the Good Shepherd are clearly allegorical, for Christ is not given any specific iconographic attribute, such as a halo, cross, or long robe.

▲ *The Good Shepherd*, floor mosaic, 4th century. Aquileia, cathedral.

Allegorical Images

The character in a hairy costume, with a long beard and armed with a cudgel, is confronted by other men armed with swords and crossbows. This tells us that we are looking at Valentine and Orson, a typical farce for Carnival time from the Carolingian cycle.

The popular burlesque "The Dirty Bride" is being performed beside the village hostelry.

In the middle of the square, a man and a woman are walking along behind a clown. Hanging down the woman's back is an unlit lantern. This seems to be the artist's interpretation of the religious situation in his own day: that is to say, Catholicism, represented by Lent, and Lutheranism, represented by Carnival, are advancing in the dark, and the clown leading them symbolizes folly and vice.

Two people are sitting on a bench intent on a game of chance.

▲ Pieter Bruegel the Elder, *The Fight between Carnival and Lent*, 1559. Vienna, Kunsthistorisches Museum.

There are various masked figures in the Carnival procession. One of them is carrying on his head a round table set for a meal, and he holds a candle to illuminate it. This reminds us of the importance of food as one of the pleasures of the festival.

A fat man, personifying Carnival, is sitting astride a large barrel and holding a long spit that is threaded with a pig's head, a chicken, and sausages. On his head is a basket with a pie from which chicken legs are protruding.

People are coming out of church carrying their own chairs, as was the custom. During Lent there was an increase in the number of church services and prayer times.

Fish is being sold by the well. This reminds us that Lenten practice required abstinence from meat.

A man is giving alms to a woman who sits waiting with her child. This could well be interpreted as a representation of the good fruits of fasting and penitence were it not for the red and pale blue of the man's clothes. These are colors that often symbolize sin and deception, and so we are led to doubt his sincerity and hence the sincerity of the Lenten rites.

Lent sits in a church chair and advances on a trolley drawn by a friar and a nun. Lent's hat is a beehive, to remind us that honey can be eaten on fast days. The same is true of the mussels in a pan behind the chair and the buns carried by the children.

At the rear of the Lenten procession is a sacristan with a bag of bread around his neck. He is also carrying a vessel with an aspergillum and Easter Saturday holy water.

The origin of sin lies in the first dis-
obedience, caused by the devil
deceiving Eve. Holbein represents
the devil as a serpent with a
woman's head, because he is
influenced by Vincent of Beauvais's
theory that the serpent must have
had a female head because the
Syriac word for serpent is heva.

▲ Hans Holbein the Younger, *An
Allegory of the Old and New
Testaments*, ca. 1530. Edinburgh,
National Gallery of Scotland.

*Isaiah's prophecy tells of grace to
come as well as the fulfillment of the
Old Testament promise.*

The dead half of the tree represents the Old Testament and life before Christ. The living, vigorous half represents the new alliance, the New Testament, and the new period of grace that came with the arrival of Christ.

To emphasize further that man has achieved grace through Christ, the artist makes use of an older iconography of the Annunciation, without the angel Gabriel or the dove representing the Holy Spirit. Instead we have an image of the Christ child descending from Heaven to become incarnate, carrying a cross on his shoulders.

Above the cross of Jesus are Latin words meaning "Our Justification." Faith in Christ is the sole basis for the justification of man in Lutheran doctrine.

The announcement to the shepherds is a reference to the Nativity, the beginning of Christ's earthly journey. He is pointed out as the "Lamb of God" by Saint John the Baptist, begins his public life, and gathers numerous disciples around him.

Christ rises again, having defeated death, and as he emerges from the tomb he crushes the skeleton, the symbol of mortality. The small, monstrous creature beside the skeleton is a symbol of evil overcome.

The cry of Saint Paul—"Wretched man that I am! Who will rescue me from this body of death?" (Romans 7:24)— is that of a man who has yet to acknowledge the grace he has received with the coming of Christ.

A chalice with the eucharistic sacrament above it reminds us that a belief in the altar sacrament lies at the basis of Catholic faith.

Faith embraces the cross of Christ's sacrifice, because belief in Christ crucified is a primary element of Christian faith.

▲ Moretto da Brescia, *An Allegory of Faith*, ca. 1530. Saint Petersburg, Hermitage.

Threaded through the branches of flowering roses and jasmine is a ribbon bearing the words "The just man is he who lives in faith."

The Crucifixion behind the allegorical figure suggests that this painting was commissioned by Jesuits, because the spiritual exercises of Saint Ignatius recommend the contemplation of images of the sacrifice of Jesus.

A sphere reflecting the universe around it symbolized the capacity of the human mind to believe in God.

In the more common iconography of Faith, her chief attributes, the chalice and cross, would be in her hands rather than on a table. Beside them is a Bible. The three objects together seem to suggest a eucharistic context.

The woman who symbolizes faith is dressed in white as an indication of purity, and blue, the color of heaven. The hand placed on her heart indicates the faith that dwells in her.

Faith rests a foot on the globe, signalling that she has the world at her feet.

The serpent is a symbol of the devil. It has been crushed to death by a stone, which reminds us of Christ as the "cornerstone."

The apple that has rolled some distance from the serpent is a symbol of original sin.

▲ Jan Vermeer, *An Allegory of the Catholic Faith*, 1671–74. New York, Metropolitan Museum.

The cross of Christ and
the chalice of salvation
are attributes of Faith.

Hope's attribute is
an anchor. Its
original meaning
as the strength of
faith has been
altered here.

Charity is represented
as a woman who
cares for and feeds
orphan children.

▲ Giambattista Tiepolo, *Faith, Hope,
and Charity*, 1743. Venice, Scuola
Grande dei Carmini.

Saint Fidelis of Sigmaringen was a Capuchin friar, and so wears the brown habit with a long hood and a cord at the waist. He points to heaven as he stamps on a figure representing heresy.

The cherub with a palm frond beside the holy friar is intended to show that he will soon be martyred by the intolerant Protestants.

The friar carrying out a baptism in the background reminds us that the Sacred Congregation of Propaganda was given the task of going to Raetia (Switzerland) during the Protestant crisis, and that its members' preaching resulted in many conversions.

▲ Giambattista Tiepolo, *Saint Fidelis of Sigmaringen and the Blessed Joseph of Leonessa Stamping on Heresy*, ca. 1752–58. Parma, Pinacoteca Nazionale.

The figure of Heresy has snakes for hair to represent evil thoughts, and the half-open book of snakes is a symbol of false doctrine.

Brother Joseph of Leonessa is shown at prayer beside his brother friar. He too became a martyr, being killed by Calvinists in 1612.

This figure of Immortality is bringing a crown of twelve stars for Divine Providence.

Time is represented as an elderly winged and bearded man. He too is defeated by Divine Providence, who towers over him.

Divine providence is personified as a woman standing in triumph in a prominent position, on clouds that themselves stand out against the luminous open sky of golden light. She is surrounded by other female figures, who can be identified as representing justice, piety, wisdom, power, truth, beauty, and modesty.

▲ Pietro da Cortona, *The Triumph of Divine Providence*, 1633–39. Rome, Palazzo Barberini.

The three Fates spinning the destinies of human lives are depicted in the traditional iconographic manner.

Glory is about to cross the keys on the laurel crown as a symbol of the pope.

The Palazzo Barberini ceiling celebrates not only divine providence but also the glory of Urban VIII's reign as pope. Hence the laurel crown held up by three figures representing the three theological virtues, faith, hope, and charity, together with the papal insignia and the bees that are the emblem of the pope's family.

The figure holding the papal tiara above the laurel crown is thought to be an allegorical representation of the city of Rome.

Allegorical Images

The triumphal procession is accompanied by an angel holding out a laurel crown and a palm branch. They are the rewards for martyrs who give up their lives for the faith.

The dove is a symbol of the Holy Spirit. It flies above the angel to guide it and illuminate the path to be followed.

The Church Triumphant is represented as a woman drawn on a splendid chariot. She holds out in front of her a monstrance containing the Blessed Sacrament, and an angel is placing the papal tiara on her head.

The two crossed keys, as insignia of the Church of Rome, are protected by a processional umbrella and carried by an angel riding one of the horses.

The horses are led by three women, each holding the reins of a horse. These are the three theological virtues: Faith, Hope, and Charity.

The chariot wheels are crushing Heresy, which is represented with snakes for hair and naked to the waist, because heresy is bare of any virtue.

Dragged along beside the chariot are Ignorance and Blindness, represented as an old man with donkey's ears and a blindfolded man. Both are bound.

▲ Peter Paul Rubens, *The Triumph of the Church over Ignorance and Blindness*, 1628. Madrid, Prado.

▶ El Greco, *The Adoration of the Name of Jesus*, 1577–80. Escorial, monastery of San Lorenzo.

It has been suggested that
the person with his back to
us is Doge Alvise Mocenigo.
His presence, together with
that of the emperor and the
ecclesiastic facing them, who
has been identified as Pope
Pius V, would mean that the
whole work may be inter-
preted as an allegory of the
Holy League.

The emperor
Philip II is
shown kneeling
in worship at
the appearance
of the name
of Jesus.

The fearsome jaws of a monster
represent the gates of hell. They
swallow the damned, some of
whom are already shown as white
skeletons. We are reminded of the
words of Paul: "At the name of
Jesus every knee should bend, in
heaven and on earth and under the
earth" (Philippians 2:10).

Above the tablet on which Christ's condemnation is written, a pelican can be seen pecking at its own breast in order to feed its young. This symbolic detail is intended to emphasize Christ's power as savior and his death as bringer of life.

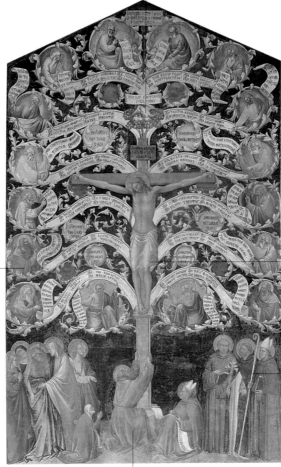

Amid the branches of the tree are the figures of those inspired prophets who wrote of the future coming of the Messiah and Savior.

The cross on which Christ dies becomes a tall tree with many branches.

In accordance with the customary iconography of the Crucifixion, saints and the Holy Women gather at the foot of the cross.

Saint Francis kneels at the foot of the cross, worshiping Christ. The basilica of Santa Croce was built by the Franciscans, who commissioned this fresco.

▲ Taddeo Gaddi, *Allegory of the Cross*, 1333. Florence, Santa Croce.

Groups of people led by priests, monks, or friars proceed on foot in an orderly manner, following a cross or other holy image.

Processions

Processions are among the most recognizable and ancient manifestations of popular piety. These collective expressions of devotion are particularly associated with the cult of Mary and certain saints as well as with Christ, especially the contemplation of the mysteries of the Passion or, more recently, the mystery of the Eucharist. A procession might act as a cortege of the faithful to accompany a saint's relics through a town or to a new place of veneration, or it might be a kind of brief community pilgrimage to a particular place of worship for a special celebration. Processions were used to seek the intercession of Mary and the saints during epidemics. In certain cases, crosses were installed as visible stations indicating the processional route. It was customary for monks or friars to lead off processions of the faithful (using, for example, a cross, relics, or statue, or the sacrament itself). In certain times and places, a procession on the feast day of a patron saint might turn into a picnic outside the town walls. That is how the Spanish *romerias*—country festivals "in the company of the saint"— came into being.

Name
From the Latin *procedere* (to advance)

Definition
A religious ceremony in which the faithful, led by a priest, monks, or friars, walk to a particular place, behind either the sacrament, a cross, or statues or relics of holy persons

Purpose
Worship

Diffusion in art
Found in particular scenes concerning saints or special events

◀ Gentile Bellini, *Procession of a Relic of the True Cross in Piazza San Marco*, 1496–1500. Venice, Gallerie dell'Accademia.

Beyond the city gate
one can see a great
crowd filling the
streets as they follow
the procession. It
passes through
streets and roads,
inside and outside
the built-up area.

A friar has been struck by the plague and
collapsed. He is tended by a fellow friar just
as the procession is passing, but the two are
avoided by the faithful, some of whom
appear terrified of catching the plague.

There are four cardi-
nals in the procession,
dressed in red and with
amice and cardinal's
hat. One of them
makes a gesture of
blessing toward the
plague victim on the
ground.

The pope raises his
arms to heaven with
an eloquent and
dramatic gesture,
asking for relief
from the plague.

▲ The Limbourg brothers, *Procession to
Invoke the Cessation of the Plague in
Rome*, miniature from *Les Très Riches
Heures du Duc de Berry*, 1413–16.
Chantilly, Musée Condé.

Saint Charles Borromeo is blessing the columns raised to commemorate the crosses that previously stood at various points.

A clerk flanked by two candle bearers carries the processional cross. It indicates that a group of the faithful has arrived for the blessing of the column.

The bishop of Milan had decided that large columns bearing crosses should be set up to mark the spots where wooden crosses and provisional altars had been erected during the plague of 1576. They had been used for daily processions in which people prayed for the scourge to end.

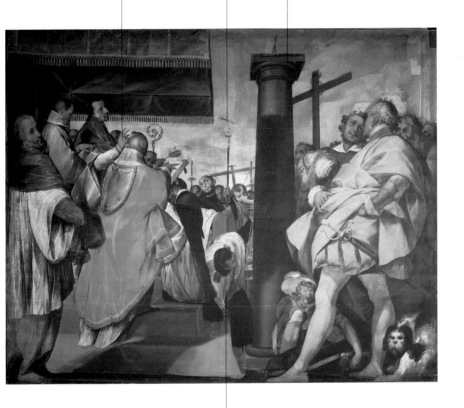

▲ Cerano, *The Raising and Blessing of Crosses after the End of the Plague,* 1603. Milan, cathedral.

There is careful realism in the splendid detail of the incense-bearing clerk bending down to blow on the embers so that the incense in the thurible will start burning. Level with his hand is a gold incense boat held by someone hidden by the column.

Processions

In the far distance, we see vast numbers of people coming on foot, forming a typical procession. But in this case the procession has no special religious or devotional substance.

The river Manzanarre is spanned by the Segovia Bridge at the foot of the hill on which Madrid was built.

The imposing architecture of the royal palace completes the background to this view of the city illuminated by the mid-May sun.

Girls in traditional costume shelter from the early hot sun under an elegant parasol.

▲ Francisco de Goya, *The Meadow of Saint Isidore*, 1788. Madrid, Prado.

The Almudena cathedral at the top of the hill dominates the city view.

The feast of their patron saint becomes an excuse for a pleasant gathering and a picnic lunch. A young woman is pouring wine for other young people sitting on the grass.

Some "pilgrims" have come to the festive spot with wagons and carriages.

191

Processions

It was customary for women taking part in religious processions to wear a veil over their heads.

A cross is carried at the head of the procession.

Girls with lighted candles accompany the procession. They are singing from texts written in their small books.

▲ Giuseppe Pellizza da Volpedo, *The Procession*, 1894. Milan, Museo della Scienza e della Tecnica.

The artist emphasizes the contrast between devotional traditions and the modern world by showing large advertising posters.

Doubt seems to be cast on the religious purpose of the procession by the fact that the passing crowd seems indifferent. Bystanders wear expressions ranging from idle curiosity to derision.

In some regions it is still customary to take part in penitential processions in ragged clothes, bare feet, and attitudes of contrition, as does this woman walking along with her hands bound together.

The procession of the faithful is preceded by a crucifix carried by three men with bare feet and crowns of thorns.

▲ Dilvo Lotti, *Procession of Crowned Saints*, 1946. Florence, Palazzo Pitti.

Images of other types of processions are easily confused with those of rogation, which show the faithful out in the fields, far from built-up areas.

Rogation

Name
From the Latin *rogare* (to request)

Definition
Popular intercessional prayers for the fruits of the earth

Diffusion in art
Not at all widespread

Rogation rites are among the most ancient forms of piety, linked to the seasonal cycle and life in the fields; the Church has kept the tradition alive. The word *rogation* means a request in prayer and indicates the specific nature of these processions of ordinary people: they resemble other processions except that their specific concern is the harvest. They have been used since early times and are in part an inheritance from pagan culture, but as a manifestation and expression of popular Christian faith they are much in decline, especially in towns. In the countryside and mountains, however, they have persisted as a strongly popular and at times even folkloric tradition, providing an occasion for communities to gather and reenact an ancient ritual. These rituals, usually processions, enjoy the keen support of the faithful. They involve special prayers and take place at particular times of the year to ask God for the gift of the yearly fruits. They are not necessarily linked to any specific feast in the liturgical year.

▼ Jules Breton, *The Blessing of Corn in Artois*, 1857. Paris, Musée d'Orsay.

The artistic expression of the cult of saints includes the use of haloes and scenes of pilgrimages to their tombs. The cult itself involves belief in their intercession through miracles.

The Cult of Saints

The cult of a saint is an honor bestowed by the Church faithful upon a chosen soul in a special form of remembrance at a local or universal level. Such cults have taken a variety of forms over the history of the Church, depending on the sensibilities of different periods. In the early days of Christianity, a saint's death was considered a *dies natalis*, that is, the first day of a new life, and so the cult commemorated the anniversary of that death by gathering at the saint's tomb to celebrate the mysteries of the Eucharist. An essential feature of the cult was the celebration of the saint's feast day, even when, for various reasons, the burial place was no longer remembered and there was no written record of the saint's martyrdom. The pagan custom of holding funeral banquets was taken over by the Christians in the commemoration of Christian saints, and so they too held banquets at tombs, but the practice had so degenerated by the 4th century that Saint Ambrose was obliged to prohibit them and Saint Augustine condemned them. Medieval sensibilities led people to express these cults by making pilgrimages to the tombs of martyr saints or to the places of Jesus' public life in the Holy Land. In conjunction there grew up a cult of relics, which proliferated throughout Europe. Successive popes who were sensitive to the problem imposed regulations on the cult of saints and the excesses it generated in popular piety.

Name
The particular expression of the communion of saints as a spiritual link between the faithful and chosen souls

Sources
The lives of saints

Diffusion in art
Found throughout the history of art, particularly in the depiction of *post mortem* miracles, or in special intercessions effected by a few saints

Influence on art
In some cases, a specific popular cult of Christians considered to be saints, especially those thought to have powers of intercession and the ability to perform miracles, has determined their appearance in images

◄ Jules Eugène Lenepveu, *Martyrs in the Catacombs* (detail), 1855. Paris, Musée d'Orsay.

Angels, too, are often given haloes to identify them as spiritual beings.

The soldier with helmet and halo is probably Longinus, or else the centurion who recognized the divinity of Christ on the cross. This type of portrayal in early Crucifixion scenes indicates that devotion to his cult was on the rise (The Golden Legend).

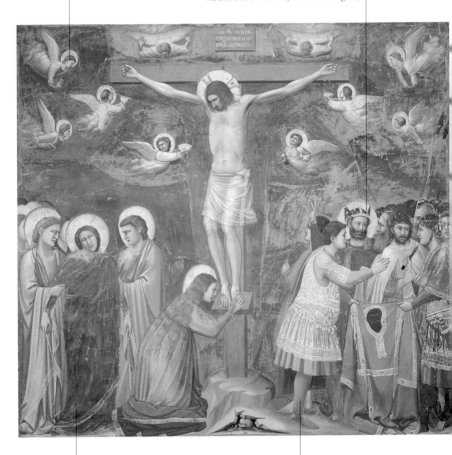

In pre-Christian art, the halo was a sign of superior rank (that of kings and emperors, for example), but it was soon taken over in Christian art to indicate saints.

The soldiers in the foreground are casting lots for Jesus' tunic (John 19:24).

▲ Giotto, *Scenes from the Passion: The Crucifixion*, 1304–6. Padua, Scrovegni chapel.

Touching the raised sarcophagus is a typical gesture for someone seeking an intercession.

Painted in the semicircular apse vault, in imitation of a mosaic, is Christ Pantocrator in a mandorla with the Virgin on his right and Saint Nicholas on his left.

One sick man has been cured and turns away from the tomb, carrying the crutches he no longer needs.

Groups of the faithful are accompanying the sick to the saint's tomb, as a kind of pilgrimage.

▲ Gentile da Fabriano, *The Crippled and Sick Cured at the Tomb of Saint Nicholas*, 1425. Washington, D.C., National Gallery.

The tomb is raised on four columns resting on an altar and is painted in imitation of Gothic architecture, but with some decidedly Renaissance features. Among the figures of saints, we can identify Saint Sebastian with his hands tied behind his back and arrows protruding from his body.

The figure of Christ in Benediction is at the center of the tomb decoration.

A poor pilgrim is trying to touch the saint's tomb in the hope that his prayer will be answered.

A man faces the saint's tomb as he kneels in prayer with hands joined and an expression of pleading on his face.

A paralyzed woman has been brought close to the saint's tomb in a kind of litter.

▲ Master of Saint Sebastian (Josse Lieferinxe), *Pilgrims at the Tomb of Saint Sebastian*, 1497–99. Rome, Palazzo Barberini, Galleria Nazionale d'Arte Antica.

This reconstruction of the basilica of Saint Francis is purely imaginary. It reflects the new ideal of beauty inspired by the classical world, even including a bas relief showing a sacrifice at a pagan altar.

A priest is performing an exorcism. He is reading the formulae from a book, which a small boy holds for him, and ordering the demon to leave the woman. Although bound in chains, she is struggling violently, and the evil spirit can be seen coming out of her mouth.

A barefoot man wearing a pilgrim's cloak that bears a pilgrim's shell seems to want to go down to the tomb of Saint Francis.

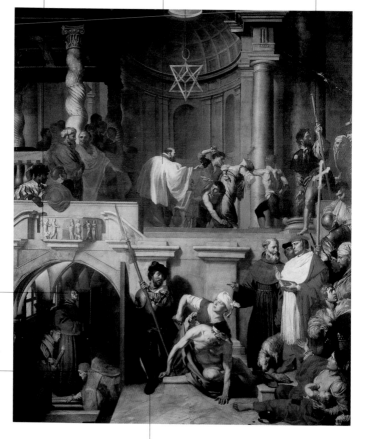

Two friars have been sent to accompany the pope to the tomb of Saint Francis. One of them looks worried by the shouts coming from above, where the exorcism is being performed.

The pope, wearing a heavy cope, bends over the saint's tomb.

▲ Gérard Douffet, *Pope Nicholas V Visiting the Tomb of Saint Francis*, ca. 1625. Munich, Alte Pinakothek.

A Swiss guard, who is probably part of the papal escort, disperses some poor beggars who have stopped on the steps leading down to Saint Francis's tomb.

When his body was found, Saint Mark himself appeared in order to put a stop to the profanation of so many tombs.

A saint's relics were required in order to found a new basilica, so some Venetian merchants sought and obtained permission to retrieve the body of Saint Mark.

The presence of a crippled man who appears on the point of recovering is further confirmation of the holy nature of the apparition.

So that the Venetians might be sure that this was a genuine holy apparition and not a trick of the devil, a possessed man was brought to be freed of his evil spirit by Saint Mark.

▲ Tintoretto, *The Finding of the Body of Saint Mark,* ca. 1562–66. Milan, Pinacoteca di Brera.

A statue of Saint Januarius is carried in solemn procession as the people seek his intercession to halt the eruption of Vesuvius.

Some of the faithful are waiting piously for the arrival of the procession and will then join it.

The task and privilege of carrying the processional baldachin has been given to a confraternity whose members have turned out in large numbers. All are wearing hoods.

The Capuchin friars who accompany the procession are singing hymns and prayers.

▲ Antoine Jean-Baptiste Thomas, *The Procession of Saint Januarius during an Eruption of Vesuvius in 1822*, 1822. Versailles, Musée National des Châteaux de Versailles et de Trianon.

The Virgin Mary is variously represented: as mother of Christ, enthroned, on clouds, as protectress, bringing aid to Christians, or in the Immaculate Conception.

The Marian Cult

Definition
The cult of Mary of
Nazareth, mother of Christ

Sources
The Gospels; exegetical
readings of Revelation
(12); documents of the
Council of Ephesus
(A.D. 431); the apocryphal
gospels; prayers and hymns
to the Virgin

Diffusion in art
Omnipresent in the history
of art from the 5th century
onward

The veneration of Mary, mother of Christ, and the beginning of her cult go back to the late 4th century, following the granting of freedom of worship in the Roman Empire and more especially the edict of Theodosius, which declared Christianity to be the official religion of the state (380). Theodosius was also responsible for summoning a council at Ephesus in 431, at which the divine motherhood of Mary was declared, and so the cult of the Mother of God was definitively authorized. The figure of Mary is indeed one of the first to appear in Christian art; *The Madonna and Child and the Prophet* and *The Annunciation* appear in the catacomb of Priscilla (ca. 3rd century). At first the image of Mary was based on that of a Roman matron. In the 5th-century mosaics in Santa Maria Maggiore in Rome, she appears as matron and queen enthroned receiving

the homage of the Magi, but in Nativities produced after the Council of Ephesus she is also a mother exhausted after childbirth. Mary is shown at various points in her life taken from the apocryphal as well as the canonical tradition, but as time passed, popular piety contributed to the development of new iconographical types, which identify her variously in the Immaculate Conception, as the Blessed Virgin of the Rosary, as the Madonna of Mercy, and in other variants.

▶ Bartolomé Esteban
Murillo, *The Immaculate
Conception of the Escorial*,
1665–70. Madrid, Prado.

Mary is seen raising a stick to strike the devil and rescue the child it is trying to carry off.

The Virgin Mary is shown as a queen with a crown on her head and a splendid gold brocade gown. Her mantle is blue, the color of heaven, symbolizing the divinity that was granted to her as mother of Christ.

The boy's mother kneels in prayer, seeking the aid of the Virgin.

According to tradition, the child's mother was exasperated by her adolescent son's bad behavior and burst out, "The devil take you," whereupon the devil appeared in person, ready to carry off the boy.

▲ Tiberio d'Assisi, *The Madonna of Succour*, 1510. Montefalco, Museo Communale, formerly the church of San Francesco.

The devil is given a repulsive, bestial appearance, with goat's hooves, bat's wings, horns, and a tail, but its attitude in grasping the child is quite human.

Above Mary's royal crown the artist has painted a golden halo as a sign of her sanctity. Her red gown symbolizes her humanity.

The Virgin Mary holds open her voluminous blue mantle as a sign of protection for all those who seek refuge there. This gesture also has a compositional purpose in that it counteracts the flattening effect of the gold ground and transforms the figure of the Virgin into a kind of niche for the faithful who are kneeling at her feet.

Only one member of the Confraternita della Misericordia, which commissioned the painting, is shown wearing his confraternity habit and a hood.

▲ Piero della Francesca, The Madonna of Mercy, 1440–42. Sansepolcro, Pinacoteca Comunale.

This is a typical example of the Madonna of the Rosary type, showing Mary or the Child in the act of giving the rosary to Saint Dominic. It reflects the tradition, spread by the Dominicans, that Saint Dominic himself received the rosary from the Virgin in 1210 in response to his prayer.

Two cherubs are holding the attributes in art of Saint Dominic de Guzmán: the lily, a symbol of chastity, and the book, which indicates the centrality of culture and theological training in the struggle against heresy.

Saint Dominic's habit is that of the Order of Preachers, which he founded: white with a scapular and black cloak.

The five joyful mysteries are placed among branches of flowering roses.

The palm fronds on which the five glorious mysteries rest are a symbol of the glory of martyrs.

▲ Guido Reni, *The Virgin Appearing to Saint Dominic and the Mysteries of the Rosary*, 1596. Bologna, Santuario della Madonna di San Luca.

The five sorrowful mysteries rest on prickly brambles.

The fifteen mysteries of the rosary are shown in fifteen ovals, with emphasis given to the central event of Christ's sacrifice.

205

The image of a dove above the Virgin's head is significant as a symbol of the Holy Spirit that "will come upon [her]" (in the words of the angel of the Annunciation [Luke 1:35]) and overwhelm her with the power of the Most High.

One of the angels around the Virgin has a flute as a sign of worship and praise accompanied by music and singing.

Mary wears her traditional red robe and blue cloak. She is raised heavenward with her feet resting on angels' heads.

In this painting, the artists are using a particular didactic representation of the Virgin of the Immaculate Conception, one that relies on an understanding of popular piety and litanies rather than on the text of Revelation. Hence the attributes of the Virgin in the landscape below her.

The distant ship may be an allusion to the Church of which Mary is mother and protectress.

Close by the Fountain of Grace, the serpent slinks away, defeated by the Immaculate Virgin.

The lily is a symbol of purity, and the rose alludes to the Virgin as the Mystic Rose.

▲ El Greco and Jorge Manuel Theotokópoulos, *The Virgin of the Immaculate Conception*, 1607–13. Madrid, Thyssen-Bornemisza Collection.

Christian men and women are depicted in devout attitudes of prayer or meditation before a holy image or during a religious celebration.

Popular Piety

In private life, the need to live and express one's faith is a very personal matter, but in a social context it has given rise to various rites that survive to our own day, some of them from very early times. Participation in Sunday services or solemn liturgies is in itself an expression of communal piety. So are certain other rites, such as that of the Via Crucis, a kind of meditation on Christ's path to Calvary with the burden of the cross. These ritual customs often require the participation of a great number of the faithful, and in some places they are arranged to include amateur actors and people in costume; they were created with the intention of involving Christians emotionally in the celebration of the Passion. There are thus some Easter week celebrations in which it is customary for an image of Christ Crucified or Risen to be presented for kissing. The veneration of the Madonna and saints plays an important part in popular Catholic piety and may be expressed in a variety of ways: in special rites, prayers, or processions, for example.

Diffusion in art
Found in various forms throughout the history of art

◀ Giuseppe Mentessi, *The Worship of the Body of Christ*, 1914. Ferrara, Civica Galleria d'Arte Moderna e Contemporanea.

The first Mass early on Sunday morning was a
celebration of the Lord's day. It recalls the visit to
the sepulcher of the women who received the
news of Christ's resurrection.

As a sign of respect and in
accordance with tradition,
women wore a head-covering
while taking part in church
services and other rites.

▲ Angelo Morbelli, *Sunday Dawn*,
1913. Piacenza, Galleria Ricci Oddi.

The six tall candles
show that this is the
solemn celebration of
sung Mass.

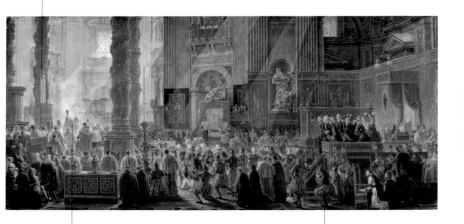

The celebrant raises the chalice
at the moment of consecration.
His white vestments indicate
that this is Christmas.

Some Swiss guards kneel
piously in the presence of
the Eucharist as it is
raised by the priest.

▲ Louis Jean Desprez, *Gustav III at
Christmas Mass in Saint Peter's*, 1784.
Stockholm, Nationalmuseum.

A poster on the facade of the church explains how to
obtain a plenary indulgence. After confession and
particular prayers and devotions, it is possible to
obtain forgiveness for one's sins.

A simple stand holds
a variety of votive
images and rosaries.
They are objects
used in personal and
communal devotions
as an aid to prayer.

A beggar by the church
door is waiting for
some charitable passing
Christian to help him
with a donation.

▶ Christoffer Wilhelm Eckersberg, *Via
Crucis Procession inside the Colosseum*,
1815–16. Copenhagen, Den
Hirschprungske Samling.

▲ Luigi Serra, *The Rosary Makers*,
1885. Florence, Palazzo Pitti.

The places where the procession will stop inside the Colosseum are marked with fixed crosses and shrines.

At each station during the procession, a friar reads passages from the Gospels and narrates popular tradition relating to that particular moment in the story of Christ's journey to Calvary, his death, and his deposition in the tomb. Only in the past century was a station for the Resurrection added.

The Via Crucis procession is led by a group from a participating confraternity. They are wearing habit and hood, and the front two are carrying lanterns.

The cross is normally carried in turn by the faithful.

The worshipers fall to their knees at the moment when the Adoration of the Cross is announced.

Scenes of a holy nature were enacted in churches or town squares. In some cases there were fixed tableaux with costumed statues.

Sacred Tableaux and Mystery Plays

Definition
Theatrical performances or staged tableaux on sacred subjects for specifically devotional purposes

Purpose
To involve the faithful

Diffusion
There were liturgical dramas in Latin between the early 10th and 12th centuries and others in the vernacular in the 14th century. After interruptions caused by the Wars of Religion, religious drama was revived by such people as Saint Philip Neri and Pope Clement IX

Diffusion in art
The few examples are usually concerned with specific religious events

The Church at first condemned the theater and its entire underlying pagan tradition. Only when the Church perceived the need for instructional communication with the faithful did it adopt a more positive attitude in the 5th century, accepting the theatrical performance of scenes on sacred subjects. In the beginning, brief theatrical shows were allowed in church, and later on liturgical dramas in Latin were produced, the first appearing around 930 at the monastery of Fleury. From that time until the 12th century, the production of so-called mystery plays became widespread, beginning with dramatized episodes from the Resurrection and Nativity; space was set aside in churches for their performance. In the early 14th century, mystery (or miracle) plays in the vernacular began to appear in Italy. Elsewhere in Europe, such plays often involved the entire Christian population of a town and therefore had to be held in the town square. These dramas kept growing in popularity until the Wars of Religion threw Europe into turmoil.

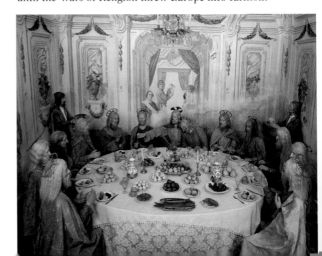

▶ Giovanni d'Enrico, *Last Supper Scene*, ca. 1630, with 18th-century additions. Varallo, Sacro Monte, chapel of the Last Supper.

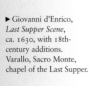

The altar is ready for Christmas Mass and in front of it Saint Francis is carrying out his extraordinary act of veneration.

Inside the church, some friars with surplices over their albs seem astonished at what is taking place.

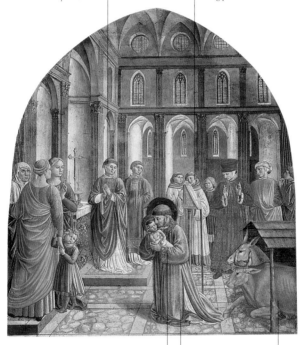

▲ Benozzo Gozzoli, *Christmas Creche at Greccio*, ca. 1450–52. Montefalco, Museo Comunale, former church of San Francesco.

According to the Fonti francescane, *Saint Francis had a vision of the Child in swaddling clothes in a manger. The saint was probably recalling the mystery play tradition. His action had the effect of diffusing such plays through Franciscan circles, with the aim of popularizing the faith.*

According to tradition, Saint Francis invented the Christmas creche in 1223. His aim was to set up a reconstruction of the Bethlehem grotto for the celebration of Christmas Mass.

In reconstructing the episode of the birth of Jesus, Saint Francis followed the iconographic tradition for Nativity scenes by having a kind of theatrical set made with an ass and an ox.

Sacred Tableaux and Mystery Plays

The steps leading into the Gothic facade of Antwerp town hall provide a stage for the play. The hall was demolished in 1464 in order to enlarge the square.

The scene to be performed is the Ecce Homo, the moment when Pilate presents Jesus, already sentenced and scourged, to the crowd.

A town's main square was often used for the performance of a mystery play, as here in Antwerp. People watch the play from house windows, and one shoos away a boy who has climbed onto the porch roof, perhaps to obtain a better view.

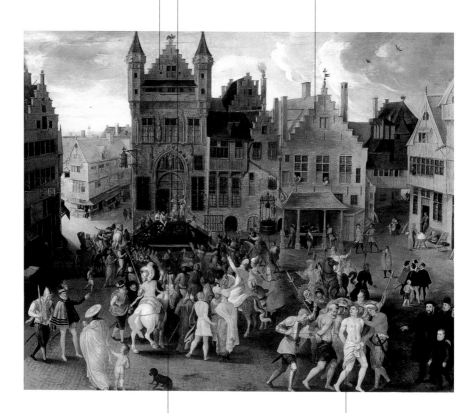

Among the crowd we can identify the individuals who asked for Jesus to be condemned. Some men on horseback wearing turbans represent the doctors of law who stirred up the people.

In the foreground are two condemned men accompanied by guards. This may be part of the next scene, involving the two thieves who were crucified with Jesus.

▲ Gillis Mostaert, *A Performance of the Passion in the Main Square at Antwerp*, 1565. Antwerp, Musée Royal des Beaux-Arts.

Artists depicted miraculous events leading to the birth of a particular cult or a religious feast that had given rise to a specific iconography.

The Commemoration of Miracles

A miracle may inspire a religious celebration to commemorate the event. Then an image of the miracle, with its own "ad hoc" iconography that is elaborated over time, may in turn contribute to popular veneration for certain episodes in Church history. A miracle may become the occasion for a conversion or for the reassessment of a belief. It may also become affiliated with a particular festivity, as with the Mass at Bolsena. According to legend, a priest called Peter of Prague was celebrating Mass in the church of Santa Cristina in 1263 when he saw blood issuing from the newly consecrated host; it dripped onto the corporal, the liturgical cloths, and the marble floor, banishing his doubts about the presence of Christ in the sacrament. Although Pope Urban IV instituted the feast of Corpus Christi in 1264, its connection with the "miracle at Bolsena" began later. That feast has kept its importance in popular piety over the course of Church history, and sometimes the miracle itself is represented in art. Other celebrated miracles supported the idea that there is divine intervention in the life of the Church, as with the miraculous snowfall in Rome in August 352, which led to the founding of the church of Santa Maria Maggiore.

Definition
Remembrance of an event through an image representing it

Purpose
The image acquires a didactic role almost as great as that of written sources describing the event

Diffusion in art
Found at particular points in Church history to record and support a tradition

◀ Francesco Trevisani, *The Mass at Bolsena*, 1704. Bolsena, Santa Cristina.

The green vestments for celebrating Mass indicate that the miracle occurred on an ordinary day. This historical detail is fairly rare in paintings of the Mass at Bolsena, because red was preferred as the color proper to the feast of Corpus Christi, which came to be affiliated with this miracle.

The faithful at Mass are thrilled by the miracle.

There is agitation among the clerks at Mass because they have noticed that the priest is disturbed.

The corporal is stained from the blood that has dripped from the host. The Bohemian priest, who according to legend had entertained doubts about the real presence of Jesus in the consecrated bread, is now convinced of this article of faith.

Pope Julius II has had himself represented kneeling in adoration before the consecrated host as it drips blood. Behind him are four cardinals: Leonardo Grosso della Rovere, Raffaello Riario, Tommaso Riario, and Agostino Spinola.

The pope leans on a large cushion placed on a faldstool.

The chair bearers have also joined in the Mass, and have kneeled at the moment of consecration. The first is leaning on the pope's gestatorial chair, while the one next to him leans on one of its bars, gazing at the sacrament on the altar.

▲ Raphael, *The Mass at Bolsena*, 1512. Vatican City, Palazzi Vaticani, Stanza di Eliodoro.

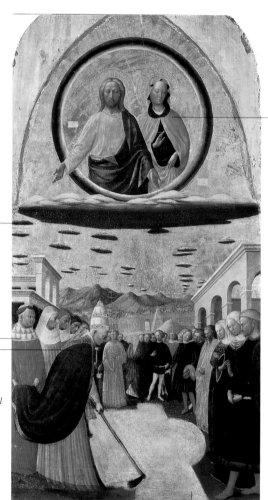

Large flakes of snow miraculously fall on Rome during an August night.

The whole papal court, including an entourage of clerks, deacons, cardinals, and bishops, has followed Pope Liberius, who is marking out the church requested by the Virgin.

Accompanied by his entire retinue, Pope Liberius has come to the Esquiline Hill in Rome, where a snowfall has occurred. He is initiating work on the new building.

According to a legend narrated by Fra Bartolomeo da Trento in the second half of the 13th century, Mary appeared in the sky on a night in August 352 not only to Pope Liberius but also to two patricians who were anxious to do something in her honor and sought permission to build a church dedicated to her.

The outline drawn by the pope is meant to be the plan of the future basilica of Santa Maria Maggiore.

▲ Masolino da Panicale, *The Miracle of the Snow*, ca. 1428. Naples, Capodimonte.

Its most usual form is that of a small wooden panel showing the person who has been spared in the act of praying to God, the Virgin, or the saints.

Ex-Voto

The term *ex-voto* derives from the Latin for "vow": it is a promise or undertaking that a believer pledges to Jesus, the Madonna, or a saint, requesting physical protection against the danger of death from disease, accident, or war. The practice of praying to intercessors is as old as religion itself, as is the making of promises to be kept once a favor has been bestowed. In the Christian tradition, the ex-voto is a visible commemoration of the grace received and a public expression of thanks in physical form. Only rarely in the history of art do we find high-quality ex-votos, that is, refined works of art to which great artists have contributed; typically, the ex-voto is a humble art object, without artistic pretensions or aesthetic purpose. It simply aims to represent an event and to show the presence of a supernatural element, often a vision. In the case of most ex-votos, moreover, we do not know the name of the painter responsible, and the various painted panels display a very uniform typology, a simple "coded" communication.

Name
From the Latin *ex voto suscepto* (from the promise made)

Definition
Remembrance and visible thanks for a grace received

Diffusion in art
Found in various forms throughout the history of art, but the standard form is that of a painted wooden panel

◀ Ex-Voto, *The Noble Paolo Antonio Restored to Health*, 1671. Vicenza, Santuario di Monte Berico.

Ex-Voto

The Virgin with the Child appears on a cloud, in an attitude of blessing. The painting of the vision is a sign that God has in fact interceded.

This ex-voto is typical in that it was executed by a nameless artist, of more popular than masterful skill. The dark-haired man in profile is Ludovico il Moro, duke of Milan.

A typical feature of the ex-voto communication code is that the person is represented in an attitude of prayer, usually while seeking the grace concerned. Ludovico is shown here ill in bed.

▲ Lombard Master, *The Virgin Appearing to Ludovico il Moro*, late 15th century. Milan, Museo Poldi Pezzoli.

In the apse vault we see once again the image of the pelican wounding its breast to feed its young. It is related thematically to the scene below of mourning over the dead Christ.

The Sibyl of the Hellespont is shown with a cross because she prophesied the Passion and Crucifixion of Christ.

The figure of Moses holding the tablets of the law stands on a lion's-head plinth.

The inscription indicates that Titian did not finish this painting (he died in 1576) and that it was completed by Jacopo Palma il Giovane "with reverence."

As in most images of the mourning over the dead Christ, Mary Magdalene is also present. Here her weeping is accompanied by grand theatrical gestures.

The artist places himself on his knees at the feet of Christ. In this last self-portrait, he is pictured stripped of all his possessions.

Leaning against the lion's-head plinth is the artist's small ex-voto. Titian kneels before the Virgin, who appears to him with the dead Christ on her lap, and thanks her for saving him from the plague. Ironically, the disease would soon kill both the artist and his son Orazio.

▲ Titian, *Pietà*, ca. 1576. Venice, Gallerie dell'Accademia.

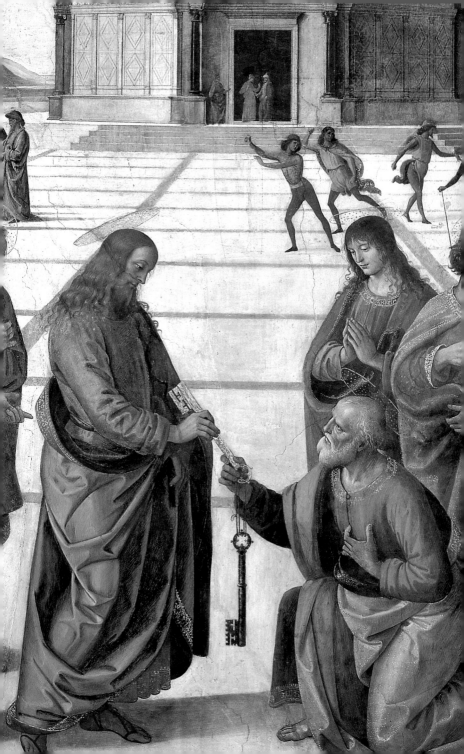

EPISODES IN THE HISTORY OF THE WESTERN CHURCH

Persecution

Iconoclasm

The Church and Temporal Power

Councils

Crusades

Pilgrimages

The Avignon Exile

Public Preaching

The Vatican Basilica

The Inquisition

Spreading the Gospel

The Protestant Reformation

The English Reformation

The Counter-Reformation

The Wars of Religion

The Battle of Lepanto

Witch Trials

The Trial of Galileo

Jansenism

◀ Perugino, *Saint Peter Receiving the Keys* (detail), 1482. Vatican City, Sistine Chapel.

Images of Christians in the circus among wild beasts are later re-creations of events, painted to honor the lives of saints or, during the 19th-century historical revival, to illustrate stories.

Persecution

When
From the 1st to the 4th century

Where
At Rome and in the Middle East

Leading figures
The persecuting Roman emperors and the Christian martyrs

Sources
Acts of the Apostles, *Acta martyrum*, Tacitus, Suetonius, Pliny, Tertullian, Lactantius

Diffusion in art
Not common until pictures of the lives of saints appeared in the Middle Ages. Enjoyed a revival in the 19th century at the time of the historical revival

Influence on art
Persecution delayed the development of any autonomous iconography that was not purely allegorical

According to the Acts of the Apostles, the first Christians soon experienced persecution at the hands of the Jewish community (the martyrdom of Stephen; the imprisonment and subsequent martyrdom of Peter and Paul). But the chief oppressor of the nascent Christian Church was the Roman Empire, which adopted different attitudes toward the Christians depending on the dynasty or emperor in power. The first great persecution occurred under Nero in the year 64, after the fire in Rome; he blamed the Christians for the fire, and hostility toward them intensified. After Nero's death, the Flavian dynasty allowed a period of tolerance, but the Christians experienced no peace until Emperor Constantine granted them freedom of worship by means of the Edict of Milan (313). Until then they experienced alternating periods of tolerance and persecution. There was a brief period of harassment under Domitian in the year 95, and they were later persecuted by Trajan and then Marcus Aurelius (161–178). After Commodus, who was fairly tolerant, the last persecutions took place under Decius, Valerian, and Diocletian (284–305).

▶ Jean-Louis Gérome, *The Christian Martyrs' Last Prayer*, 1875–85. Baltimore, Walters Art Museum.

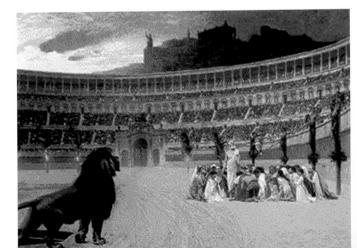

Symphorian's mother was herself a Christian and witnessed the martyrdom of her son. As she sees him passing below the walls of their town, Autun, she shouts words of encouragement.

It was the Roman governor Heraclius who had Symphorian condemned for deriding celebrations in honor of the goddess Cybele.

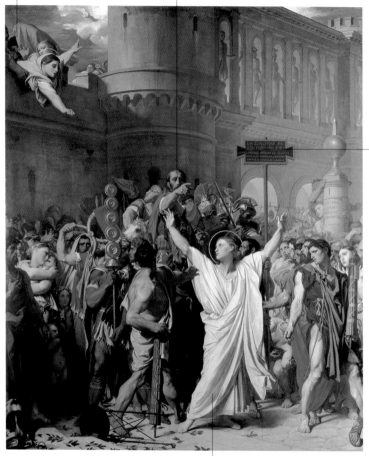

Emperor Diocletian's decree of persecution is referred to on a sign carried by the soldiers.

▲ Jean-Auguste-Dominique Ingres, *The Martyrdom of Saint Symphorian*, 1834. Autun, cathedral of Saint-Lazare.

In this Romantic interpretation by Ingres, young Symphorian pauses beneath the walls of his home town on his way to martyrdom to give one last courageous greeting to his fellow townspeople.

According to medieval texts—
in particular those gathered in
Jacobus de Voragine's Golden
Legend—Saint Catherine's chief
dispute was with civil authorities,
who were subsequently responsible
for her torture and martyrdom.
She also had a dispute with the
emperor Maxentius, whom she
refused to marry because she was a
Christian and a bride of Christ.

The story that Catherine
of Alexandria was of
royal blood is merely
legend, but in art she is
traditionally represented
as a princess wearing
a crown.

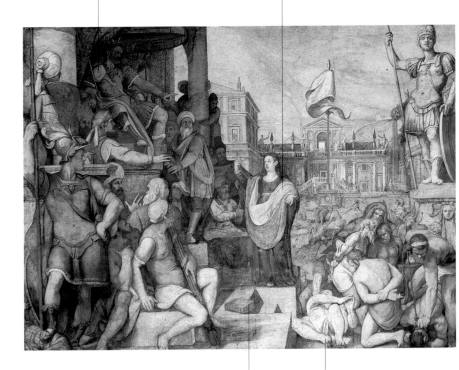

▲ Federico Zuccaro, *Saint Catherine
Disputing before the Emperor*, late
16th–early 17th century. Rome, Santa
Caterina dei Funari.

The book on the
ground refers to a test
Catherine had to
undergo: she had to
defend the Christian
faith against fifty of
the wisest men in the
country. She spoke so
well that they were
confounded.

The men who are bound
are scholars, orators, and
philosophers. They
acknowledged the inspira-
tion of God in Catherine's
words, and when they con-
fessed this to the emperor,
they too were martyred:
slaughtered and burned in
the city square.

Images of sacred subjects that have been obliterated, defaced, or disfigured become subjects of art themselves. Rarely, we see scenes of sacred images being destroyed.

Iconoclasm

As the Christian religion spread, places for worship were built, and rites and liturgies defined, so Christian theologians soon had to deal with the problem of representing the divine and events from the Old and New Testaments. Initially, Christian art was aniconic, having inherited this principle from Jewish thought, which followed the Mosaic commandment prohibiting the making of graven images. After an early period of adjustment, it was deemed acceptable to make images representing the fundamentals of the faith, because of their didactic power. The first great crisis occurred in the 8th and 9th centuries. Byzantine emperor Leo III ordered the removal of all images because their veneration was held to be idolatrous. John of Damascus was firmly opposed to this, but it was a long time before the conflict could be resolved: it took two councils and 150 years before the right to represent Christ, the Virgin, and the saints was reestablished, and by that time there had been large-scale destruction of images in the East. Much later, after the Protestant Reformation, the issue reemerged. This time it lasted for a shorter period, but the destructive violence was equally great, especially in Calvinist areas and in England.

When
In the 8th and 9th centuries; also around the Protestant Reformation (1524–25), the Calvinist Reformation (1559), and the English Reformation

Where
The first crisis affected the whole Christian Roman Empire; the second affected areas that embraced the Protestant Reformation

Leading figures
Emperor Leo III; John of Damascus; Pope Stephen III; the Eastern empress Irene; Calvin; Edward VI

Influence on art
Works from the early centuries were lost, and closely defined iconographies were imposed in the East. Pre-Reformation works were lost in iconoclastic areas, and religious art production largely ceased in Protestant countries

◄ *The Holy Face* disfigured by iconoclasts, in *The Ladder of Divine Ascent* by John Climacus, ca. 1100. Vatican City, Biblioteca Apostolica Vaticana.

Christ in agony is further humiliated by being offered a sponge soaked in vinegar to quench his thirst.

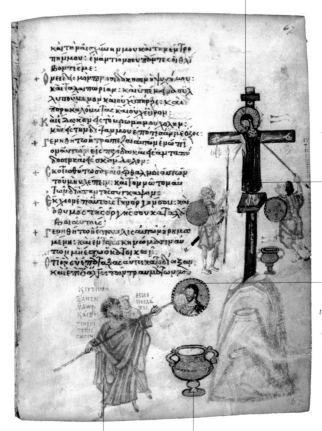

Christ on the cross is dressed in a priest's robe, as was usual in art from the 4th to about the 9th century.

This image of Christ's face in a tondo reflects the widespread cult of the Holy Face from the earliest centuries.

The jar of paint used to obliterate images is very similar to the jar, higher up on the same page, from which the soldiers take the vinegar for Jesus. It is no coincidence that the two images are related through this gesture of humiliating Jesus. This was the view taken by Nicephorus and Saint Theodore.

▲ *Iconoclasm and Crucifixion*, Chludov Psalter, 9th century. Moscow, Museum of History.

Two iconoclasts are busy obliterating images of Christ.

There is still a triptych on the altar, with a rudimentary representation of the Crucifixion in the central panel.

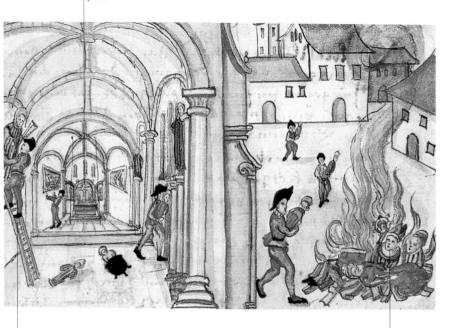

Frenzied iconoclasm preceded the arrival of Calvin in Zurich. Although he condemned religious images, he disapproved of the way in which images were being dismantled and destroyed without consulting the local authority.

The anonymous artist who documented the destruction of these statues presents the event almost like a chronicle. Among the burning statues we can see that of a bishop saint.

▲ *The Destruction of Idols at Zurich*, 16th century. Zurich, Zentralbibliothek.

Specific scenes in the history of art illustrate encounters and clashes between popes and bishops as representatives of the Church on the one hand and kings and emperors on the other.

The Church and Temporal Power

When
From the 8th century to 1849

Where
The Papal States

Leading figures
Popes, kings, and emperors

Diffusion in art
Found in every period of the history of art

Influence on art
The development of iconographic types designed to exalt and justify the temporal power of the papacy

We can follow the developing relationship between the Church and temporal powers at least from the time of the Donation of Sutri (728) to the fall of Porta Pia (1870). It is interwoven with many political episodes that are often far removed from the essence of the Church as founded by Christ; blame for these events can be ascribed to both sides. The history of art has preserved only a few moments in the history of this largely unedifying power struggle, but for various reasons, including a desire to commemorate miracles or events in the lives of saints, it is possible to find pictorial evidence of the clash between the Church and temporal powers. One example is the painting of Pope Leo the Great's meeting with Attila, which Leo X commissioned from Raphael. One also finds representations of Saint Ambrose using his authority to impose a public penance on Emperor Theodosius after the Massacre of Thessalonica. Paintings were produced to celebrate the apocryphal Donation of Constantine to Pope Sylvester, as well as various coronations at which the pope's presence put a seal on the authority of the emperor.

▶ Raphael, *The Meeting between Leo the Great and Attila*, 1513. Vatican City, Palazzi Vaticani, Stanza di Eliodoro.

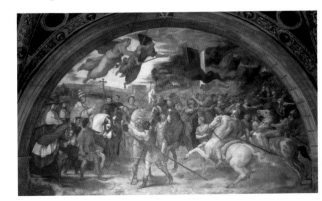

For his blessing of Constantine's donation, the pope is wearing a miter of the earliest type with two points at the front.

The processional umbrella forms part of the insignia given by the emperor to the pope as a sign of the latter's right to exercise temporal power.

The imperial crown is held by a court dignitary.

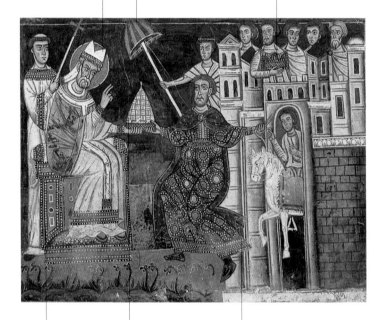

Pope Sylvester is sitting on a royal throne to provide visual confirmation of his supremacy over the emperor.

The tiara given to the pope as a sign of papal dignity derives historically from Byzantine royal dress. In later scenes from the same fresco cycle the pope is seen wearing it.

Constantine approaches the pope in an attitude of deference and submission. His head is bare and he kneels.

▲ *Scenes from the Life of Constantine: The Donation of the Insignia to the Pope*, 1246–48. Rome, Basilica dei Santi Coronati, Oratorio di San Silvestro.

Above the pope's throne is a baldachin with the papal insignia, to give him even greater prestige.

An early mosaic of Christ enthroned with saints has been painted in the apse vault.

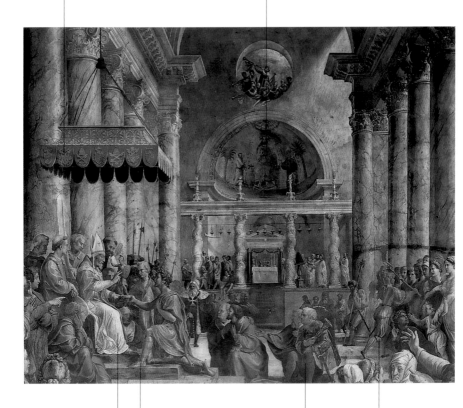

Pope Sylvester is shown in liturgical robes, complete with pallium and papal insignia. The prestige of his pontifical office is thus on full display, and he sits on his throne to receive and bless Constantine's donation.

The emperor Constantine kneels at the pope's feet, and he wears a laurel crown, the symbol of his imperial dignity. According to a forged document created in France in the 8th or 9th century, Constantine was converted to Christianity and baptized after being cured of disease by the pope. Consequently he granted the pope the right to exercise imperial power.

The emperor's court dignitaries follow him and join in the homage to the pope.

The Swiss guards are an anachronistic feature, because they were founded much later (1503). They are keeping order in the church and keeping curious bystanders at bay.

▲ Giulio Romano, *The Donation of Constantine*, 1523–24. Vatican City, Palazzi Vaticani, Sala di Costantino.

Bishop Ambrose sits on his throne and receives Theodosius with paternal condescension, having imposed public penance on him after the serious affair of the Massacre of Thessalonica.

The penitential attitude adopted by Theodosius as he kneels at the bishop's feet indicates that he accepts the bishop's authority. This painting was commissioned by Cardinal Federico Borromeo of Milan, and its subject matter is a deliberate commentary on a dispute between Borromeo himself and the Spanish governor Juan de Velasco about the governor's place in church.

The imperial insignia—the symbols of imperial power—have been laid at the bishop's feet in recognition of the latter's superior authority.

The emperor's public penance is watched not only by the clergy but also by the Milanese people.

▲ Federico Barocci, *Saint Ambrose Pardoning Theodosius*, 1603. Milan, cathedral.

The Church and Temporal Power

Theodosius is dressed as a soldier and wears a laurel crown as a sign of his imperial rank. He makes a slight bow and raises his hand toward his chest as a sign of repentance.

Bishop Ambrose stops the emperor outside the church with a firm gesture.

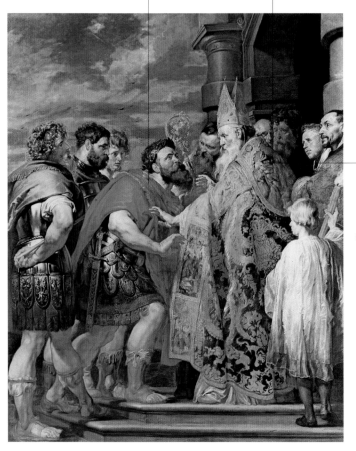

The hood on the bishop's rich cope is decorated with a scene showing Christ appearing and being acknowledged—perhaps as a suggestion that even the emperor needs to acknowledge spiritual authority.

▲ Anthony van Dyck, *Saint Ambrose and Theodosius*, 1618–19. Vienna, Kunsthistorisches Museum.

On the side of the pulpit facing the imperial banners, one can clearly see the papal insignia of crossed keys surmounted by the tiara.

The double-headed eagle of the Habsburg imperial house stands out among the banners brought into church.

Clement VII is wearing the tiara as a sign of papal dignity. Having previously opposed the emperor and suffered the Sack of Rome, he is now crowning him at Bologna in late 1529.

Charles V holds the orb and scepter as signs of his power. He kneels to receive the crown from the pope's hands.

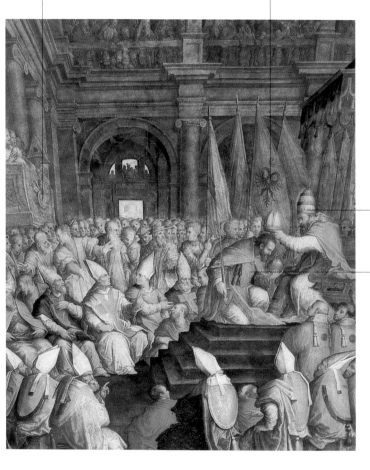

▲ Giorgio Vasari, *Charles V Crowned by Pope Clement VII*, ca. 1560. Florence, Palazzo Vecchio.

Napoleon holds the crown with which he will proclaim Josephine de Beauharnais empress, having with his newly acquired authority already crowned himself.

The new emperor revived the crown of the ancient emperors and by crowning himself was declaring his own independence and autonomy relative to the Church.

Pope Pius VII has come to Paris for the specific purpose of presiding over the ceremony, but he serves no useful purpose, for Napoleon had taken the crown from his hands and placed it on his own head.

The solemnity of the occasion is indicated by the seven candlesticks on the altar, the number prescribed for a pontifical Mass.

▲ Jacques-Louis David, *Napoleon Crowning Josephine at His Coronation Ceremony*, 1805–7. Paris, Louvre Museum.

Gatherings of prelates, bishops, and cardinals for discussions in the presence of the pope, and sometimes even the emperor, these meetings were often held at holy places.

Councils

A council is a gathering of bishops to decide on theological and doctrinal matters. The first general or ecumenical council was held at Nicea (325), during the reign of Pope Sylvester. It was the first to be convened by an emperor, Constantine, who was referred to as "bishop of those outside" and took part in doctrinal discussions. Although councils were often convened to combat nascent heresies and were therefore primarily concerned with doctrinal matters, they also dealt with political affairs. Such was the case with the First Council of Lyon (1245), presided over by Innocent IV, which condemned Emperor Frederick II and summoned a crusade, whereas others attempted to repair schisms. The Second Council of Lyon (1274), presided over by Gregory X, and the Council of Florence, presided over by Eugenius IV and brought to a conclusion in 1442, aimed to heal the schism between the Latin and Greek Churches. The Council of Constance (1614–18) put an end to the Western schism with the election of Pope Martin V.

◀ Eugenio Pellini, *The Council*, ca. 1965–70. Bologna, Lercaro collection.

When
From 325 (the first ecumenical council) to 1965

Where
In various cities, from which they took their names. The most recent councils have been held in the Vatican

Leading figures
Popes and emperors

Diffusion in art
In historical art and art intended to provide a record

Influence on art
In a few cases, councils decided to regulate art and decide how it was to represent the divine

The carriages approaching Nicea, which is not far from Constantinople, were put at the disposal of the bishops attending the council by the emperor Constantine, free of charge.

The image of the Father identifying the Son by grasping his wrist is effectively a declaration of the Nicene Symbol of the consubstantiality of Father and Son.

Three hundred and eighteen bishops attended the conference—a biblical number, since Abraham had three hundred and eighteen servants.

The bishop being force-marched into the council building may be one of those who supported Arius from the beginning. The teachings of Arius were to be condemned at the council.

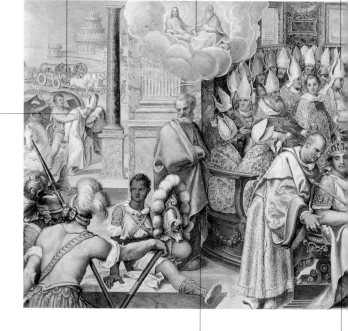

Saint Peter, accompanied by Saint Paul, is a witness at the council because he is a model of faith in Christ.

It was the emperor Constantine who, as co-bishop, convened the council in the summer of 325.

▲ Cesare Nebbia, *The Council of Nicea,* second half of the 16th century. Vatican City, Biblioteca Apostolica Vaticana.

Sylvester was pope at the time of the Council of Nicea but could not attend because of his advanced age. The chairman and mediator of the council was in fact Osius of Cordoba, one of Constantine's advisers.

The young deacon reading the council document may be Athanasius, who was present at the council as secretary to the bishop of Alexandria and was one of the chief supporters of the Nicene Symbol.

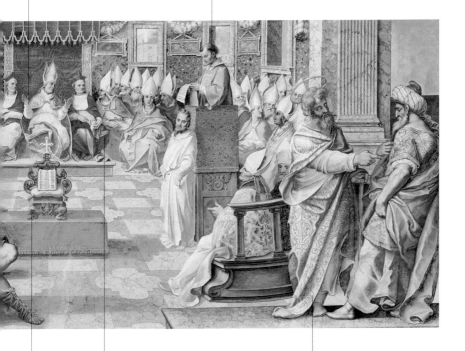

The Word is symbolically enthroned at the center of the council hall.

The two papal legates, Vitus and Vicentius, are sitting on either side of the chairman. Although wearing red, they are not cardinals.

Saint Paul is talking to a man in Eastern dress, perhaps a philosopher, for models and categories from Greek philosophy were used during the council.

From the Middle Ages to the 16th century, the most frequent scenes are of preaching a crusade or soldiers embarking. In the Romantic period there are also battle scenes.

Crusades

When
Two centuries, from the First Crusade (1095–99) to the Eighth (1270)

Where
The Holy Land

Leading figures
Popes, preachers, emperors, noblemen, and the disinherited, against the Muslims

Diffusion in art
Contemporary images are very rare. The 19th-century Romantic Revival took an interest in the subject

Sources contemporary with the events that are now commonly called "the crusades" never used that term. For Christians, these expeditions were pilgrimages, armed expeditions, or sea crossings called *passagia* or *passagia generalia* in Latin when they were invoked by a papal bull. They affected the whole of Western Christendom, but it is probable that the Arab side did not grasp the immense significance that Christians attached to these forays and took them to be incursions by the Franks. There were in fact more than the eight crusades normally identified by historians, if we add other penitential mass movements, such as the Children's Crusade, which often had tragic outcomes. The term *crusade* derives from the fact that, from the very first expedition launched by Pope Urban II, a soldier had to wear a cloth cross sewn to his tunic or cloak as a sign of the link between the military expedition and the Christian pilgrimage tradition. As an armed pilgrimage aiming to free the holy sites, a crusade was an adventure that admirably suited the medieval mentality of the soldier of Christ, who saw himself almost on a level with the martyrs and regarded death in battle as a guarantee of eternal reward.

► Master of Saint John of Capistrano, *Saint John Capistrano Preaching against the Turks* (detail), ca. 1465. L'Aquila, Museo Nazionale.

Peter the Hermit was a religious from Flanders who, according to legend, traveled over half of Europe preaching the crusade called by Pope Urban II.

A man proudly displays the cross sewn on his shirt.

A motley crowd of volunteers of all ages has gathered behind Peter as he preaches, all bent on setting off for Constantinople with him.

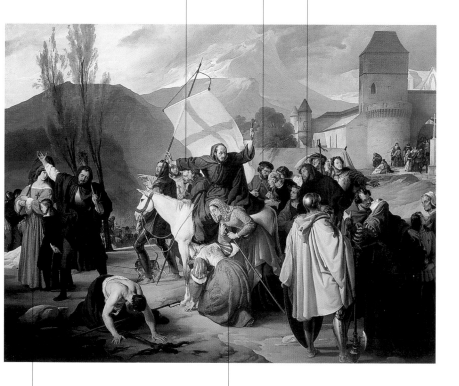

A woman with a cross sewn on her dress and a bundle slung over her shoulder comes forward with her young son and husband, who is armed with a cudgel.

One woman feels this preaching friar deserves the tribute appropriate to persons of the highest rank, and so she kneels to kiss his foot.

▲ Francesco Hayez, *Peter the Hermit, on a White Mule with a Crucifix in His Hand, Rides through Towns and Villages Preaching the Crusade*, 1827–29. Milan, private collection.

Pilgrims wear special costumes—short cloaks, broad-brimmed hats, and walking sticks. They are shown making their way along isolated roads or at churches and shrines.

Pilgrimages

When
Throughout the history of the Church, with periods of particular intensity in the Middle Ages

Where
Rome, Jerusalem, Saint Catherine's in Sinai, Santiago de Compostela, Monte Sant'Angelo, Cologne, Le Puy, Rocamadour, Canterbury

Leading figures
The pilgrims

Sources
Travel diaries

Diffusion in art
Dotted along the pilgrim routes are signs and symbols used as route finders and expressions of welcome. Proper works of art about pilgrimages and the welcoming of pilgrims are less widespread

The custom of visiting the tomb of a martyr saint on his *dies natalis* led to pilgrimages as a devotional practice. Such visits often constituted a substantial journey. The pilgrim spirit increased dramatically toward the end of the first millennium, when a new spiritual fervor arose. For Europeans in the late Middle Ages, the chief pilgrimage destinations were Jerusalem and the places of Christ's Passion, Rome and the tomb of Saint Peter, and Santiago de Compostela for the tomb of Saint James. In addition, Christian pilgrims flocked in large numbers to other shrines that were erected along the routes to the places mentioned above: Mont Saint-Michel in Normandy, Monte Sant'Angelo on Monte Gargano in southern Italy, and later Cologne in northern Germany, where the presumed remains of the three Magi were venerated. A pilgrimage was a long, expensive, and demanding undertaking. Pilgrims might be driven to set off by piety, but also perhaps as a penance given by a confessor or a penalty imposed by a judge. Wayfarers traveled in groups as a protection against brigands, and the rich sometimes paid others to go on pilgrimages in their place. Pilgrimages encouraged the spread of art motifs and styles along the pilgrim routes.

▶ *The Blessing of Pilgrims' Wallets and Staffs*, late 15th century. Lyon, Bibliothèque Municipale.

The halo allows us to identify the pilgrim walking ahead of the boy as Saint James, the guide and helper of devotees on their way to Santiago de Compostela.

The staff is one of the typical attributes of the pilgrim.

The broad-brimmed hat served as protection from sun or rain. Otherwise it was carried on the pilgrim's back.

The young traveler is dressed exactly like his companion, Saint James. He wears a long, wide-sleeved gown of a kind that changed shape over the years until it became a sort of cape.

The pilgrim's only luggage is the wallet, or scrip, carried over his shoulder, as he can rely on hospitales *built along the way for hospitality and charity.*

▲ Nicola di Lira, *Saint James Guiding a Young Pilgrim,* 15th century. Vatican City, Biblioteca Apostolica Vaticana.

This pilgrim's badge—the face of Christ on Veronica's veil—tells us that he has completed a pilgrimage to Rome. After the Jubilee year of 1300, this badge replaced the numerous others with pictures of Saint Peter and Saint Paul.

A badge with a picture of Saint James the Pilgrim showed that he has also completed a pilgrimage to Santiago de Compostela. The most typical badge for this pilgrimage was one shaped like a seashell.

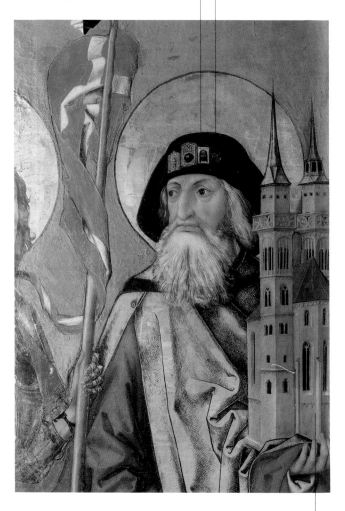

The two tall towers of the model carried by Saint Sebaldus characterize the church in Nuremberg dedicated to him.

▲ *Saint Sebaldus Dressed as a Pilgrim* (detail), 1487. Nuremberg, Germanisches Nationalmuseum.

Welcoming pilgrims was considered a meritorious occupation.

The church facade was modified more than once up to the 18th century. In this reconstruction we see a relief of the Crucifixion.

A pilgrim sits resting in the shade of the church apse. This is the Church of the Holy Cross in Jerusalem, one of the seven Roman Catholic churches visited by pilgrims since the 16th century.

The pilgrim approaching to ask for information has a rosary in his hand.

Sewn on this pilgrim's shoulder are crossed keys, indicating that he has been on a pilgrimage to Rome.

In front of the church entrance was an atrium often used by pilgrims for shelter or refuge, or simply as a place to pause and rest.

▲ Hans Burgkmair the Elder, *Pilgrims outside the Church of the Holy Cross in Jerusalem*, 1505. Munich, Bayerische Staatsgemäldesammlung.

The most frequently depicted scenes are of the return to Rome from Avignon. In some cases the pope is shown listening to the advice of saints.

The Avignon Exile

When
1309–1377

Where
Avignon

Leading figures
Philip IV of France, known as Philip the Fair; Popes Clement V, John XXII, Benedict XII, Clement VI, Innocent VI, Urban V, Gregory XI, Saint Bridget of Sweden, and Saint Catherine of Siena

Diffusion in art
Apart from the construction and decoration of the Palace of the Popes, there are a few rare works in the history of art illustrating episodes connected with the resolution of the Avignon problem

The early 14th century was a nadir in the history of the Church as the papacy permanently lost its political autonomy and became subservient to the king of France. At the close of the 13th century, Boniface VIII had vigorously opposed the pretensions of Philip the Fair, but his successor, Clement V, proved incapable of putting up a spirited opposition. He was elected at Perugia and began his reign by journeying to Avignon in Provence, outside French territory but within that of the Angevins of Naples. He had intended to return to Rome, but he now found himself complicit in the ambitions of Philip the Fair. His pro-French policies included elections to the College of Cardinals that gave it a French majority, and the massacre of the Templars. For seventy years, Rome remained without a pope and fell into a decline that only the energetic action of Cardinal Albornoz managed partially to stem. It was the last two popes in exile (the Italians called it "captivity" because the Roman curia was so submissive) who managed to effect a permanent return to Rome, thanks in part to Saints Bridget of Sweden and Catherine of Siena.

▶ Giovanni di Paolo, *Saint Catherine before the Pope at Avignon*, 1460–65. Madrid, Thyssen-Bornemisza Collection.

As was customary at the time, the pope is protected from sun and rain by a processional umbrella, which accompanies him whenever he is in the open air.

The whole papal court is leaving Avignon for good and returning to Rome. The pope is joined on his journey by numerous cardinals, who can be identified by their big red hats.

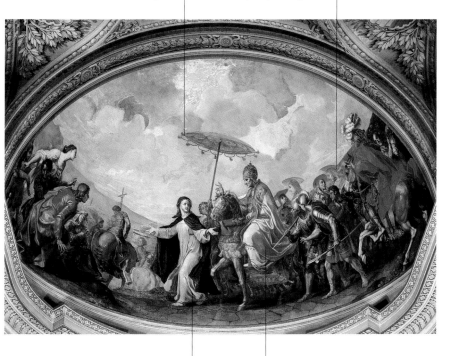

Saint Catherine leads the papal procession on foot as it returns to Rome. In this way the importance of her contribution is acknowledged, because it was her decisive behavior that brought the Avignon exile to an end.

Pope Gregory XI blesses the crowds as he passes by on horseback wearing papal robes and his tiara. He reached Rome in January 1377 and chose the Vatican as the papal residence.

▲ Laurent Pécheux, *Saint Catherine Brings the Pope back to Rome*, 1770. Rome, Santa Caterina da Siena.

We see large crowds, sometimes divided by social class, gathered in town squares, which can be identified by the facades of cathedrals and town halls. They listen intently to a preacher.

Public Preaching

When
15th century

Where
Throughout Europe

Leading figures
Bernardino of Siena,
Vincent Ferrer, Fra
Girolamo Savonarola, Fra
Riccardo, Fra Brugman,
and Fra Merton

Diffusion in art
Scenes of preaching in the
lives of saints

The practice of preaching to the people in town squares became widespread in the 15th century. Preaching had been considered a key instrument for Christian teaching since the time of Saints Francis and Dominic, but it was after their time that the practice was perfected. The social and political situation in Europe was typically one of divisions and conflicts but also of general affluence. This fostered corrupt morals among both rich and poor, leading to violence, usury, gambling, corruption, superstition, and other vices. From among the mendicant orders there emerged some outstanding preachers who drew large crowds as they traveled from town to town. They were often accompanied by confessors who administered the sacrament of penitence, and sometimes by notaries to draw up deeds of reconciliation between feuding families or help penitents set up charitable foundations or make donations. Bernardino of Siena, a Franciscan friar, traveled up and down Italy without respite, denouncing the ills of society, encouraging faith, and preaching piety in the name of Jesus. Important preaching work was also done in France and Spain by Vincent Ferrer, a Dominican who made great efforts to convert Cathar and Waldensian heretics.

▶ Master of Saint John of Capistrano, *Saint John Capistrano and Scenes from His Life: Saint John Capistrano Preaching* (detail), ca. 1465. L'Aquila, Museo Nazionale.

A small altar has been set up at the back of the square, behind the preacher's pulpit. On it is an altarpiece depicting the Madonna and Child with saints.

Saint Bernardino is wearing the dark Franciscan habit and his face appears worn. As he tirelessly preaches the Christian faith, he holds up a monogram of Jesus' name (IHS).

Even the gentry of Siena, segregated on a lavish platform, find themselves down on their knees listening to exhortations to change their ways.

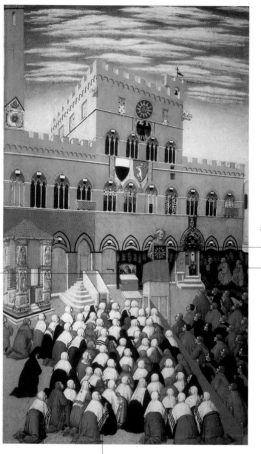

▲ Sano di Pietro, *Saint Bernardino Preaching in Piazza del Campo,* ca. 1445. Siena, cathedral.

There are both men and women in the large crowd listening to Bernardino. To show how effective his words are, the artist shows all the faithful down on their knees.

The most common scenes are those showing the model for the new building being presented to the pope. Building work in progress is rarely depicted.

The Vatican Basilica

When
From the 15th to the 17th century

Where
Vatican City

Leading figures
Pope Nicholas V, Julius II, Leo X, and Urban VIII; Bramante, Raphael, Giuliano da Sangallo, and Michelangelo

Diffusion in art
To extol the papacy and the greatness of Rome

When the popes finally returned to Rome from their exile in Avignon, the Vatican was chosen as the papal residence instead of the Lateran. But it was only in the mid-15th century, under Pope Nicholas V, that work began on rebuilding the Vatican basilica. The reconstruction of the ancient basilica of Saint Peter recommenced in 1452 in the apse area, and the original paleo-Christian building was abandoned. Later popes expanded the papal residence by founding the library and building the Sistine Chapel, but work on the basilica itself stalled until the election of Pope Julius II, who decided to rebuild the whole church in a modern idiom. Donato Bramante was put in charge of the project. In 1506 he demolished all previous work, pursuing a plan for an enormous basilica in the form of a Greek cross. But after the death of both Bramante and Julius II, a different plan was approved, and responsibility was given to Raphael and Giuliano da Sangallo. Pope Leo X approved plans for a new basilica with the form of a Latin cross. Further debate ensued after Raphael's death (1520).

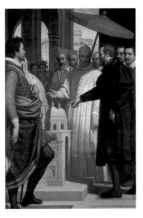

Giuliano da Sangallo became director of works, with Peruzzi as his assistant, and he preferred a central plan. The commission subsequently passed to Michelangelo when Sangallo died in 1546, and the project now reverted to a Greek cross, with a dome and three apses. But this plan too was never brought to completion. Instead, building went ahead with various modifications (the last of these being designed by Bernini) until the church was finally consecrated by Pope Urban VIII in 1626.

► Domenico Cresti (Domenico Passignano), *Michelangelo Presenting a Model of the Dome of Saint Peter's*, 1619. Florence, Casa Buonarroti.

Artists recorded trials with monks or friars among the judges and punishment fires or instruments of torture nearby. In Spanish Inquisition scenes, the victims wear conical hats.

The Inquisition

One reaction to the spread of heresies and social and political instability in the Middle Ages was the creation of the Inquisition. Its stated purpose was defeating heresy, principally through preaching. It got its name when Pope Lucius III gave instructions that all bishops must carry out an *inquisizione* (inquiry) in their diocese twice a year to seek out heretics. Subsequently, Pope Innocent III invited the Cistercians to preach to the heretics and dispute with them in public. Finally, Pope Gregory IX's constitution *Excommunicamus* appointed the first permanent inquisitors. The Inquisition subsided around the 15th century, but it was revived in the 16th because of new disturbances leading to the Protestant Reformation. To counter this threat, Pope Paul III reorganized the medieval system by creating the Holy Office; the latter was reformed in recent times, and Pope Paul VI transformed it into the Congregation for the Doctrine of the Faith. The Spanish Inquisition, by contrast, was created by the Catholic Kings in 1481 in order to persecute dissidents and non-Christians at Seville. Its intense activities gradually declined in the 17th and 18th centuries, and it was permanently abolished in 1834.

When
During the Middle Ages, with revivals in the 15th and 16th centuries. Brought to an end in the 19th century

Where
Throughout Europe

Leading figures
The inquisitors of the Tribunal of the Holy Office

Diffusion in art
Scenes of the Inquisition in art mostly relate either to the medieval period anywhere in Europe or to Spain from the 15th to the 19th century

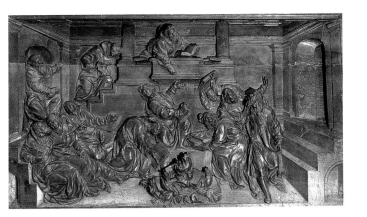

◀ Juan de Juni, *The Judgment of a Heretical Monk*, also known as *Punishment Fire* or *The Examination of Heretical Books*, ca. 1540. León, Museo de León.

The Inquisition

Verdicts regarding those accused of heresy are read out in public in the presence of the authorities and people of Valladolid.

The defendants are made to sit on a raised platform. Either their absolution, after an act of faith, or their punishment is publicly confirmed.

Those convicted of heresy have been taken out to a place near the Puerta del Campo, seen at the back of this complex composition, and are being burned in a tremendous fire.

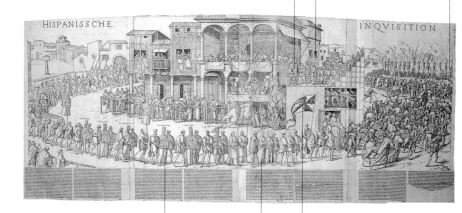

The procession of the condemned enters the main square of the town. Those who have been convicted of heresy wear the typical conical hat and a scapular on which their sentence—burning at the stake—is painted.

Those who have renounced heresy and made a profession of faith are carrying lighted candles in the second part of the procession.

At the head of the procession is the great banner of the Inquisition.

▲ Unknown German artist, *Auto-da-fé in the Town Square at Valladolid on May 21, 1559*, 1570–1600. Berlin, Staatliche Museen.

Saint Dominic went to Albi to combat heresy. In 1207, his own books and other allegedly heretical books were put to trial by fire.

One of Saint Dominic's books flies up into the air, having been rejected by the fire. This is a sign that the book contains the truths of faith and inspired words.

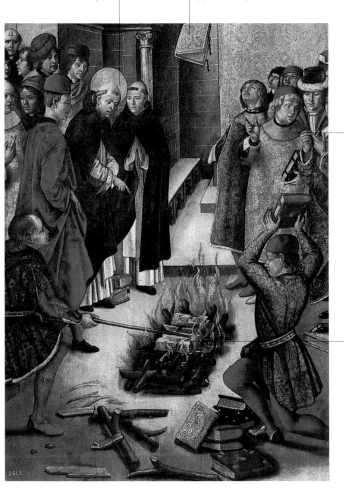

One man, who may be a heretic, is arguing with some degree of authority. The gesture of counting on his fingers conveys the erudition and gravity with which he is speaking.

The fact that the heretical books fail the trial by fire and are destroyed is taken as an indication that their contents are false.

▲ Pedro Berruguete, *The Trial by Fire*, ca. 1480. Madrid, Prado.

At the back of this dark, depressing room is a crucifix between two lighted candles, a symbol of the true foundation of the Christian faith.

The cross with short arms is an instrument of torture. The person on trial was probably suspended from it.

Those accused of heresy who refused to retract were forced to wear conical hats (this one's shape has been exaggerated by the 19th-century artist) and scapulars showing the verdict and sentence against them. Those who retracted had to wear these same items in public as a punishment.

A Dominican friar is reading a passage from a holy book to a condemned man.

▲ Eugenio Lucas Velázquez, *Inquisition Scene*, ca. 1850. Brussels, Musées Royaux des Beaux-Arts.

We see images of friars meeting native peoples, either in peaceful situations such as baptisms or sermons, or in situations of conflict such as martyrdoms or the imposition of rites.

Spreading the Gospel

Strictly speaking, gospel missions began with the apostles' travels. After the spread of Christianity into the lands of the Roman Empire and the granting of freedom of worship, and after the age of the great migrations and the conversion of the "barbarian" peoples of Europe, the desire to spread the faith led friars to go as missionaries into more distant lands. Among the first peoples they encountered in the Middle Ages were the Arabs who had moved into North Africa; some missionaries lost their lives there. When Saint Francis himself went on a journey to the Holy Land, it was certainly his intention to proclaim Christ to the sultan, and he dreamed of offering his life in Christ's cause. Saint Dominic, too, sought, but was refused, permission to go and preach to the Cumans. The mendicant orders founded religious provinces in the Holy Land and, after the Council of Lyons, they also traveled toward East Asia, to which missionary expeditions had already been sent. From Byzantium one could reach central China, as Franciscan missionaries did in the mid-13th century. With the discovery of new lands after the voyages of Columbus, friars set off with the conquistadores. Conquest and spreading the Gospel were not particularly compatible, though the conquistadores often took it upon themselves to spread the faith in order to justify dreadful massacres. Fra Bartolomé de las Casas and others condemned these excesses, but their opposition was ignored for economic reasons.

When
From the 13th century

Where
Asia, Africa, and America

Leading figures
Religious orders, natives

Diffusion in art
Rare. Some specific scenes such as disembarkation in the New World, the baptism of natives, or the martyrdom of religious missionaries

Influence on art
Slight, except for the inclusion of certain exotic objects, forms of dress, or animals in standard iconography

◀ Miguel Gonzáles, *Indians Receiving Baptism*, late 17th century. Madrid, Museo de América.

255

Spreading the Gospel

A group of musicians greets the arrival of a cardinal on African soil.

The cardinal is helped out of the boat by a soldier and blesses the waiting people with his right hand.

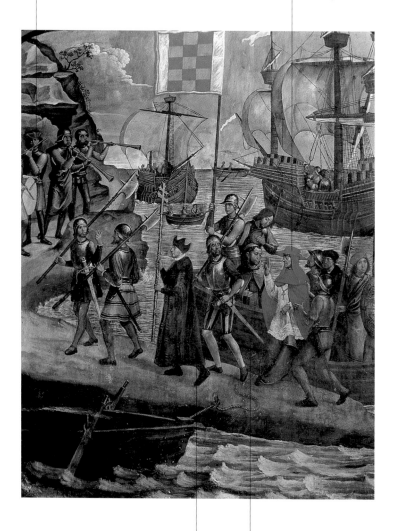

▲ Juan de Borgoña, *Cardinal Cisneros Landing at Oran*, ca. 1514. Toledo, cathedral.

The procession is led by a prelate carrying a cross.

Among the cardinal's entourage on the boat is a Franciscan friar. Since the very beginnings of their order, the Franciscans had been zealous in pursuing missionary work and spreading the Gospel.

The crucified martyrs were pierced through the chest with lances as they praised God and forgave the emperor and their executioners.

The break in the clouds above the martyrs is a typical feature of 17th-century iconography, intended to indicate the presence of the supernatural. According to the account of events at Nagasaki, spheres of light were seen above the heads of the martyrs when they died.

A crowd had gathered on the hill near Nagasaki. The man responsible for the massacre thought this would serve as a warning, but the Christians clung to their faith.

Among the martyrs were three Japanese Jesuit catechists, six Spanish Franciscan missionaries, and seventeen Japanese Franciscan tertiaries. All were suspended from crosses and held with five rings, one for each hand and foot and one for the neck.

▲ Tanzio da Varallo, *The Martyrdom of the Franciscans at Nagasaki*, 1627–32. Milan, Pinacoteca di Brera.

Religious pictures were imbued with particular symbols deriving from Lutheran thought. There were also historical paintings of significant events of the period.

The Protestant Reformation

When
October 31, 1517

Where
Northern Europe

Leading figures
Luther, Karlstadt, Melanchthon, Zwingli, Calvin

Attitude to images
Luther did not condemn images, but most Protestants accepted the iconoclastic ideas of Calvin

Influence on art
At first a form of art as propaganda developed, which was highly critical of the Church of Rome, but it was the iconoclastic movement that gained the upper hand

Evidence from art
Luther himself commissioned some contemporary paintings before the supremacy of iconoclasm

At a time when the political situation in Europe was tense because of competition for the imperial throne (the principal contenders were Charles V of Spain and Francis I of France, with Charles as the eventual winner), there were also signs of great moral and religious instability. Across Europe, the Church of Rome seemed to have lost sight of its role, being controlled by corrupt popes against whom protests had already been lodged at the end of the previous century (Savonarola), and its credibility had been largely squandered. The beginning of the Protestant Reformation is traditionally dated to 1517, when Martin Luther, an Augustinian monk, nailed his ninety-five theses to the door of Wittenberg castle church. For Luther, the argument over the practice of selling indulgences was an opportunity to publicize his doctrine of justification by faith alone, which diffused rapidly through Germany. When Pope Leo X summoned him to Rome to withdraw his theses, Luther's refusal sparked a rebellion. It very quickly led to new forms of religious protest and the birth of churches that were independent of Rome.

▶ Bartholomaeus Bruyn the Elder, *The Temptations of Christ*, 1547. Bonn, Rheinisches Landesmuseum.

In the middle ground a baby is being baptized.

A fat friar is preaching from a pulpit (some identify him as Johann Tetzel). He is being advised by an imp, symbolizing the devil, who is blowing "ideas" into his ear with a bellows.

The procession is intended as a criticism of the cult of saints.

Up in the clouds, the figures of Saint Francis and God the Father appear visibly scandalized at what is going on in the Church of Rome.

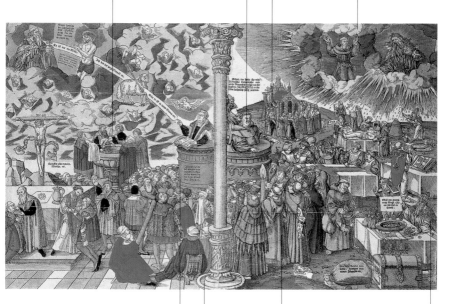

Martin Luther himself is preaching from the pulpit and is inspired by the dove of the Holy Spirit: the words he speaks come from God, via the Son and the sacrificial Lamb.

A column separates two distinct visions of the Christian world. The Lutheran Church, on the left, is favored, while the Church of Rome, on the right, is heavily criticized.

Among those listening to the sermon are two friars. The habit of one has a hood with ass's ears and a fancy fringe at the hem, while the other's hood is overflowing with sealed envelopes—a sign of corruption.

The pope is shown holding an indulgence and counting the money he's made from selling others like it.

▲ Lucas Cranach the Elder, *The Contrast between Catholics and Protestants*, ca. 1545. Berlin, Gemäldegalerie.

A terrified man is being driven toward the fiery depths, pursued by Death and Evil armed with pikes and sticks.

The artist has portrayed himself in a devout attitude with hands together between Luther and Saint John the Baptist. A drop of blood falls on the artist's own head: he feels that, having supported Luther's reformist ideas, he has been touched by grace.

The bronze serpent made by Moses to cure the Jews (Numbers 21:8–9) prefigures the sacrifice of Christ (John 3:14).

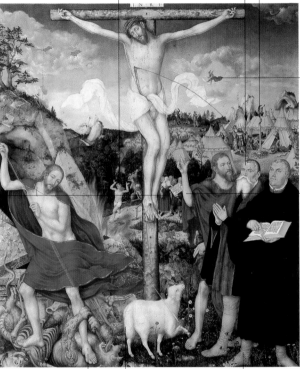

Moses presents the Tablets of the Law, representing the ancient covenant, to Aaron and the Jews.

The angel is bringing news of the birth of Christ the Redeemer to the shepherds.

Saint John is making two gestures: he points to Christ on the cross as the source of salvation and also to his symbol, the mystic lamb.

Behind Jesus is the open sepulcher, for he has risen and is now defeating Death and Evil. The wounds from the nails are visible on the foot that is trampling a skeleton, symbolizing death, and the other crushes a fearsome monster, symbolizing evil, which he is suffocating with the staff of the banner of resurrection.

The mystic lamb at the foot of the cross holds a banner in his hooves bearing, in Latin, the words spoken by John the Baptist when he saw Jesus for the first time: "Here is the Lamb of God, who takes away the sin of the world."

Luther stands at the foot of the cross with a Bible open in his hand. He is pointing to the phrase "In sola scriptura," because it summarizes the Lutheran view that faith is based on scripture and not on tradition and authority, as maintained by the Roman Church.

Martin Luther joins in the meal at the corner of the table, on Jesus' right hand.

The artist was closely associated with the Protestant Reformation. Here he has placed figures of the reformers among the apostles at the Last Supper: close to Jesus and with hands clasped in a pious gesture is Philipp Melanchthon.

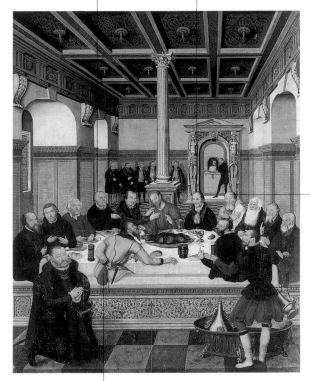

Apart from Jesus and Judas, only one other person in the painting is dressed in ancient garb and probably does not represent a contemporary figure. He may be Saint Peter, on whom Christ founded the Church.

As in almost all paintings of the Last Supper, Judas the traitor is placed apart from the others. Behind his back he is holding the money bag that is his attribute in art, and he is receiving a morsel of food from Jesus before going out to betray him.

◀ Lucas Cranach the Younger, *Redemption*, 1555. Weimar, Evangelische-Lutheranische Kirchgemeinde.

▲ Lucas Cranach the Younger, *The Last Supper*, 1565. Dessau, Schlosskirche.

The only decorative elements in this Protestant church are the text of the Holy Scripture and a few heraldic symbols.

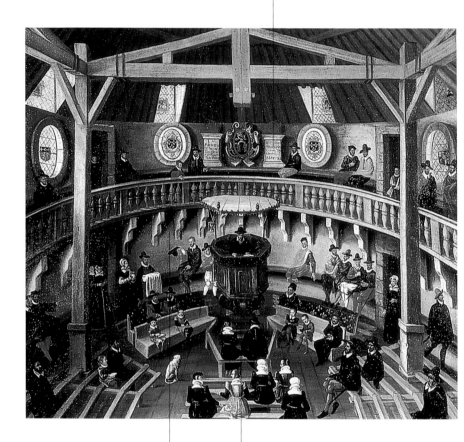

There are no images whatsoever in this Protestant church. In a wave of often violent iconoclasm, fed by a desire to return to apostolic purity, Protestant churches were largely cleared of their figurative images in order to avoid idolatry.

The central position is held not by the altar, as in a Catholic church, but by the pulpit, from which the Word of God is proclaimed.

▲ Unknown artist, *Calvinists Meeting at Lyon*, 1564. Geneva, Bibliothèque Publique et Universitaire.

There is a splendid still life set up on the carpet-covered table. The Bible is there, of course, as well as other texts, and a candelabra nearby bears a single candle. The Mennonite preacher is studying these texts.

Cornelius Claesz. Anslo was a Mennonite preacher, a member of a small Anabaptist reform movement in Holland. His words of explanation accompanied by hand gestures may therefore indicate that he is preparing a sermon.

His wife sits close beside him and listens attentively to his words.

▲ Rembrandt, *The Mennonite Minister Cornelius Claesz. Anslo in Conversation with His Wife, Aaltje,* 1641. Berlin, Gemäldegalerie.

Because it has no specific iconography, the English Reformation can in effect be seen only through images of the Protestants involved in it.

The English Reformation

When
In 1531, the king made Parliament pass the Act of Supremacy, which recognized him as head of the Church in England. In 1534 he was excommunicated, and his reply was total separation of the Churches

Where
England

Leading figures
Henry VIII; Pope Clement VII; Pope Paul III; Mary Tudor; Elizabeth I; Thomas More

Evidence from art
From the time of Edward VI, England followed a Calvinist orientation, and religious images began to disappear, with the exception of the crucifix and the Tablets of the Law

The English Reformation came about for political reasons and was not proclaimed as such. Henry VIII had opposed the spread of Lutheranism and was rewarded by the Roman Church with the title Fidei Defensor (defender of the faith). But matters soon took a different turn. The king had married Catherine of Aragon, thanks to a papal dispensation, but when no male heir resulted, Henry sought to annul the dispensation in order to marry Anne Boleyn. It was a question not just of a marriage annulment but also of political alliances (Catherine was Charles V's aunt). Negotiations were protracted, as scholars across Europe debated the legality of the first marriage. Matters reached crisis point when Henry declared his Act of Supremacy of 1531 and married Anne Boleyn in 1533; the pope

▶ Hans Holbein the Younger, *Henry VIII of England*, 1536–37. Madrid, Thyssen-Bornemisza collection.

responded with excommunication, which received a sharp reply from Henry. The king was very hard on the Catholic clergy and faithful, demanding their loyalty to the crown on pain of trial and execution. A period of bloody repression began that continued into the successive reigns of "Bloody Mary" (a brief period of renewed adherence to Catholicism) and Elizabeth I, who brought about the final separation of the English Church from the Church of Rome.

A splendid processional cross rests against the wall behind the archbishop. He opposed the king's attempt to have his marriage annulled, never accepted separation from the Church of Rome, and remained a Catholic throughout his life.

In painting William Warham's face, the artist displays his usual skill in conveying character through facial features. Warham lived at a very hard time for men of his vocation, but he never betrayed his beliefs.

The only item of episcopal insignia in this portrait is the gilded, gem-encrusted miter behind the sitter.

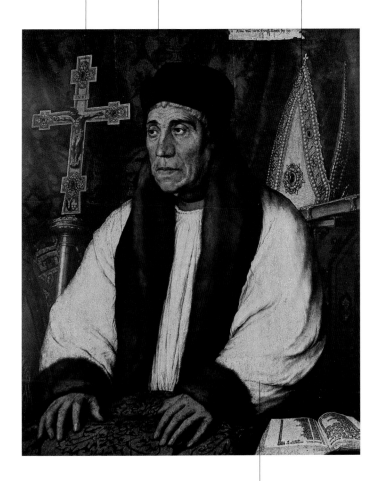

▲ Hans Holbein the Younger, *Portrait of William Warham, Archbishop of Canterbury*, 1527. Paris, Louvre Museum.

The archbishop is portrayed at a moment when he is not involved in the liturgy, so he is simply wearing a stole over his ordinary clothes.

Among the various artistic trends deriving from the Council of Trent, paintings of the council itself are fairly frequent, as well as images of saints regarded as typifying its spirit.

The Counter-Reformation

When
1545–48; 1551–52;
1562–63

Where
Trent

Leading figures
Five popes: Paul III,
Julius III, Marcellus II,
Paul IV, and Pius IV

Evidence in art
Some scenes document
council sessions, and a new
iconography arose to exalt
the Church Triumphant
and the new spirituality

Influence on art
Religious art was discussed
at one session and new
norms were approved by
the Church: guidance was
given for correct and deco-
rous works, for allegorical
works, and for new didac-
tic images that would
involve the spectator
emotionally

From the time of the Lutheran crisis, many had called for a council that would restore unity to the Church. It was delayed due to resistance to change within curia circles because of special interests and privileges, the memory of how ineffective council resolutions had been in the previous century, and the fear that failure to achieve unity might result in fragmentation into national churches that would be subservient to regional politics. Pope Paul III finally convened a council in the city of Trent (Trento). Trent was in the Holy Roman Empire sphere and would therefore be acceptable to the Germans, but it was also an Italian city. The Protestants refused an invitation to attend because the council had been convened by the pope and was chaired by his legates. Because of the continuing wars of supremacy in Europe, the work of the council was protracted and took place in three stages. The first interruption occurred when the council moved to Bologna for political reasons and its work was suspended. Three years later, when it reconvened,

▶ Pasquale Cati, *The Council of Trent*, 1588–89. Rome, Santa Maria in Trastevere, Altemps chapel.

the French bishops absented themselves because of a conflict between Henry II and the pope. Then the Wars of Religion between Charles V and the Protestants flared up again. Some important definitions of doctrine produced by the council opened a new chapter in the history of the Church, known as the Counter-Reformation.

266

Pope Paul III Farnese pays careful attention to this inspiration, which he will indeed follow by convening a general council in the city of Trent.

Faith is represented allegorically as a woman bearing the cross of Christ and holding the chalice of the Eucharist. By means of a vision she is inspiring the pope to convene an ecumenical council.

In this image of a meeting of the council fathers, the Holy Spirit is present in the form of a dove to inspire and lead the council.

One of the arms of the pope's Baroque chair takes the form of a half-naked human figure, reminiscent of the allegorical figure of Heresy.

A council session is seen in a large hanging held up by cherubs.

▲ Sebastiano Ricci, *Paul III Inspired by Faith to Convene the Ecumenical Council*, 1687–88. Piacenza, Museo Civico.

The Counter-Reformation

Pope Paul III solemnly hands the cardinals the order to convene a general council in Trent.

The consecrated host placed on the altar reminds us of the sacrificial nature of the Mass. Sections 13, 21, and 22 formally declare the real presence of Christ in the bread and wine of the Eucharist.

At the beginning of the council, there were few clerics present: about twenty bishops, four archbishops, and five generals of religious orders. The most conspicuous absentees were the Protestants, who had been invited but declined to attend because the council had been convened by the pope and was chaired by his legates.

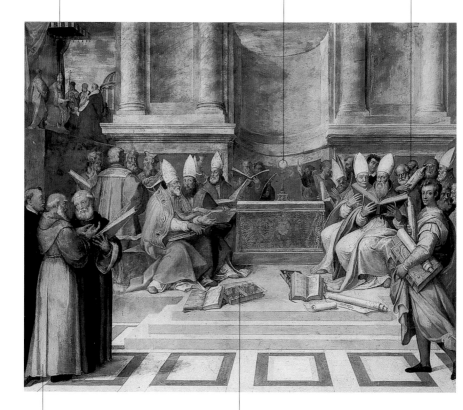

Among these monks and friars we can identify the superiors of three religious orders: a Franciscan, a Dominican, and a Benedictine.

The numerous books being consulted may be a reference to the first session, which declared that the sources of faith were scripture and tradition.

▲ Taddeo Zuccaro, *The Proclamation of the Council of Trent*, 1562–63. Caprarola, Palazzo Farnese, Anticamera del Concilio.

The Virgin and
Child appear to
Saint Philip as he
kneels in prayer at
the altar.

An angel holding a lit
taper is present at the
vision. Lying on the
ground are Philip's
attributes, a miter
and a cardinal's hat.

▲ Giovanni Battista Piazzetta, *The
Virgin Appearing to Saint Philip Neri*,
1725. Venice, Santa Maria della Fava.

*Saint Philip Neri was a great saint and a leading
figure in the period after the Council of Trent.
Together with Saint Charles Borromeo, Saint
Camillus de Lellis, and Saint Ignatius Loyola,
he was strongly of the opinion that the Church
should be reformed from within, by applying
simplicity and rigor. He is shown here as a very
old man; he died at the age of eighty.*

The Counter-Reformation

A disciplinary decree of the Council of Trent had
established that priests and bishops had to reside
where they had been appointed for the care of the
faithful. Consequently, Saint Charles left Rome
and applied himself with zeal to his diocese,
which became an exemplar and guide for the
practical application of council decrees.

One of the cardinal's
secretaries is reading
out the names of the
clerics who have been
summoned to found
colleges in the diocese
of Milan.

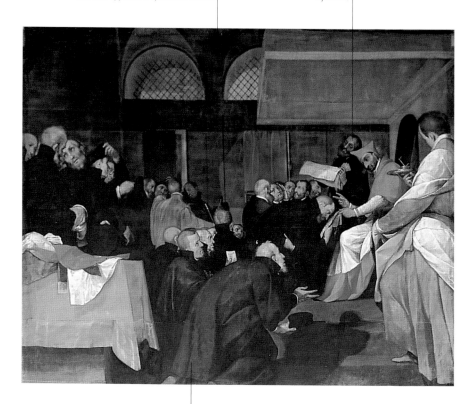

The new orders of clerks regular—
Jesuits, Theatines, and Barnabites—
with which Cardinal Borromeo had
become familiar in Rome, were also
brought to the diocese of Milan in order
to "make its Church fruitful with every
sort of spiritual good" (Giussano).

▲ Cerano, *Saint Charles Founding the
Colleges of Jesuits, Theatines, and
Barnabites*, 1603. Milan, cathedral.

Scenes of bloody wars and massacres associated with this series of conflicts were given a clear historical setting, with recognizable representations of the places where the events unfolded.

The Wars of Religion

During the religious crises that spread through the 16th and 17th centuries, both theologians and politicians were convinced that the coexistence of different confessions would lead to the destruction of the state and society. But it was rarely comprehended that converting people to the Word of God by military force was absurd, and religious affairs became tainted with political, social, and economic interests. In the first of the Wars of Religion, Charles V fought against the Protestant Schmalkaldic League in Thuringia in 1546–47. As an example of the absurdity of these affairs, Charles V relied in part on the military assistance of German Protestants, while the Catholic princes and the pope declined to get involved, apprehensive of increasing the emperor's power. The Huguenot wars racked France for more than thirty years, culminating in the Saint Bartholomew's Day massacre (1572). At the same time, the Low Countries were convulsed in fierce revolts and waves of repression, leading to a geographical division: an independent Calvinist republic in the north, and a Catholic country ruled by Spain in the south. Finally, there came the Thirty Years' War (1618–48), in which Bohemia, Sweden, Denmark, and France took up arms against the Habsburg Empire. It was brought to an end by the Peace of Westphalia.

When
16th and 17th centuries

Where
Europe

Those involved
Catholics and Protestants

Evidence in art
Infrequent, usually relating to specific episodes

◀ François Dubois, *The Massacre of Saint Bartholomew*, late 16th century. Lausanne, Musée des Beaux-Arts.

Some scholars have identified the Duke of Alba in the middle of the party of soldiers. His presence means that this Massacre of the Innocents can be interpreted as representing the atrocities committed by the Spanish in the southern Low Countries.

This little town with snow-covered houses is a typical Brabant setting. It acts as a symbolic background to the Gospel massacre. Such towns were also tragically real settings for so many battles fought during the Wars of Religion.

A horrendous slaughter of children torn from their mothers' arms is taking place in the middle of the square.

This is certainly not the traditional iconography of the Massacre of the Innocents. Local men and women are apparently begging two mounted noblemen to intervene and put a stop to this violent raid. Traditionally only women appear in these images.

On the orders of a mounted soldier, two men are breaking into a house with the obvious intention of looting.

▲ Pieter Brueghel the Younger, *The Massacre of the Innocents*, 1566–67. Bucharest, National Museum of Art of Romania.

The Virgin often appears in this scene of naval warfare, seated on a throne of clouds and accompanied by interceding saints.

The Battle of Lepanto

Toward the end of the 16th century, the chief powers of Western Europe—Spain under Philip II, Venice, and the papacy—could no longer ignore the increasingly powerful Ottoman Empire. As early as 1537 and 1540, the Venetians had allied themselves with the pope and Emperor Charles V against the Turks. The Venetians and their allies suffered a number of defeats, but after making a separate peace with the Turks and losing a number of its bases, Venice had been able to resume trade with the East. When the Turks finally conquered the island of Cyprus in 1570, however, the Holy League was formed at the request of Doge Alvise Mocenigo. It was supported by Philip II and Pope Pius V in order to create a bulwark against the Turkish menace. On October 7, 1571, a naval battle took place in the Gulf of Corinth, near Lepanto

When
October 7, 1571

Where
The Gulf of Lepanto
(Navpaktos, Greece)

Those involved
The Turks against the
Holy League (Spain under
Philip II, Pope Pius V, and
Venice)

Diffusion in art
Only found in the years
following the battle, and
exclusively as a celebration
requested by the victorious
powers

(Navpaktos), in which the League destroyed Turkish sea power. Control of the Mediterranean by the Turks and North African pirates in their service ceased, as did the Turkish advance in Europe. Once the victory had been celebrated and the danger averted, the Holy League was dissolved.

◄ Paolo Veronese, *The Battle of Lepanto*, ca. 1573. Venice, Gallerie dell'Accademia.

The victims, usually old women in rags, are depicted at the center of a public court with instruments of torture at hand.

Witch Trials

When
From the late 15th to the 18th century

Where
Europe

Those involved
Women accused of witchcraft; their accusers, including members of the clergy, the Tribunal of the Inquisition, and secular courts

Evidence in art
Scenes of trial, torture, and execution, most frequently found in later centuries as a denunciation and criticism of persecution

Even before the 16th century, religious intolerance and fanaticism had led to witch hunts and trials, but matters intensified after Europe was thrown into turmoil by the events surrounding the Reformation and Counter-Reformation. Catholics and Protestants were equally culpable in what amounted to persecutory madness, leading to a large number of trials, sentences, and executions for witchcraft. Fear and superstition were responsible for denunciations and accusations; the hysteria was such that even a woman's piety might arouse suspicion in the community. An accused woman's confession was enough to send her to the stake, and the remorseless use of torture could extort not just confessions but often denunciations of other women who were supposed to belong to malevolent witches' covens. Society was obsessed with witchcraft, and the clergy saw it as closely associated with possession by the devil. A few voices, however, were raised against trial systems that were manifestly contrary to justice and humanity. Among them were Jesuit moralists such as Tanner and Laymann and, in particular, Friedrich Spee, who was spiritual adviser to many of the accused. He considered the methods used against them as cruel as those of Nero against the early Christians.

▶ Giovanni Grevembroch, *A Witch's Punishment*, 18th century. Venice, Museo Correr.

The soldier's body faces the crowd, but his gaze is turned toward the trial of the woman. He is there to keep order and escort the authorities.

The public showed prurient curiosity toward anyone accused of witchcraft: crowds attended executions and took part in public demonstrations. This attitude led to a great many false suspicions and denunciations.

The woman is on her knees, explaining with a stick what she has been asked to demonstrate. This is probably not so much a public trial as a test of her powers.

A member of the local authority, who is probably also a representative of the secular courts, is following the woman's demonstration with great interest.

The woman is bound, but a man holds on to her. He allows her a certain freedom of movement, but seems apprehensive of what she may do.

▲ Willem de Poorter, *The Trial of a Witch*, 17th century. Dijon, Musée des Beaux-Arts.

We see a court, with clergy among the judges, whose representatives are questioning a man with a thick beard. We recognize him as Galileo Galilei.

The Trial of Galileo

When
1616–33

Where
Rome, the church of Santa
Maria sopra Minerva

Leading figures
Galileo Galilei, the
Tribunal of the Inquisition,
Pope Urban VIII

Evidence in art
Most works are contemporary with the events concerned and aim to record them

The saga of Galileo began in 1543 with the publication of *De Revolutionibus Orbium* by Copernicus, whose heliocentric thesis ran counter to the ancient view that the earth, and therefore humankind, was at the center of the universe. The new theory was accepted by other scholars such as Johannes Kepler, a Protestant, and Galileo Galilei, a Catholic, but they soon encountered theological resistance. The earliest opposition came from Protestants, while the Catholic Church seemed prepared to wait. Meanwhile, in defending the new theory, Galileo found it necessary to explain how to interpret words in the Bible that dealt with scientific matters; otherwise the famous phrase of Joshua (10:12–13), "Sun, stand still," would have to be considered false. It was not Galileo's intention to cast doubt on the truths of faith in the Bible, and by repeating the words of Cardinal Federico Borromeo, "The intention of the Holy Spirit is to teach us how to go to Heaven, not how the heavens go," he asserted the possibility of error in relation to

▶ Justus Suttermans,
Portrait of Galileo Galilei,
1635. Florence, Uffizi.

the natural world. He was nevertheless called to judgment by the Holy Office, where, at a first session, he was instructed to keep quiet about his theories. When his trial was resumed at a later time, at the insistence of Pope Urban VIII, he was condemned to life imprisonment, though this was subsequently commuted to house arrest. Only in 1992 was he formally acquitted of heresy.

The tribunal judges ask Galileo to abjure the new theories, which they found very disturbing and which threatened to destabilize the established order. It was feared that the truth of the Bible would no longer be acknowledged.

On the table where a secretary is taking minutes, a crucifix stands as a reminder of the faith that is being so strenuously defended in the court.

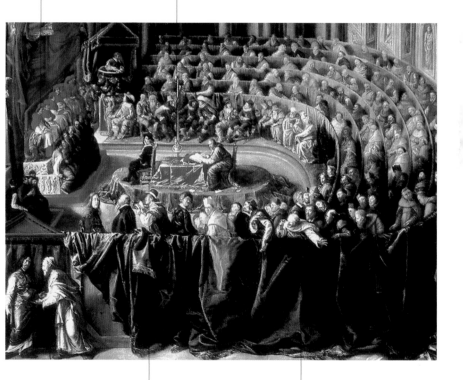

Galileo has been summoned by the Tribunal of the Inquisition and told to renounce his theories because they contradict the words of the Bible.

It looks as though a heated debate is taking place among the clergy and friars watching the trial, but that will not save Galileo from a guilty verdict.

▲ *Galileo Galilei on Trial*, 17th century. New York, private collection.

This doctrine can be identified in certain iconographic details—for example, arms urgently outstretched toward the crucifix—devised to convey that salvation is for the select few.

Jansenism

When
From 1640, when Jansen's
Augustinus was published

Where
France

Leading figures
Cornelius Otto Jansen; the
community of Port-Royal;
Pope Clement IX

Influence on art
There are no images of any
consequence showing
episodes concerning the
diffusion of Jansenist doc-
trine, but there are certain
particular iconographic
variations that were
influenced by Jansenism

Jansenist doctrine was formulated by the Dutch theologian Cornelius Otto Jansen (1585–1638) and made public in his *Augustinus*, a work published posthumously in 1640. His intention was to place himself somewhere between a Counter-Reformation position, akin to the Jesuits', and Protestant Reformist tendencies. For Jansen, humanity is irremediably corrupt and tends toward evil and sin, and in spite of free will cannot carry out the will of God except by divine grace. This grace was given to humanity in "sufficient" quantity at creation but has been lost through sin. So God decided to give "efficient" grace for conquering sin, but only to those predestined for it through faith and good works. This led to the elaboration of a pessimistic theology and a severe moral code that was contrary to the Jesuit attitude, which was relaxed by comparison. The chief center of Jansenist thought was the Cistercian convent of Port-Royal in France. Jansenism was condemned by Pope Clement XI in his bulls *Unigenitus* (1713) and *Pastorali Officii* (1718). While the movement survived the French Revolution, it died a natural death in 1848, when the last Jansenist congregation returned to Catholicism.

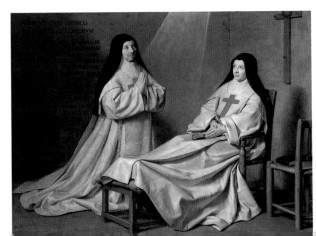

▶ Philippe de Champaigne,
Ex-Voto, 1662. Paris,
Louvre Museum.

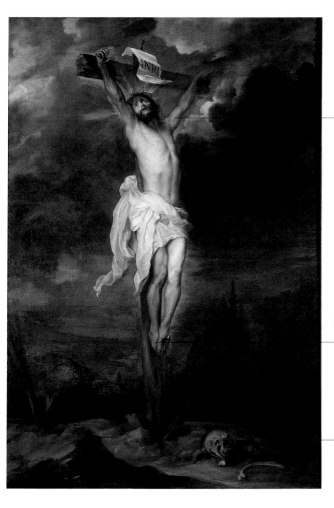

The taut, upwardly stretched arms of Jesus on the cross are an indication of salvation for the few: for those, that is to say, who undertake to pass along the narrow way. This is an iconographic choice made under the influence of Jansenism and one that became widespread in the 17th and 18th centuries.

Jesus' feet are nailed one on top of the other with a single nail. This is an iconographic choice that changed over the centuries. Early Crucifixions have two nails for the feet, but later on versions with one nail prevailed.

The ancient symbol of the skull and bones can be seen at the foot of the cross. In the Middle Ages they were a reminder of the tomb of Adam, over which the cross was supposed to have been raised for Jesus, the new Adam. In this painting the symbolism of death seems stronger; it was an ever-present and much contemplated subject in the 17th century.

▲ Anthony van Dyck, *Christ Crucified*, 1621–27. Genoa, Galleria di Palazzo Reale.

ALBERTVS · DVRER
NORICVS · FACI E
BAT · ANNO · A · VIR
GINIS · PARTV
· 1511 ·

HISTORICAL FIGURES IN THE ROMAN CHURCH TRADITION

Peter and Paul
Fathers of the Church
Mystics
Benedict and Scholastica
Bernard of Clairvaux
Antipope
Innocent III
Francis of Assisi
Dominic de Guzmán
Gregory IX
Thomas Aquinas
Celestine V
Boniface VIII
Catherine of Siena
Bernardino of Siena
Joan of Arc
Pius II
Sixtus IV
Alexander VI
Girolamo Savonarola

Julius II
Leo X
Erasmus of Rotterdam
Martin Luther
Clement VII
Thomas More
Paul III
Ignatius Loyola
Teresa of Avila
Charles Borromeo
Sixtus V
Cardinal Richelieu
Urban VIII
Innocent X
Alexander VII
Clement IX
Benedict XIV
Pius IX
John XXIII
Paul VI

Their facial features became standardized in the early centuries: Peter has a lined face, short, curly hair, and a curly beard; Paul has a long face, very little hair, and a long, black beard.

Peter and Paul

Name
Peter comes from a Latin word meaning "rock" or "stone"; *Paul* comes from a Latin word meaning "short in stature"

Life
First-century Palestine and Rome for Peter; first-century Palestine, Asia Minor, and Rome for Paul

Activities and qualities
Both were apostles of Christ; Paul was at first a persecutor

Diffusion of their cult
Both enjoy a universal cult, but it came later for Paul than for Peter

Feast day
June 29

Among the leading figures in the earliest Christian texts are the apostles Peter and Paul, who were also to some extent its writers and inspirers. The faith in Christ of the Roman Church is founded on these two apostle-martyrs who bore witness to it until their deaths. It is no coincidence that early in the development of Christian iconography, they were among the first saints to be singled out in the group of apostles and given independent treatment, nor is it a coincidence that they often appear together. Initially, their life stories were different, but they became intertwined, and in the end they shared the epilogue of martyrdom. The Gospels tell us that Peter was a very early apostle, and he is presented as one who immediately acknowledges Christ and is able to follow him, although he is subject to human weakness and imperfection. His position of primacy is based on what Christ entrusted to him. Paul was at first a vigorous persecutor of the new doctrine and the followers of Christ, until Christ himself appeared to Paul and called on him to be his follower and apostle—a mission that Paul pursued until his death.

▶ Gilded glass with Peter and Paul, 4th century. Vatican City, Musei Vaticani.

Jesus wears a simple white robe, and the wounds left by the nails are visible in his hands and feet. He is the Risen Christ who appeared several times to the apostles before his ascension.

John can be identified among the apostles because he is the youngest and beardless.

There are eleven apostles because the artist's source is the Gospel of John, which places this episode after the Resurrection. Judas is no longer one of their number.

The sheep are a figurative reference to Jesus' exhortation to Peter: "Feed my sheep."

Peter has a key in his hand. It symbolizes the key of heaven, which Jesus promised him when he founded his church on Peter.

This is the boat from which the apostles debarked when they recognized Christ upon his appearance to them after the Resurrection.

▲ Raphael, *Christ's Charge to Peter*, 1514–15. London, Victoria and Albert Museum.

A young angel is pulling across a red cloth canopy or baldachin— a sign of honor for the person sitting beneath it.

Christ hands a pair of keys to the disciple who changed his name from Simon to Peter. The two keys, one of gold and one of silver, may allude to the dual powers— both spiritual and temporal—of the pope.

An angel is waiting to give Peter the papal headgear—the tiara, or triregno. Its three superimposed crowns are clearly visible.

With his left hand Jesus is pointing to the throne that his disciple, as supreme head of the Church, will have to occupy with authority.

In the middle ground, two apostles present at the handing over of the keys seem to be debating Christ's action. This is a strange detail, because the primacy of Peter was never questioned among the other eleven apostles.

▲ Guercino, *Saint Peter Receiving the Keys from Christ (The Throne of Saint Peter)*, 1618. Cento, Pinacoteca Civica.

Saint Peter is shown kneeling rather awkwardly as he receives the keys from Christ. Certain Caravaggesque stylistic devices can be detected here.

The figure of Saint Paul was already settled in Christian iconography by the 5th century. He has a long face and long, dark beard and is accompanying his sermon with emphatic gestures.

The building on a central plan that acts as an architectural backdrop reflects an ideal of classical architecture with particular reference to the perfect form of the *templum*. According to Renaissance architects, it should preferably be round.

The statue of an ancient deity, not readily identifiable, probably links this painting to Paul's words in his speech at the Areopagus in Athens, when he referred to the "unknown god" worshiped by the Athenians along with the other Greek gods (Acts of the Apostles 17:23).

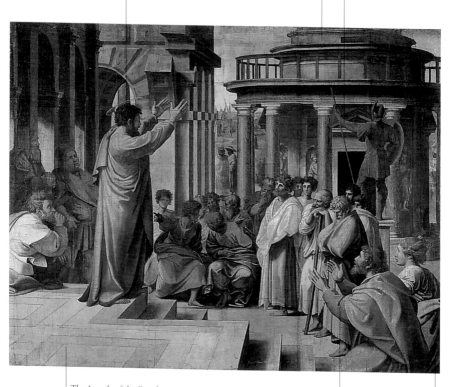

The Apostle of the Gentiles was taken by the Epicurean and Stoic philosophers of Athens to the square in front of the Areopagus, an important meeting place, because they were curious about the new doctrine he was preaching.

The evident gesture of amazement and the rapt expression on this man's face suggest that he may be Dionysius the Areopagite, who was converted by Saint Paul's speech.

A woman with her hair in typical Greek style, held close to her head with a ribbon, may be Damaris, who is mentioned in Acts as one of those who was converted after listening to Paul's words.

▲ Raphael, *Paul Preaching at Athens*, 1515. London, Victoria and Albert Museum.

Peter and Paul

No source states that the future Apostle of the Gentiles was traveling on horseback, but from almost the earliest versions of this scene in art, the equestrian theme has been used to add dramatic effect.

The groom seems more concerned with controlling the horse that has thrown Paul than with his master.

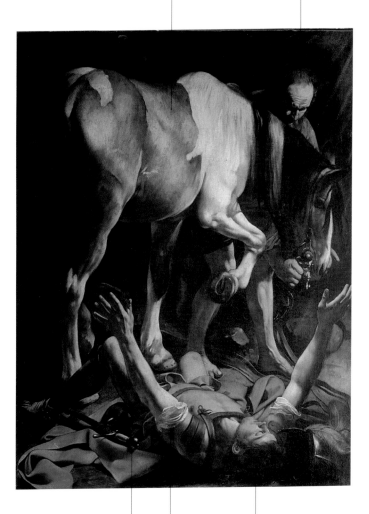

Paul's sword and armor convey his character as described at the beginning of Acts 9: "Still breathing threats and murder against the disciples of the Lord."

▲ Caravaggio, *The Conversion of Saint Paul*, 1602. Rome, Santa Maria del Popolo, Cerasi chapel.

Paul has fallen to the ground, and his outstretched arms poignantly express his extreme amazement.

Paul's eyes are closed because he has been blinded by a vision, and a voice has said, "I am Jesus whom you are persecuting" (Acts of the Apostles 9:5). He will remain blind for three days, until the laying on of hands by Ananias and the opening of his eyes at baptism.

Holy fathers, generally well advanced in years, are shown with their specific attributes, the chief and most common of which is a book.

Fathers of the Church

The word *father* had long been used in the East to honor intellectual dignitaries, and it was adopted by the early Christian Church for bishops who were held to be generators of life in Christ. From the 4th century onward the title of father was limited to those who had borne written witness. In designating the fathers of the Church, attention was paid to their doctrinal standing, the sanctity of their lives, the approval of the Church, and their antiquity: the patristic age closed out with Isidore of Seville (636) in the West and John of Damascus (ca. 750) in the East. For the period up to the Council of Nicea (325), we have the apostolic fathers, whose writings on apostolic preaching were based on a close knowledge of events. The Golden Age, ending with the death of Augustine (431), saw the greatest flowering of patristic literature, with outstanding doctors of the Church both in the East (Athanasius, Basil, Gregory of Nazianzus, and John Chrysostom) and the West (Jerome, Ambrose, and Augustine). Finally there came a period of decline, with just a few outstanding figures (John of Damascus and Gregory the Great). But they helped preserve ancient theological knowledge and so provide a theological basis for the new Middle Ages.

Names
Doctors of the Eastern Church: Athanasius, Basil, Gregory of Nazianzus, and John Chrysostom; doctors of the Western Church: Jerome, Ambrose, Augustine, and Gregory the Great

Life
From the 4th to the 8th century

Activities and qualities
Men learned in the faith who left important doctrinal writings

Diffusion of their cult
Universal

Diffusion in art
Most widespread are images of the four doctors of the Western Church, to be found in paintings at all periods of art history

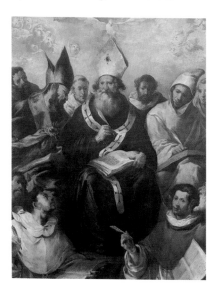

◄ Francisco Herrera the Elder, *Saint Basil Dictating His Rule*, 1637. Paris, Louvre Museum.

The characteristic and basic attribute for identifying a
father and doctor of the Church is a book. It is a symbol of
his doctrinal orthodoxy and his writings; but when held in
a gloved hand, the book is the Holy Bible.

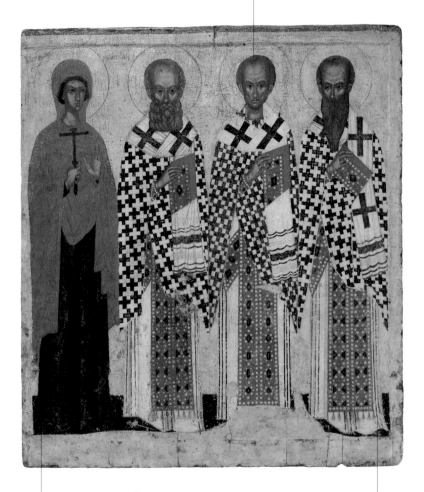

Saint Paraskeve was a 10th-century
hermit from a town not far from
Constantinople. She is shown holding
a cross, a sign that she is a follower
of Christ.

▲ Pskov school, *Saints Paraskeve,
Gregory the Theologian, John
Chrysostom, and Basil the Great*, 15th
century. Moscow, Tretyakov Gallery.

These three fathers of the
Eastern Church can be
identified by their vestments,
their postures, and their fixed
expressions, but they are
differentiated by the details of
their facial features.

Saint Jerome is wearing a cardinal's robes and hat, but there is no evidence that he was ever appointed cardinal. This iconographic error probably derives from the fact that he was called to Rome by Pope Damasus to revise a Latin translation of the Bible and also acted as papal secretary.

The papal tiara shows that Gregory was a pope.

The lion at Saint Jerome's feet reminds us of the legend that an injured lion arrived at the Bethlehem monastery where Jerome was living. After the saint cured and tamed the lion, the docile animal remained in his service.

The child trying to fill a pool with water from a shell recalls a dream in which Augustine saw a child trying to empty the sea. When he stopped the child, pointing out that the task was impossible, the child replied that Augustine would find it equally impossible to understand the mystery of the Trinity.

Trajan is drawn up out of the earth to show that Saint Gregory is attentively praying for souls in purgatory. He prayed hard for this emperor, who died before Jesus was born, and learned in a dream that he had been saved.

The baby in the cradle is Saint Ambrose. As an infant he was attacked by a swarm of bees, which entered his mouth and came out again as though it were a beehive, without doing him any harm. This was a prophetic sign of his future greatness.

▲ Michael Pacher, *Altarpiece of the Church Fathers*, 1482–83. Munich, Alte Pinakothek.

Mystic saints are principally shown studying religious works, contemplating a crucifix or, more commonly, rapt in an ecstatic vision.

Mystics

When and Where
Ever since the origins of Christianity but especially in the Middle Ages and the 16th and 17th centuries, throughout the Christian world

Leading figures
Hildegard of Bingen, Bonaventure, Teresa of Avila, John of the Cross, Veronica Giuliani, Mary Magdalen de' Pazzi, the German mystics

Activities and qualities
The search for spirituality through mystical contact with God

Diffusion in art
Found in the iconography of individual mystics, especially in the art of the 16th and 17th centuries

Influence on art
Attempts were made to depict the mystical experience of ecstasy, especially at the time of the Counter-Reformation

▶ *Saint Hildegard of Bingen Inspired,* wood engraving from *The Legend of Saint Hildegard* (Oppenheim, 1524).

Although mysticism is not a prerogative of the Christian religion, it has been part of the Christian experience from the very beginning. A spiritual predisposition for mystical experiences among Christians reflects Eastern influences and can already be discerned in the writings of Paul and John. Dionysius the Areopagite, a Greek, is supposed to have brought an understanding of mystical attitudes to the West. Important mystic saints arose in the late Middle Ages. Intimate contact with God and a search for elevated spirituality were experienced at different times by men and women from monastic environments, such as Bonaventure, Hildegard of Bingen, and John of the Cross. Each of them left highly edifying written witness of their lives and experiences. No particular period of history seems to

have been more prolific than any other in producing mystics, but there have been times when the spiritual search has seemed to become more intense and to have produced a greater response in the persons of great male and female saints who, even from within their cloistered life and personal experience, made a fundamental contribution to the spiritual growth of the Church.

The crucifix that the saint is addressing indicates the spiritual tension of his prayer and, more specifically, his less rational and more spiritual approach to the divine mysteries.

The bishop's miter reminds us that he was appointed bishop of Albano in 1273.

The book in Saint Bonaventure's hand not only signifies his status as an apostle of Christ but also makes reference to his writings.

His Franciscan habit with cord drawn in at the waist can be seen under the red cardinal's robe. This reminds us that he was a Franciscan and was made minister general of the order in 1257.

In pictures of Saint Bonaventure, his cardinal's hat is often hanging on a tree, because tradition relates that when it was brought to him he was busy in the kitchen and finished his tasks before accepting it.

▲ Carlo Crivelli,
Saint Bonaventure, ca. 1488.
Berlin, Gemäldegalerie.

Christ appears to Saint John carrying the cross on his back and clearly showing the nail wounds in his feet. This is a vision derived from a supernatural source and not from a sensory image, a distinction that Saint John makes in his writings.

The presence of an amazed fellow Carmelite gazing at the apparition from the doorway confirms that it is an extraordinary and supernatural event.

Christ is accompanied in the vision by putti carrying the instruments of the Passion.

Saint John of the Cross is wearing the habit of the Carmelites and kneels in a precarious pose with his arms spread wide in a sign of abandonment. His gaze is rapt and he appears short of breath.

A cherub carries a lily, the attribute of Saint John's purity and virginity.

Some cherubs are holding an open book on which is written Christ's question to John: "John, what reward do you desire for your hard work?" and his answer: "To suffer, Lord, and to be despised because of you." This is an extreme synthesis of the mystical experience of the soul's union with God and its annihilation in the suffering of the Passion.

▲ Domenico Piola I, *Christ Appearing to Saint John of the Cross*, ca. 1675. Genoa, Santi Vittore e Carlo.

The Virgin Mary appears to the Florentine mystic Saint Mary Magdalen de' Pazzi in order to give her a veil of purity. It will protect her from the temptations of the flesh that had so tormented her on the day she completed her novitiate.

Mary Magdalen is wearing the Carmelite habit and waits on her knees to be covered by the protective veil, a reward for her efforts to fight temptation.

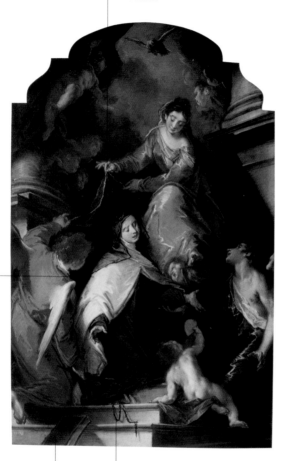

The book is a reference to the Conversations, in which she left witness of her mystical experiences.

When she was assaulted by tremendous temptations of the flesh, Mary Magdalen first whipped herself with thorny branches and then put on a kind of belt made of sharp nails.

▲ Giuseppe Bazzani, *Saint Mary Magdalen de' Pazzi Receiving the Veil of Purity*, 1751. Revere (Italy), parish church.

Benedict appears with a book, an abbot's pastoral staff, a crow with bread in its beak, and a bundle of sticks. Scholastica has a Benedictine habit, with a dove and the rule of her order.

Benedict and Scholastica

Name
Benedict is of Latin origin and means "he who has been blessed"; *Scholastica*, meaning "she who teaches," was a very common name in the 5th century

Life
5th and 6th centuries, Italy

Activities and qualities
Benedict founded a new form of Western monasticism, and his sister founded its female branch

Diffusion of their cults
Both were canonized. The feast of Saint Benedict is July 11 and that of Scholastica is February 10

Diffusion in art
Scenes depicting their lives and Benedictine monasteries, following the cult that began after their deaths

Benedict of Nursia and his sister Scholastica lived in Italy in the 5th and 6th centuries and it was there that Benedict founded a new form of monasticism based on liturgical prayer and manual labor. He first took up literary studies in Rome, but then retired to the life of a semi-hermit at Subiaco in the Aniene river valley. A number of disciples joined him there and it was for them that he drew up his rule, which is usually summarized as *Ecce! labora!* (Go and work). He subsequently founded a number of monasteries. As a result of jealousy and envy, he had to leave Subiaco and he then founded the monastery of Montecassino not far away. The principal source for Saint Benedict is Gregory the

Great's *Dialogues*, which tell us that his sister Scholastica also chose a monastic life and founded the female branch of the order, living first at the women's convent at Subiaco and then at Plombariola at the foot of Montecassino. The representation of the two in art derives entirely from Gregory's account, as subsequently elaborated by Jacobus de Voragine in *The Golden Legend*.

► Bartolomeo Cesi, *Saint Benedict*, 1590. Bologna, Amministrazione Provinciale.

Saint Benedict wears the black habit of the Benedictine Order. He is rejecting his sister's request that he put off his return to his monastery for the whole evening so that they might talk.

Scholastica founded the female branch of the order. With a gesture, she begs her brother to stay. She knew that this would be her last meeting with him, so she sought the assistance of the Lord, who sent a storm, allowing brother and sister to remain together and talk throughout the night.

▲ *Saint Benedict and Saint Scholastica*, 14th century. Subiaco, Sacro Speco.

He is shown in a white habit, with an abbot's pastoral staff and miter. There is often a white dog at his feet to symbolize his refusal of a bishopric.

Bernard of Clairvaux

Name
Of Germanic origin, his name means "strong as a bear" or "strong bear"

Life
ca. 1090–1153, France

Activities and qualities
He founded the Cistercian Order, which had many monasteries throughout Europe by the time of his death. He preached the Second Crusade

Patronage
He is patron saint of Genoa, Burgundy, bee-keepers (because of his appellation *doctor mellifluus*), and candlemakers

Links with other saints
Saint Bruno

Diffusion of his cult
Already spreading during his lifetime

Feast day
August 20

► Carlo Crivelli, *Saint Bernard*, ca. 1488. Berlin, Gemäldegalerie.

Bernard was born into a noble family at Fontaines, near Dijon, in 1090, and initially undertook secular studies. But at the age of twenty-two, he and thirty-one companions entered Cîteaux, a reformed Benedictine monastery in Burgundy where the Cistercian Order would come into being. In 1115, Bernard was appointed abbot of the new monastery of Clairvaux, which was to have a number of offshoots. At first he was heavily criticized by his monks for excessive harshness, but he proved willing to modify their living conditions. He took part in the Synod of Troyes, where he supported recognition of the Order of Templars, whose rule he had written; later (1130) he supported the election of Innocent II, who was in dispute with Anacletus II. He was worried that exhaustion was causing a decline in monastic standards. Severely critical of Cluny and traditional monasticism, he left a clear, lasting mark on monastic reform. He debated with the greatest scholars of his time, Peter Abelard and Gilbert de la Porre, over the foundations of their theology. His numerous writings, including *Letters*, *Treatise on the Love of God*, and especially *Sermons on the Canticle of Canticles*, convey the breadth of his spirit. He died in 1153.

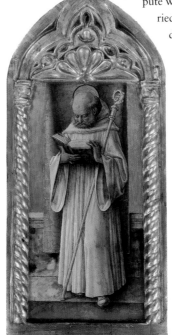

The sudarium bearing an impression of Christ's face is also known as the veil of Veronica, since she is traditionally supposed to have wiped Christ's face on his way to Calvary.

The expression on the saint's face is intended to convey the ecstasy of a mystic mind trying to lose itself in the suffering of Christ.

The instruments of Christ's Passion are tied to the cross: the stick with the sponge soaked in vinegar, the lance that pierced his side, and the nails that pierced his hands and feet.

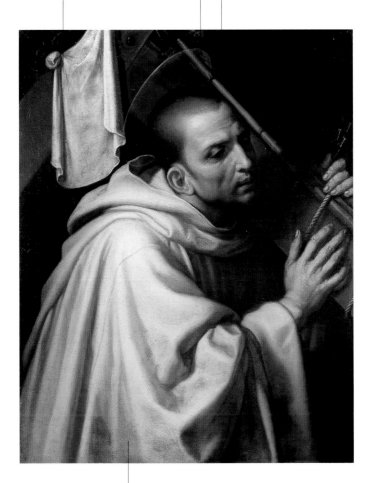

▲ Jerónimo Jacinto Espinosa, *Saint Bernard of Clairvaux Carrying the Instruments of the Passion*, mid-17th century. Poughkeepsie (N.Y.), Frances Lehman Loeb Art Center, Vassar College.

Saint Bernard is wearing the white Cistercian habit.

Antipopes appear in art in liturgical and pontifical robes, exactly like true popes.

Antipope

Name
One who is in opposition
to the pope

Definition
A pope who has claimed
the title in a noncanonical
way or in opposition to
one who is considered
legitimate

When
More than thirty times
between 217 and 1440

Diffusion in art
Antipopes rarely appear in
art. They are almost
entirely limited to illustra-
tions in manuscripts of
historical documents

Influence on art
No particular influence

Antipopes appeared in Church history from the 3rd century onward, and especially at times of political and pastoral difficulty. An antipope is someone who claims the title of pope in a noncanonical manner, usually in opposition to another pope who is considered legitimate, or at a time when the papal throne is vacant. The phenomenon was more political than doctrinal, and took place more than thirty times over a period of thirteen centuries, from the first antipope, Saint Hippolytus, in 217, to Felix V in 1440. However, the criteria used to establish the legitimacy of papal elections varied so much over the course of time that the exact number of antipopes is bound to remain uncertain. The general criterion used today is that antipopes were those elected in opposition to a Roman candidate either through simony or direct pressure from a power outside the Church or when there was a schism. The term *antipope* was not intended to indicate doctrinal error, that is, a heresy that needed to be opposed. Its purpose rather was to clarify the canonical legitimacy of the person elected to the position of supreme head of the Catholic Church. The word *antipope* came into use in the 14th century to replace the word *invasor* (usurper of the papal throne).

▶ Roman missal, *The Duke and Antipope Felix V Celebrating Mass in the Chapel at Ripaille Castle*, 1439. Turin, Biblioteca Reale.

The attributes of the Church—the book of doctrine and the processional cross—are held close at hand by a cherub.

Suspended in flight above the head of the Church is a dove representing the inspiration of the Holy Spirit. Higher still two cherubs are holding the papal tiara.

The Church of Rome is represented by a female figure with an inspired expression, wearing a white robe. She holds a key in her right hand.

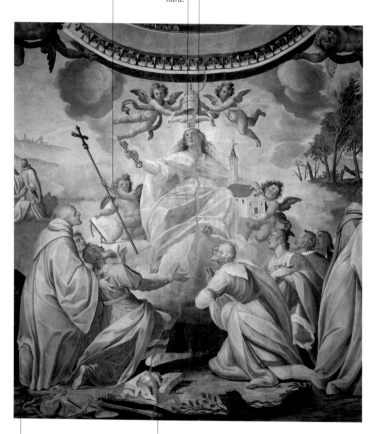

Gregory Conti had taken the name Victor IV as antipope in 1138. Now Bernard brings him before the Church to show the part he played in persuading Victor to withdraw and so bring an end to the schism that had begun in 1130.

The antipope Victor IV is kneeling at the feet of the Church. Scattered close by are the papal insignia that he renounced two months after an election engineered by Roger II of Sicily.

▲ Giovanni Battista della Rovere and Giovanni Mauro della Rovere (called the Fiamminghini), *Saint Bernard of Clairvaux Brings the Antipope Victor before the Roman Church*, ca. 1613–16. Milan, Chiaravalle abbey.

In his earliest portrait he has a long face and protruding ears and wears papal robes, with a conical, single-crown tiara. Later on he can be identified only by his robes.

Innocent III

Secular name
Lotario, of the family of the counts of Segni

Life
1160–1216

Pontificate
1198–1216

Features of his reign
The first great 13th-century pope. He attacked heretical movements and supported the activities of the new mendicant orders

Diffusion in art
Scenes from his own life, but more frequently scenes from the lives of saints who lived during his pontificate

▶ Consolo and an unknown artist, *Innocent III and Saint Benedict*, second half of the 12th century. Subiaco, Sacro Speco, lower church.

The first great 13th-century pope was born into the family of the counts of Segni at Anagni in 1160. He was a nephew of Pope Clement III and was appointed cardinal by him after completing studies in canon law and theology at Paris and Bologna. He felt that the Church should use the authority of the pope as Vicar of Christ in order to succor humanity in its wretchedness, which he viewed as unable to govern itself effectively. He believed that Rome's sovereignty should supersede any other authority, because not only spiritual power had been entrusted to the pope but also, indirectly, temporal power, which he could devolve upon the emperor as defender of the Church. When elected pope in 1198, he proved inflexible toward the various heretical movements (Joachimites, Waldensians, Cathars, and Albigensians), at the same time supporting the new religious orders. He gave Saint Dominic the task of preaching in the lands infected by heresy, approved the Rule of Saint Francis, and tried to banish corruption from the papal court. In 1215 he summoned the Fourth Lateran Council, which condemned heretics, defined the dogma of transubstantiation, and set out regulations to reform the Roman curia. He died in Rome in 1216.

The Lateran church is a symbol of the
whole Lateran complex, where the pope
resided at the time, and is therefore
emblematic of the Church. It is shown
collapsing sideways.

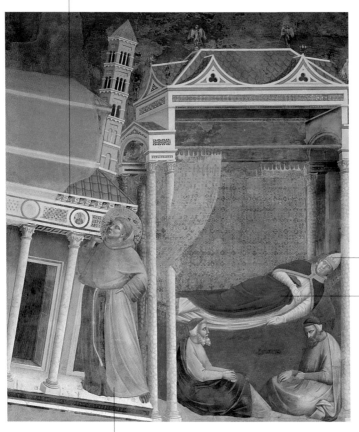

Innocent III's head-
gear is a conical
tiara with a single
crown. The second
and third crowns
were apparently
later additions.

Pope Innocent III is
shown asleep and
dreaming of the
imminent collapse of
the Lateran, which is
averted by the action
of Saint Francis,
according to the Fonti
francescane.

According to the three versions of
Innocent III's dream about the collapse
of the Lateran, as found in the early
biographies of Saint Francis, the pope
saw a small, wretched, insignificant
friar propping up the palace on his
shoulders and saving it from collapse.

▲ Giotto, *Scenes from the Life of Saint
Francis: The Dream of Innocent III,*
1297–99. Assisi, upper church of
San Francesco.

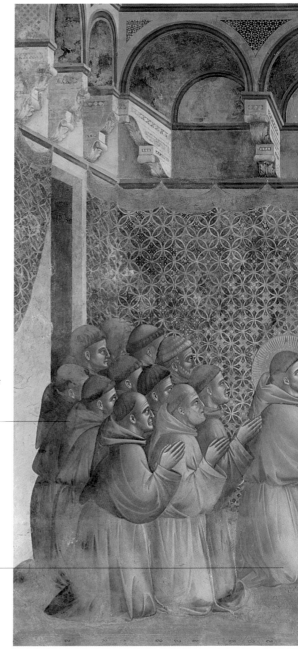

A group of eleven friars has accompa-
nied Francis on his visit to the pope in
Rome. Their tonsures are clearly visible:
the pope had insisted on the tonsure so
that they would be easily recognizable
as friars when they were out preaching.

Saint Francis, wearing a dark habit, is
kneeling with one hand on his chest as
a sign of thanks, for he is receiving
confirmation of his rule.

▶ Giotto, *Scenes from the Life of Saint
Francis: The Confirmation of the Rule*,
1297–99. Assisi, upper church of
San Francesco.

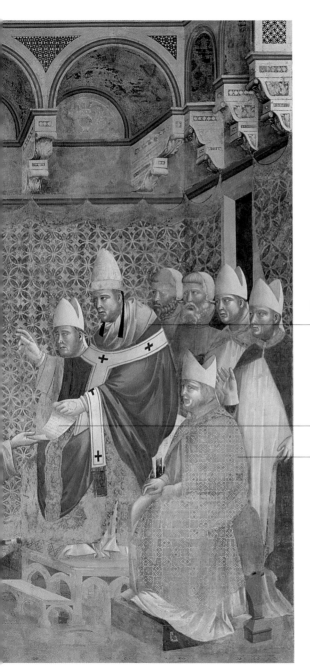

Pope Innocent III receives Saint Francis and his fellow friars. The pope is wearing liturgical dress, with cope, pallium, and tiara.

Now that the text of the rule has been approved, it is returned to the hands of Saint Francis. The pope had initially thought its ideals so elevated as to be beyond human strength.

The confirmation of the rule for the new religious order is attended by bishops and other prelates.

He is shown in a dark habit with a cord at the waist, and his chief attributes are the stigmata and a cross. In the earliest images he is thin and small and looks unwell.

Francis of Assisi

Name
An adjective of Germanic origin. It first meant "free" and then "French." Francis was baptized Giovanni but became known as Francesco because his mother came from Provence

Life
1181–1226, Assisi

Activities
He founded the Order of Friars Minor

Patronage
He is the patron saint of shopkeepers, rope makers, ecologists, flower growers, merchants, upholsterers, poets, and Italy

Diffusion of his cult
He was canonized in 1228 and rapidly became one of the most popular saints in Christendom

Feast day
October 4

▶ Bonaventura Berlinghieri, *Saint Francis and Scenes from His Life*, 1223. Pescia, San Francesco.

Francis was born at Assisi in 1181, the son of a cloth merchant. He spent his youth pursuing amusement and hoped to become a knight. At the age of twenty-three, he was at Spoleto on his way to Apulia to fight for Walter of Brienne, when he had a vision that led to his conversion. When he returned home, an encounter with a leper and words spoken by a crucifix at San Damiano led him to embrace poverty and live solely for God, in spite of his father's opposition. In 1208, dressed in sackcloth and living on charity, he began preaching penitence, attracting his first companions. The first rule of the order was submitted to Pope Innocent III, who approved it, seeing the order's work as an efficient way to combat the Cathar heresy. Franciscan missions then began in Italy and France. Francis also went to the Holy Land to announce Christ to the sultan. When he returned to Assisi, he had to face internal problems in the order. He resigned the leadership to Pietro Catani at the general chapter of 1220. He received the stigmata in 1224 on Mount Averna and they became his chief attribute in art. Shortly afterward he was afflicted by a severe eye disease and when almost blind he composed *The Canticle of the Creatures* at San Damiano. He died on October 3, 1226.

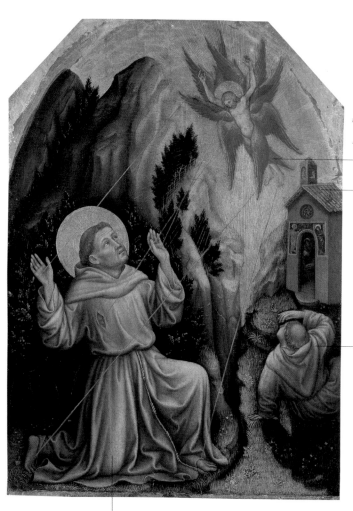

The stigmata impressed on the body of Saint Francis by the crucified Christ with seraph's wings resemble the wounds that Jesus suffered on the cross. This was Saint Francis's vision when he retired to Mount Averna for prayer and penitence.

A little church was built at the Averna shrine. It closely resembles the Porziuncola, a small church near Assisi.

Brother Leo also retired to Mount Averna with Francis. His presence in this scene of Francis receiving the stigmata makes him a witness to the miraculous event.

The wounds to his hands, feet, and side were so distinctive that they became his chief attribute in art.

▲ Gentile da Fabriano, *The Stigmata of Saint Francis*, ca. 1405–10. Parma, Fondazione Magnani Rocca.

Francis of Assisi

Saint Francis is visibly moved as he gazes toward the source of light from which his vision came.

The skull is a symbol of the transience of earthly things and also a memento mori (remember that you must die). It is often used as an attribute of ascetics and hermits.

His crossed hands on his chest show the marks of the stigmata.

His habit is held at the waist by a simple cord.

▲ El Greco, *Saint Francis in Ecstasy*, 1577–80. Madrid, Museo Lázaro Galdiano.

The three allegorical figures of Poverty (with torn clothes), Chastity (with a white gown of purity) and Obedience (with a yoke) are flying toward God.

The elderly friar behind Saint Francis could be Ubertino da Casale, one of the Spirituals and the author of Arbor vitae crucifixae Jesu.

The landscape seems to be that of the plain of Assisi.

Of the three ladies approaching Saint Francis, only Lady Poverty receives a ring, the others acting as her escort.

▲ Sassetta, *The Mystic Marriage of Saint Francis and Sister Poverty*, 1437. Chantilly, Musée Condé.

Saint Francis places the ring on the finger of Lady Poverty. The mystic marriage is symbolic of the vow of poverty and is based on the Sacrum Commercium, *a short work written in the second half of the 13th century.*

His attributes are a star on his forehead, a lily, and sometimes a black and white dog (from Domini canis, *the name of his order) with a torch in its mouth as a symbol of truth.*

Dominic de Guzmán

Name
Of Latin origin and common among Christians. Related to *domenica*, the day of the Lord

Life
ca. 1170–1221, Spain, France, and Italy

Activities
He founded the Order of Friars Preachers, also known as Dominicans, and made it his task to see that friars were educated in religious culture at communities created as study centers

Patronage
Patron saint of astronomers (because of his star attribute), orators, and needlewomen

Diffusion of his cult
Canonized in 1234. First venerated at Toulouse, where he had preached, and then in Bologna, where he died

Feast day
August 8

Dominic de Guzmán was born at Calahorra, the fourth child of the town's governor. He was initially educated by his archpriest uncle, but went on to complete his studies at the University of Palencia. During this time he became a canon regular at Osma cathedral. In 1204 he was sent on a mission to the Marches with his bishop, Diego de Acevedo. There Dominic first encountered the Albigensian heretics of Toulouse and came to realize the importance of what was to be his mission in life: their reconciliation with the Church. He perceived that monks' attempts to bring the heretics back to the Church, largely through exemplifying the ascetic life, were likely to fail because of their inadequate doctrinal preparation. For this reason, he worked energetically to found the Order of Friars Preachers, with the aim of creating communities that would be centers for the study of religious culture. In 1215, Innocent III had urged him to adopt the Rule of Saint Augustine with some additional statutes, because ecumenical council decisions discouraged the creation of new religious orders, for fear of causing confusion in the Church. Nevertheless, Dominic's new order was approved by the next pope, Honorius III, in 1216. The new order spread rapidly throughout Europe. Its first general chapter was held at Bologna in 1220, and Dominic died there in 1221.

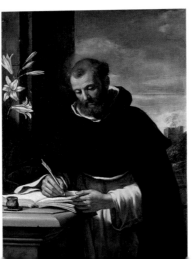

► Bartolomeo Gennari, *Saint Dominic*, 17th century. Cento, Cassa di Risparmio collection.

The processional cross with fleurs-de-lis (lilies) is an emblem of the Dominican Order.

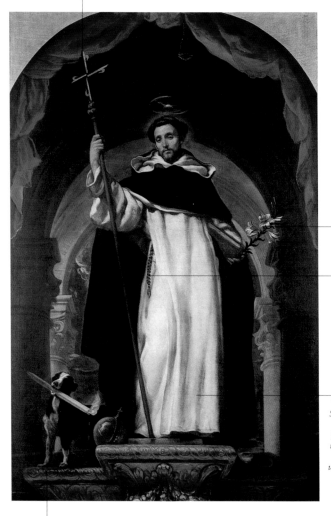

The flowering lilies are a symbol of chastity.

A rosary hanging from the saint's belt reminds us of the Dominican cult of the Virgin and of this type of prayer. According to tradition it was entrusted to Saint Dominic during a vision.

The primary feature identifying Saint Dominic is the white habit and black cloak of the order he founded. He apparently chose a white habit because it was worn by the canons regular among whom he began his religious life.

Shortly before Dominic was born, his mother dreamed that in her womb she was carrying a dog with a torch, which, when it was born, seemed to set the world alight. The dream was interpreted as a prophecy that her child would set the world on fire with his words.

▲ Claudio Coello, *Saint Dominic de Guzmán*, ca. 1683. Madrid, Prado.

As Saint Dominic preaches, he holds up a crucifix, the chief symbol of the Christian faith.

Another friar accompanies Saint Dominic but seems to be hiding behind him for fear that their crusade may end in violence.

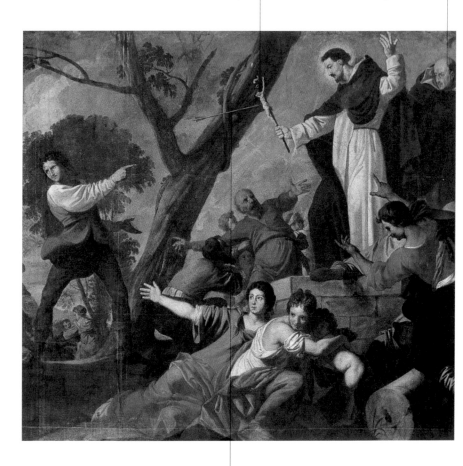

The arrow piercing the crucifix is a sign of the obstinacy of the heretics.

▲ Daniel van den Dyck, *Saint Dominic Accompanied by Simon de Montfort Raising the Crucifix against the Albigensians* (detail), mid-17th century. Treviso, San Nicolò.

There is a small cross in the angel's right hand. Saint Dominic uses this primary Christian symbol in his preaching against the heretics.

A flying angel holds the iconographic attributes of Saint Dominic: in his left hand is a stem of flowering lilies, a symbol of chastity.

Saint Dominic is grasping a book that will be thrown into the fire. This is a test for the heretics, who will see the books of Christian doctrine fly over the flames without burning, whereas the fire will destroy those written by heretics.

A figure in the foreground is blowing to stoke the fire that will burn the heretical books.

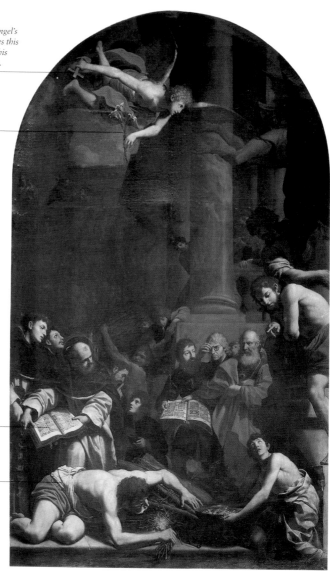

▲ Lionello Spada, *Saint Dominic Burning Heretical Books*, 1616. Bologna, San Domenico.

A contemporary portrait shows him dressed as a bishop and with individualized facial features, but he appears more generic in scenes from the lives of saints.

Gregory IX

Secular name
Ugolino, a member of the family of the counts of Segni

Life
ca. 1145–1241

Pontificate
1227–1241

Features of his reign
He fought hard against the emperor in defense of papal supremacy

Diffusion in art
Scenes of his life linked to approval of the new religious orders

Innocent III had promoted a decidedly hierocratic view of the papacy but had also genuinely sought to reform the Church. Gregory IX was a member of the same family, and he, too, fought hard against the emperor, vigorously defending the idea of papal supremacy. Ugolino was born into the family of the counts of Segni at Anagni around 1145. He was appointed cardinal in 1198, made bishop of Ostia in 1206, and elected pope in 1227. The outstanding quality of his pontificate was his concern for pastoral matters and his protection of the Franciscan Order, which he had come to know and appreciate as a bishop. He contributed to the final form of the Franciscan Rule as well as that of the female branch of the order, the Poor Clares. He canonized the founders of the mendicant orders, Francis of Assisi and Dominic de Guzmán, while at the same time carrying on a struggle against the emperor. He excommunicated Frederick II in 1227 and again in 1239, although he had made peace with him at San Germano in 1230.

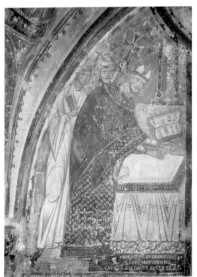

In 1232 he set up the Tribunal of the Inquisition and put it in the hands of the Dominicans. He failed to bring about union with the Eastern Church, but contributed to canon law by organizing a collection of papal decretals, which came to form part of the *Corpus juris canonici.*

► Maestro di Frate Francesco, *Ugolino Consecrating an Altar,* ca. 1224. Subiaco, Sacro Speco.

Saint Francis holds open the slit
in his habit and shows the wound
in his side received from Christ
on Mount Averna. This episode
is narrated in the Legenda maior
(1.2) and is one of the first to
refer to miracles performed by
Saint Francis after his death.

A phial can be seen in the
pope's hand. He saw Saint
Francis in a dream and
used the phial to collect
blood from his wound,
thus banishing any doubts
he might have had about
the wound in Saint
Francis's side.

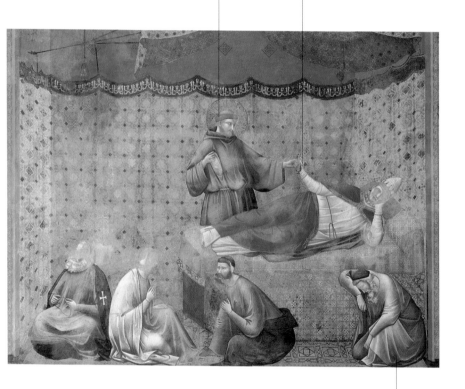

None of the pope's servants
seems to notice the pope's
disturbing dream.

▲ Giotto, *Saint Francis Appearing to
Gregory IX*, 1300. Assisi, upper church
of San Francesco.

This Dominican friar's attributes are a sun on his chest as a symbol of religious erudition, a pen, the dove of inspiration, and sometimes an ox, reflecting his nickname, "silent ox."

Thomas Aquinas

Name
From an Aramaic term meaning "twin"

Life
ca. 1225–1274, Italy, Paris, Cologne

Activities and qualities
A Dominican friar and theologian

Patronage
Patron saint of academics, booksellers, schoolchildren, students, and theologians

Special cult
He is invoked against lightning and as a protector of chastity

Links with other saints
Albert the Great, his teacher

Diffusion of his cult
Canonized in 1323. His cult is much promoted by the Dominican Order

Feast day
January 28

► Sebastiano Ricci, *Pius V and Saints* (detail), 1732–34. Venice, church of the Gesuati.

Thomas was born to the count of Aquino at the castle of Roccasecca around 1225. He first studied at the abbey of Montecassino and then at the university in Naples, which had recently been founded by Frederick II. There, he came into contact with the Dominican Order of Preachers, which he entered despite strong opposition from his father. He moved to the faculty of theology at Paris, where he was a pupil of Saint Albert the Great. Thomas completed his studies at Cologne and returned to Paris, where he became a teacher of philosophy and theology in 1256. At the time, universities were new institutions and Christian thought was still based on patristics.

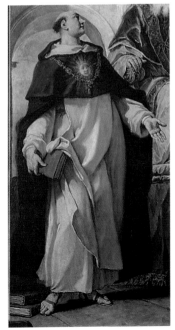

Recent contact with the Arab world gave scholars access to the works of Averroës and Aristotle, whose ideas (an eternal world, monopsychism, the nonexistence of providence) were considered irreconcilable with Christianity. Thomas Aquinas read Aristotle from a Christian perspective. His theology was an attempt to give Christian doctrine a systematic scientific, philosophical, and theological basis. He died at Fossanova in March 1274, on his way to a council at Lyon.

A putto with an incense boat is
ready with a pair of tongs to put
extra grains of incense into the
thurible so that incensation of the
sacrament is not interrupted.

Saint Thomas wrote a hymn
about the Eucharist. Angels are
holding the sacrament suspended
in the sky above a gold chalice.

An angel disperses
incense with a thurible.

Thomas has a pen in hand
and is writing the hymn for
the Mass of Corpus Christi:
ECCE PANIS ANGELORUM,
FACTUS CIBUS VIATORUM,
VERE PANIS FILIORUM, NON
MITTENDUS CANIBUS.

The sun on the saint's chest is
a symbol of his burning love
and religious erudition.

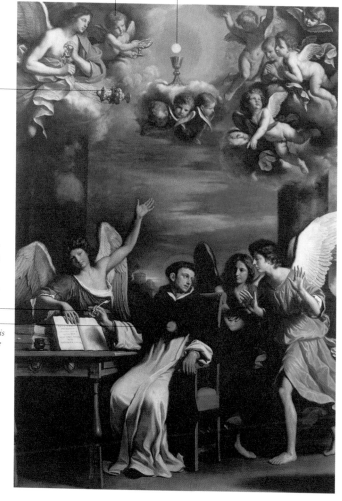

▲ Guercino, *Saint Thomas Aquinas
Writing about the Eucharist,* 1662–63.
Bologna, San Domenico.

There are few contemporary portraits of Celestine V. He appears in a 15th-century miniature as a young pope with a tiara that a fox (Boniface VIII) is trying to take away from him.

Celestine V

Secular name
Pietro d'Angelerio (later called Pietro da Morrone)

Life
1215–1296

Pontificate
From August 29 to December 13, 1294

Special features of his reign
After five months as pope he resigned, but he was prevented from returning to his life as a hermit

Diffusion in art
Represented very occasionally in his own time

Pietro da Morrone was born into a peasant family in the province of Isernia in 1215, the eleventh of twelve children. By the age of twenty he had already decided to become a religious, and after spending a period in the Benedictine monastery of Santa Maria in Faifoli, he turned to the solitary life of a hermit. He lived first in a cave near Castel di Sangro and then moved to a cave on Mount Pelleno, where he remained for three years. He was often questioned by pilgrims and local people, who finally persuaded him to go to Rome to become a priest. In 1263 he set up a religious brotherhood with the approval of Pope Urban IV and under the aegis of the Benedictine Order. But his life changed course when the cardinals were unable to find a successor to Nicholas IV after spending over two years in conclave. His name was put forward, perhaps as a result of a letter that Charles II of Anjou persuaded him to write to upbraid the cardinals. Having been elected pope as Celestine V at an advanced age, he rapidly became the emperor's political pawn and ended by abdicating after only five months. His successor, Boniface VIII, fearful of a schism, removed Celestine from his hermitage and imprisoned him until his death. Celestine V was canonized by Clement V in 1313.

► Girolamo da Cremona, *Presentation of an Elixir to a Pope; A Fox (perhaps Boniface VIII) Tries to Take His Tiara* (detail), from Ramon Llull, *Opera Alchemica*, second half of the 15th century. Florence, Biblioteca Nazionale.

He can probably be identified in a famous fresco by Giotto, originally in the Lateran. His physical appearance in some later statues and other works derives from Giotto.

Boniface VIII

Benedetto Caetani was born at Anagni in 1235. As a cardinal expert in canon law, it was he who advised Celestine V to abdicate. He was elected pope on December 24, 1294, and was crowned in Saint Peter's in the following month. He was a brash, authoritarian man and immediately became embroiled in politics. His family's traditional rivalry with the Colonna family caused him to depose and excommunicate Cardinals Giacomo and Pietro Colonna, and he began a campaign against the family. He opposed the intransigent Spiritual wing of the Franciscans, which was supported by the Colonnas. One of the toughest battles fought by Boniface VIII was against Philip IV (Philip the Fair) of France, who ruled over a strengthening state that was disinclined to tolerate interference from Rome. Outstanding among the bulls that the pope hurled at the king of France in an attempt to reclaim his supremacy was *Unam Sanctam* of 1302. It was based on an outdated concept of power, and the king, with the support of the Colonna family, responded by attacking the pope at his palace in Anagni and bringing his pontificate to an end by means of the famous slap and imprisonment.

Secular name
Benedetto Caetani

Life
1235–1303

Pontificate
1295–1303

Special features of his reign
He was the last 13th-century pope, and the political autonomy of the Church came to an end when he died. He celebrated the first Jubilee in 1300

Diffusion in art
He appears very occasionally in connection with the proclamation of the Jubilee

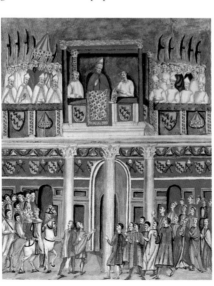

◄ Giacomo Grimaldi, *Boniface VIII Appears to the Crowd on the Balcony of Blessing in the Lateran*, late 16th century. Milan, Biblioteca Ambrosiana.

Pope Boniface VIII is wearing the papal tiara at the solemn celebration of the conferment on Louis of Anjou of the vows of the Franciscan Order.

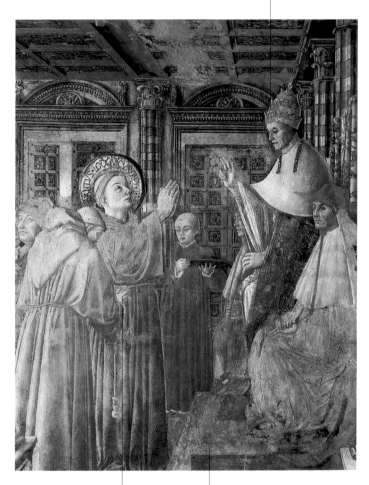

A friar is tying the cord that goes over the habit and completes the Franciscan form of dress.

▲ Benedetto Bonfigli, *Boniface VIII Conferring the Vows of the Franciscan Order on Saint Louis of Anjou*, 1454. Perugia, Palazzo dei Priori.

Saint Louis agreed to be ordained bishop of the diocese of Toulouse, but wanted to take vows of poverty, chastity, and obedience and enter the Franciscan Order. He felt attracted to the order but he had been refused entry because it was considered unsuitable for one of his rank. On the orders of the pope, he was secretly admitted to the order, to avoid annoying his father, the king.

She is wearing the white habit and black cloak of the Dominicans. Her attributes may be a cross, a lily, or a book, and her hands bear the stigmata.

Catherine of Siena

Catherine was born in Siena in 1347, the twenty-fourth child of a cloth-dyer. As a result of a childhood vision she decided to remain a virgin, and at age eighteen she became a Dominican tertiary. In spite of her parents' opposition, she spent her days in prayer and penance at home until she decided to devote herself to outside work in 1370. With a few disciples, she nursed the sick and traveled around preaching conversion. She intervened in the serious disputes afflicting not only Siena but Florence and the papacy. She was attached to the Church as the bride of the Word and to the pope, calling him "the sweet Christ on earth." She urged Gregory XI to escape from the "Avignon captivity," where the papal curia was tainted by French politics, and return to Rome. She supported the next pope, Urban VI, after the election of the antipope, writing letters to him, to heads of state, and to cardinals throughout Europe. Her mysticism and ideals are preserved in her numerous writings. According to tradition, she received the stigmata in 1375. She died in Rome on April 29, 1380.

Name
From the Greek *kataros*, meaning "pure"

Life
1347–1380, Siena

Activities
She was a Dominican tertiary, initially leading a life of prayer and penance and later becoming involved in Church problems

Patronage
Patron saint of nurses

Special cult
Invoked against the plague and headaches and for a good death

Diffusion of her cult
Proclaimed patron saint of Italy in 1939. Since 1970 she has been a Doctor of the Church Universal

Feast day
April 29

◄ Francesco Cairo, *Saint Catherine of Siena with the Stigmata*, ca. 1645. Milan, Pinacoteca di Brera.

Rays of light from Christ's wounds impress the stigmata on Catherine's body, signifying that she shares Christ's Passion in body and soul.

Two angels support her as she swoons in ecstasy.

Saint Catherine is wearing the Dominican habit and has a rapt expression on her face. The episode represented occurred in 1375 when, after praying, she was bathed in light from the wounds of Christ on the cross.

The angel on the left is holding a crown of woven thorns as a sign of Catherine's mortification.

The stem of flowering lilies alludes to her purity and virginity.

In addition to the wounds on her hands, there is what appears to be a wound in her side, visible as a stain on her white scapular.

▲ Pompeo Batoni, *Saint Catherine of Siena in Ecstasy*, 1743. Lucca, Museo Nazionale di Villa Guinigi.

He wears the Franciscan habit and a worn expression. His attributes in art are the monogram of the name of Jesus (IHS) and three miters at his feet.

Bernardino of Siena

Bernardino was born into the noble Sienese Albizzeschi family at Massa Marittima in 1380. His parents died when he was three and he was brought up by an aunt. During the 1400 plague, he and some companions took charge at the Siena hospital. In 1404 he entered the Order of Friars Minor; he was ordained a priest, and from 1417 traveled the length and breadth of Italy, preaching as he went. He was skilled at identifying the ills of society and brought about many conversions. He used everyday language and did not fear to criticize the rich and noble. He spread the worship of the Holy Name of Jesus, which became his chief attribute in art. He was also one of the most ardent supporters of the reform of the Observant Franciscans (he became vicar general in 1437), for whom he wrote some theological treatises that aroused a good deal of opposition. He also organized a number of theological schools, being convinced that ignorance was as dangerous as wealth for friars. He refused three bishoprics (those of Siena, Ferrara, and Urbino), which in art is symbolized by three miters at his feet. He died at L'Aquila in 1444 while on his way to Naples.

Name
A diminutive of *Bernard*, which is of Germanic origin and means "as strong as a bear" or "strong bear"

Life
1380–1444, Italy

Activities
A priest in the Franciscan Order. He preached penitence and poverty and attacked gambling, usury, superstition, and political conflict

Patronage
Patron saint of preachers, publicists, wool merchants, weavers, and boxers

Special cult
Invoked against bleeding and hoarseness

Diffusion of his cult
He was canonized by Nicholas V only six years after his death

Feast day
May 20

◄ Benedetto Bonfigli, *Saint Bernardino's Banner*, 1465. Perugia, Pinacoteca Nazionale dell'Umbria.

Bernardino of Siena

Saint Bernardino is usually represented with a thin, careworn face, and in this particular case, his head seems small in relation to his body. That is because of new, elongated proportions given to the human form by Mannerists in order to accentuate a figure's upward thrust.

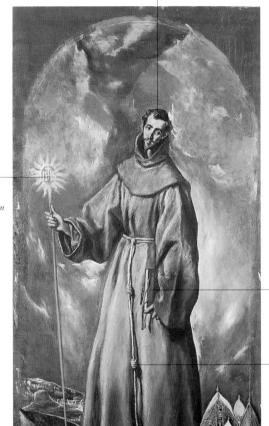

The monogram Iesus Hominum Salvator *inside a radiant sun is an indication of the saint's vigorous promotion of the name of Jesus.*

The book alludes to his establishment of schools of theology in order to avoid the dangers of ignorance.

The three knots in the cord around his habit are intended as a permanent reminder of the three vows of his order: poverty, chastity, and obedience.

Three splendid bishop's miters lying on the ground are a symbol of his refusal of appointments to the sees of Siena, Ferrara, and Urbino.

▲ El Greco, *Saint Bernardino*, 1603. Toledo, Museo Casa de El Greco.

She is shown in armor but usually without a helmet, so that her female features can be seen. She is often on horseback, carrying a banner.

Joan of Arc

Joan was an illiterate peasant girl who, when she was only thirteen, heard saints' voices urging her to free France from the torment of the Hundred Years' War. She managed to speak to the Dauphin, the future King Charles VII, about relieving Orléans from a siege by the English, who already occupied northern France and Paris. Some (including her parents) said she was mad, but she managed to convince the military commanders and freed Orléans at the head of the French troops. After this important military success, she scored a great political victory when she conducted the fearful, reluctant Charles VII to Reims for his coronation on July 17, 1429. Now France had a real king, one who was recognized and accepted. But Joan was unable to witness the important outcome of these events—

Charles VII's triumphant entry into Paris in 1437. She had been wounded in 1429 and was betrayed, captured by the Burgundians, sold to the English, and put on trial as a heretic and witch at Rouen. Joan of Arc, not yet twenty, was burned at the stake in 1431 in the market square at Rouen. It was said that as she burned, she gazed on the crucifix that her confessor held up before her.

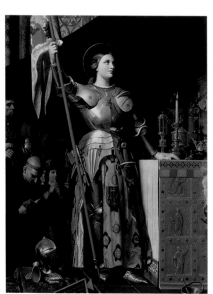

Name
Her name comes from Hebrew and means "the Lord has been gracious," "gift of the Lord"

Life
1412–1431, France

Activities and qualities
Under the inspiration of mysterious voices, she fought for France against the English and brought Charles VII to the throne

Patronage
Patron saint of telegraphy, radio, and France

Diffusion of her cult
In 1455, Pope Callistus III ordered a re-examination of her trial and she was fully rehabilitated. She was beatified by Pius X in 1909 and canonized by Benedict XV in 1920

Feast day
May 30

◄ Jean-Auguste-Dominique Ingres, *Joan of Arc at the Coronation of Charles VII*, 1851. Paris, Louvre Museum.

He appears almost solely in a series of works in the Libreria Piccolomini in Siena, which he himself commissioned from Pinturicchio to celebrate his pontificate.

Pius II

Secular name
Enea Silvio Piccolomini

Life
1405–1464

Pontificate
1458–1464

Special features of his reign
He was the first pope to be a humanist and patron of the arts

Diffusion in art
Mostly in Pinturicchio's work to celebrate his pontificate

Influence on art
He was a protector of artists and men of letters. He made use of art and justified his great works of architectural reconstruction as necessary to show the superiority of the Church

Enea Silvio was born in 1405 at Corsignano, near Siena, to the noble but declining Piccolomini family. At the age of eighteen, he attended Siena University, where he devoted himself to both study and pleasure. Impressed by the preaching of Saint Bernardino, he felt a desire for the monastic life but was dissuaded by his companions. He studied literature and philosophy and devoted himself to poetry and the classics as well as to the study of jurisprudence. He established useful relationships with important cultural and ecclesiastical figures, and so was appointed secretary to Bishop Caprinica at the Council of Basel, in opposition to Pope Eugenius IV and other bishops in important positions, and then secretary to the antipope Felix V (1439). He realized, however, that he would do well to change sides and so, as secretary to Frederick III, he managed to become reconciled with Eugenius IV (1445). At that point he rejected his previous life, becoming a priest, then a bishop; in 1456 Pope Callistus III made him cardinal. He was elected pope in 1458 as Pius II. His principal concern during his reign was to free Europe from Turkish domination. He also appointed a commission to reform the Roman Tribunal and took steps toward the reform of the monastic orders.

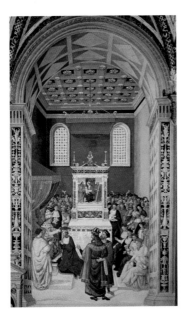

► Bernardino Pinturicchio, *Enea Silvio Piccolomini, the Future Pope Pius II, Receiving the Cardinal's Hat from Pope Callistus III*, 1502–8. Siena, cathedral, Libreria Piccolomini.

The classical ciborium over the altar adds importance and prestige to the place where the eucharistic ritual is performed.

The pope is symbolically protected by a processional baldachin on which papal coats of arms can be seen.

The new pope is wearing liturgical dress, with a blue cope and the papal tiara on his head. He is blessing the faithful with his right hand.

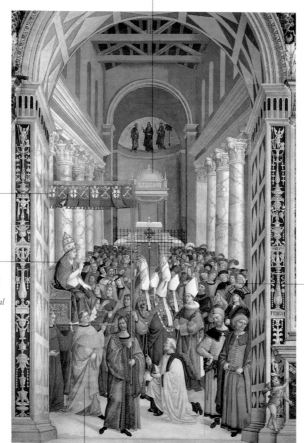

The arrival of the pope is preceded by a procession of bishops in strikingly white miters.

The pope sits on his gestatorial chair as it is carried on the shoulders of bearers.

▲ Bernardino Pinturicchio, *Enea Silvio Piccolomini Made Pope as Pius II*, 1502–8. Siena, cathedral, Libreria Piccolomini.

In the best-known portrait he is wearing a white robe, camauro (cap), and mozzetta (short cape) as he appoints Bartolomeo Sacchi, called Platina, first prefect of the Vatican Library.

Sixtus IV

Secular name
Francesco Della Rovere

Life
1414–1484

Pontificate
1471–1484

Special features of his reign
He came from the Franciscan Order and was the last pope to try to raise a crusade against the Ottoman Empire

Diffusion in art
The little there is concerns the founding of the Vatican Library

Influence on the arts
He revived the Accademia di Pomponio Leto, the Schola Cantorum, and the Vatican Library

Francesco was born at Celle Ligure in 1414 into the noble Della Rovere family of Savona. He entered the Franciscan Order and obtained a doctorate in theology at Padua, subsequently becoming a teacher at the University of Bologna. He was appointed minister general of the order in 1464, and three years later Pope Paul II appointed him cardinal. At the 1471 conclave he was supported by the Orsini, Gonzaga, and Borgia families and was elected pope as Sixtus IV. His initial concern was to consolidate his power in Italy, so he devoted himself to internal politics. In foreign affairs he was the last pope to attempt to stir up a crusade against the Ottoman Empire. He was an undisguised nepotist, supporting the ambitions of various relatives who were responsible for new conflicts in Italy, with serious consequences for peace (the Pazzi conspiracy of 1478, war between Florence and Naples, and the Ferrara war). During his reign, there was serious strife between the Orsini and Colonna families, unpopular heavy taxation, and the unbridled sale of jobs and favors.

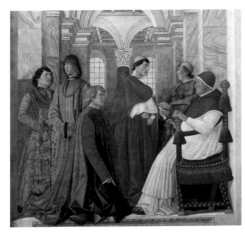

▶ Melozzo da Forlì,
Pope Sixtus IV Appoints Bartolomeo Platina Prefect of the Vatican Library, 1477. Vatican City, Musei Vaticani.

Sixtus IV helped revive the Accademia di Pomponio Leto, the institution of the Schola Cantorum (building what was later called the Sistine Chapel), and the Vatican Library.

Official portraits were painted by Pinturicchio and other artists in his circle. He also appears in celebratory works either as protagonist or spectator.

Alexander VI

The election of Pope Alexander VI brought the curia to its worst level of corruption and dissipation. He was a Spanish cardinal by the name of Rodrigo Borja (italianized to Borgia) from Xàtiva near Valencia. He was the son of Jofré de Borja y Doms and Isabella Borja, sister of the future Pope Callistus III, and at the age of only fourteen was given canonries and prebends by Nicholas V. In 1455, his uncle, now pope, appointed him protonotary apostolic and in 1456, even before he had received major orders, he was made cardinal and vice-chancellor of the Church. Immediately afterward he was appointed bishop of Valencia. After the death of Callistus in 1458, Rodrigo enjoyed the favor of both Pius II and Sixtus IV. By the time he was elected pope in 1492, he already had six children, all of whom were legitimized, and another daughter was born later. His primary concern was his position as tempo-

ral sovereign and Renaissance prince, though he paid little attention to the arts. Girolamo Savonarola harshly criticized the pope's dissipated life in his sermons and accused him of simony, to which the pope responded by excommunicating him and then having him tried for heresy. Alexander died of malaria (not by poison, as was insinuated at the time) in 1503.

Secular name
Rodrigo (de Borja) Borgia

Life
1431–1503

Pontificate
1492–1503

Special features of his reign
He was a true Renaissance prince and much involved in Italian politics

Diffusion in art
In his position of sovereign power, he was able have his portrait painted by the most important painters of his time

Influence on art
He paid little attention to the arts, preferring to involve himself in politics

◄ Circle of Melozzo da Forlì, *Portrait of Pope Alexander VI Borgia*, late 15th century. Vatican City, Musei Vaticani.

The ships in the background remind us that a naval victory, the Battle of Saint Maura (1502), had just been won against the Turks.

The donor, Bishop Jacopo Pesaro of Paphos, carries a battle standard with his family's coat of arms. He commanded the papal fleet.

At Saint Peter's feet are two keys, one silver and the other gold. They are symbols of the spiritual and temporal power of the Church.

Saint Peter is seated on a plinth with a classical relief showing a scene of human sacrifice. His position is meant to show the superiority of the Christian faith over that of the pagans, and at the same time remind us of the donor's recent military victory over non-Christians.

The bishop is presented to Saint Peter by Pope Alexander VI. The pope's liturgical dress is covered by a rich cope, under which a splendid gold stole can be seen.

▲ Titian, *Alexander VI and Bishop Pesaro before Saint Peter*, 1506–9. Antwerp, Musée des Beaux-Arts.

▶ Albrecht Dürer, *The Feast of the Rose Garlands*, 1506. Prague, Národni Galerie.

Saint Dominic is wearing a black cloak over his white habit and carries a stem of flowering lilies as he distributes wreaths of roses at the feast of the Rose Garlands. Tradition has it that he was responsible for instituting this Marian prayer, hence his presence here.

Two cherubs are holding a crown over Mary's head. The crown is encrusted with pearls and precious stones and symbolizes her position as queen of heaven.

The emperor Maximilian has placed his imperial crown on the ground in order to receive a crown of roses from the Virgin.

In the middle ground, but still quite visible and recognizable, is a self-portrait of the artist. He has signed and dated the painting on the sheet of paper in his hand.

The pope awaits his turn to be crowned with a rose wreath by the Child as a sign of his veneration of the Blessed Virgin of the Rose Garlands. He has been identified as Alexander VI Borgia.

The pope's tiara is on the ground, partly covered by a rose branch.

One of the devotees is holding a string of rosary beads, as though he were counting the Hail Marys of the rosary.

Among the crowd we find a likeness of the Venetian architect Gerolamo Tedesco.

He is painted in the white habit and black cloak of the Dominicans with the hood always raised. He is typically portrayed in profile, showing his aquiline nose.

Girolamo Savonarola

Name
Girolamo Savonarola

Life
1452–1498

Activities
A Dominican friar and preacher

Special features of his life
He denounced the dissipation and corruption of his time, especially as regards the Church

Diffusion in art
Rarely found. There are a few portraits and records of his execution

Influence on art
He preached a return to simple forms of iconography, without representations of immoral subjects. He influenced the painting of Bartolomeo della Porta and Sandro Botticelli. The latter was so impressed by Savonarola that he only painted religious subjects after Savonarola's death

Girolamo was born in Ferrara in 1452. He studied philosophy and medicine, but before taking his degree, he left for Bologna to begin life as a religious in a convent of Dominican friars. After a period at Ferrara as novice master, he was invited to preach in the church of San Lorenzo in Florence in 1480. His unusual style was at first far too exhortative for the Florentines, whose refined language and enjoyment of literary inquiry made them disinclined to listen to biblical quotations, criticism of their conduct, or forecasts of disaster. From 1485 onward he preached in various towns, returning to Florence in 1490 at the request of Lorenzo the Magnificent on the advice of Giovanni Pico della Mirandola. So successful were his sermons that he was called to Santa Maria Novella and appointed prior of San Marco. When Charles VIII descended on Florence, Savonarola's prophecies seemed to be coming true, and he was given a voice in the city's political organization. In his sermons against corruption he openly criticized Pope Alexander VI, who ordered him to stop preaching. Savonarola disobeyed and was excommunicated. In 1498 he was arrested, tried, found guilty of heresy, and burned at the stake on May 23.

▶ Fra Bartolomeo, *Portrait of Girolamo Savonarola*, ca. 1499–1500. Florence, Museo di San Marco.

The tragic end to Girolamo Savonarola's life is played out in the most important square in Florence, the Piazza della Signoria, dominated by the palazzo of the same name.

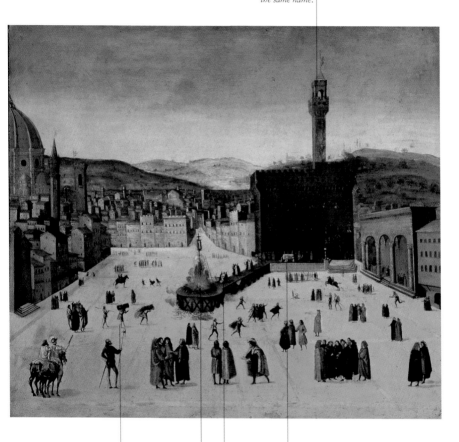

Two men, escorted by a guard, are bringing bundles of brushwood to feed the fire.

The three victims are raised high on a stake and surrounded by flames.

The three condemned men are led to the place of execution.

The first act of the tragedy shows Girolamo Savonarola with Domenico Buonvicini and Silvestro Baruffi. They have been arrested and bound, and they kneel before the court that will find them guilty and sentence them.

▲ Florentine artist, *The Execution of Savonarola*, 17th century. Florence, convent of San Marco, Pinacoteca.

He can be identified by his long white beard. There are numerous official portraits in which he appears in a white robe and with papal mozzetta and camauro.

Julius II

Secular name
Giuliano della Rovere

Life
1443–1513

Pontificate
1503–1513

Special features of his reign
More of a warrior than a spiritual leader, he was concerned to consolidate the temporal power of the Church

Diffusion in art
There are numerous official portraits, and he can also be seen as protagonist or at least a presence in Raphael's famous Vatican frescoes

Influence on art
He promoted the arts and protected artists, summoning the greatest artists of his time to Rome

► Michelangelo Buonarroti, *Tomb of Julius II* (detail), 1545. Rome, San Pietro in Vincoli.

Giuliano della Rovere was born into a modest family at Albisola in 1443 and studied with the Franciscans at Perugia, embarking on a career in the Church when his uncle Francesco della Rovere was elected pope. He was made bishop and then cardinal, and after a period of "exile" in France to avoid trouble with his enemy, Alexander VI, he was elected pope and took the name Julius II. He had a rather martial personality, and he responded to the popular demand for reform of the Church by consolidating his temporal power, because he was convinced that the Church should be free and independent. In making alliances and fighting battles for the recovery of the Papal States, he behaved more like an absolute sovereign than a pope. He promised a council, however, and the Fifth Lateran Council was finally convened in 1512, though he did not live to see its conclusion. Despite hopes for genuine reform of the Church, it proved once again to be tainted with politics and dealt only with isolated matters. As a great prince concerned to maintain the prestige of his pontificate, he summoned to Rome the greatest artists of his time and commissioned extraordinary works of decoration.

Julius II is shown wearing his camauro (papal cap) at the age of seventy, after nine years on the papal throne. By this time he had already summoned the Fifth Lateran Council, from which much was expected in terms of Church reform.

The mozzetta is a garment reserved for the pope, cardinals, and bishops. The pope's is red, except during Easter week.

Papal portraits were traditionally confined to head and bust, but here we have a three-quarter view, a prelude to the full-length portraits that will come later. This permits the artist to show his masterly treatment of the heavy velvet of the mozzetta and the tight-sleeved white robe.

▲ Raphael and workshop, *Portrait of Pope Julius II*, 1512. Florence, Uffizi.

The ring was a distinguishing sign of the pope. The one normally worn was ornamented with precious stones. A larger, heavier ring was required to fit over gloves.

According to the apocryphal text of 2 Maccabees
(3:21–28), Heliodorus had been sent to steal the contents
of the temple treasury, but the high priest Onias prayed
to the Lord to prevent him from succeeding.

Julius II has had himself
painted as a spectator at the
expulsion of Heliodorus. It
was his intention that the
painting demonstrate God's
protection of the Church
and its assets.

Raphael includes himself
among the bearers.

▲ Raphael, *The Expulsion of
Heliodorus*, 1512. Vatican City, Palazzi
Vaticani, Stanza di Eliodoro.

Among the bearers of
Julius II's gestatorial chair
Raphael has included a
portrait of Marcantonio
Raimondi, a well-known
engraver who publicized
Raphael's works.

The faithful in the Temple
watch the dramatic scene.
The presence of women and
children reminds us that the
treasury money was intended
for widows and orphans.

It seemed as though Heliodorus might succeed in stealing the temple treasure, but suddenly a rider appeared on a white horse and knocked Heliodorus to the ground.

A looter can be seen in the background carrying off a chest on his shoulders.

As the high priest had pointed out, the temple treasure did not amount to much. It is represented here by an overturned jug spilling out some gold coins.

One of the two young men accompanying the rider starts castigating Heliodorus.

The supernatural nature of the rescuers is emphasized by the leap, or rather flight, of the young man with a cudgel who is attacking the profaner of the Temple.

His body was massive, his face round, and his nose fat. He is always shown beardless, whether in official portraits or in scenes of celebration.

Leo X

Secular name
Giovanni de' Medici

Life
1475–1521

Pontificate
1513–1521

Special features of his reign
He was a humanist pope and lacked any spirit of asceticism. He confronted Luther and excommunicated him without fully understanding the consequences of the schism for the Church

Diffusion in art
There are various known portraits by the great artists whom he liked to gather around himself

The "Medici Pope" was the second son of Lorenzo the Magnificent. He was born in Florence in 1475 and was thus educated by the major humanists at his father's court. He obtained a degree in canon law in 1489, the same year in which Innocent VIII appointed him cardinal. He was elected pope on the death of Julius II in 1513, and soon began distributing ecclesiastical appointments and territorial governorships to his family. It was his declared aim to govern in peace, and he adopted a policy of compromise toward the European powers. His interest in the reform of the religious orders went back to his time as cardinal, when he had been called upon to bring Julius II's Lateran Council to a conclusion. He failed to appreciate the seriousness of Luther's appearance on the scene. He tried to rein Luther in by means of the bull *Exurge Domine* and later excommunicated him, but was slow to react to the consequences and allowed the situation to deteriorate. He was another Renaissance pope: a prince devoid of ascetic spirit, enjoying the arts and taking pleasure in surrounding himself with artists and men of letters.

▶ Giorgio Vasari, *Leo X Appointing Cardinals*, ca. 1555. Florence, Palazzo Vecchio.

Cardinal Giulio de' Medici, the future Clement VII, was the pope's cousin. He is shown dressed as a cardinal and with a deep ecclesiastical tonsure.

Since Leo X could not personally attend the wedding of Lorenzo de' Medici of Urbino and Madeleine de la Tour d'Auvergne, he sent a portrait instead. Raphael's portrait displays not only an almost Flemish attention to fabrics and details but also deep psychological insight in the pope's face.

The light catches the polished pommel of the chair on which Cardinal Luigi de' Rossi, another of the pope's relatives, has placed his hands. In it we can see the reflection of a window.

The detail in the illuminated codex emphasizes the pope's humanist inheritance as the son of Lorenzo de' Medici.

The pope's delicate hands are suggestive of his love and patronage of the arts. The hand on the page and the magnifying glass show that he was just reading the codex in front of him.

▲ Raphael, *Portrait of Leo X with Cardinals Giulio de' Medici and Luigi de' Rossi*, 1518. Florence, Uffizi.

The signs of the zodiac in the ornamental band symbolize the passage of time. The lion (Leo) is placed exactly above the pope so that there shall be no doubt as to the identity of the person whose likeness is borrowed to represent Pope Clement I.

The sainted 1st century pope is painted to look like Leo X. Leo commissioned the work and planned the iconographic program for the Sala di Costantino, at the corners of which were placed figures of past popes. The painting is by Giulio Romano and the cartoon from which it was painted is generally attributed to Raphael.

▲ Giulio Romano and assistants, *Portrait of Leo X as Clement I*, 1521. Vatican City, Palazzi Vaticani, Sala di Costantino.

He has a lean face, a long, narrow nose, and thin lips, and is often represented wearing a heavy overcoat and cap as he sits writing.

Erasmus of Rotterdam

Geert Gerrits was born in Rotterdam in 1469 and later adopted a Latinized name, Desiderius Erasmus, as was customary among humanists. Since both his parents had died when he was very young, he entered the Augustinian convent at Steyn, where he was ordained a priest. From 1496, his passion for classical studies took him to the great cultural centers of the time: Cologne, Paris, Oxford, and London, where he struck up a friendship with Thomas More. In 1506 he went to Italy. He was proclaimed doctor of philosophy at Turin, watched the victorious entry of Julius II into Bologna, and was received with great honor at the papal court in Rome. Here he became acquainted with the worldliness of the Church, its purely superficial religiosity, the pomp of its rituals, and the theatrical acts of penitence; everything about this society met with his criticism. Later on, in London, he wrote *In Praise of Folly*, a work that ends in praising the "folly of the cross." After a stint in the Low Countries, he settled in Basel (1514), toiling for the publisher Froben and living as a simple lay priest. After Lutheranism took hold in Basel, he wrote *De Libero Arbitrio*, in which he criticized Protestant theology. He died at Basel in 1536.

Name
Geert Gerrits, which he changed to Desiderius Erasmus, in the humanist tradition

Life
1469–1536

Activities
Priest, humanist, and philosopher

Special features of his life
He was critical of Christian society, having experienced its religious superficiality, and wrote *In Praise of Folly*, in which he lauded the "folly of the cross"

Diffusion in art
Various portraits are known

◄ Hans Holbein the Younger, *Erasmus of Rotterdam*, 1532. Basel, Öffentliche Kunstsammlung.

339

Erasmus of Rotterdam

His sober dress, devoid of any ornamentation, can be taken as indicative of his entire life as a lay priest.

In the portrait's background we find a floral tapestry, typical of the decorative tastes of the Low Countries.

The humanist is intent on writing a letter, perhaps the one that accompanied his portrait to England, probably at the request of his friend Thomas More.

His writing paper rests on some books. His works were of fundamental importance to the future of Christian culture in Europe. Examples are his Enchiridion Militis Christiani, *in which he exhorts the reader to make Christ the sole purpose of his life, and the first printed translation of the Greek New Testament into Latin.*

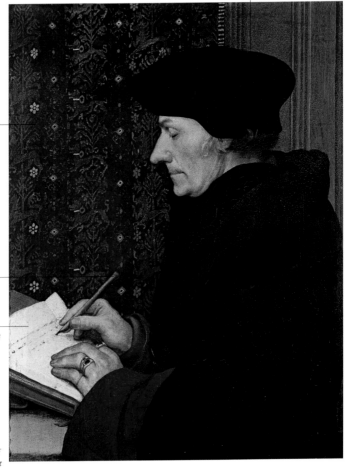

▲ Hans Holbein the Younger, *Erasmus of Rotterdam*, 1523. Paris, Louvre Museum.

In youthful portraits he is still wearing the black-hooded habit of the Augustinians. Later on he is shown wearing a cloth cap. He often appears with his wife.

Martin Luther

Martin Luther was born in Eisleben on November 10, 1483, the second child of peasants. He gained the *magister artium* qualification and was to enter Erfurt University. But owing to a vow made during a thunderstorm, he instead entered the Augustinian convent at Erfurt, against the wishes of his father. In 1507 he was ordained a priest, and in 1521 he began teaching theology at Wittenberg University. Martin had long been troubled by the problem of salvation and had found solace in the strict convent regime, but continued to feel inadequacy before God. When this gained expression in his teaching, he was in conflict with the Church, especially as regards the trade in indulgences. Pope Leo X unwittingly prepared the ground for a clash by granting indulgences in return for offerings for the new basilica of Saint Peter's. After Luther posted his ninety-five theses and his ideas spread throughout Germany, he found himself opposed by the pope (who excommunicated him in 1520), and then by Charles V, the University of Paris, and the king of England, but supported by the German princes. The schism was about to commence. In 1525, he married Katharina von Bora, a former nun, and he spent the rest of his life as a pastor at Wittenberg. He died in Eisleben on February 18, 1546.

Name
Martin Luther

Life
1483–1546

Activities
He was an Augustinian, a priest, and a teacher of theology, in open conflict with the Church of Rome

Special features of his life
He was excommunicated by the pope for his opposition to Rome and provoked a schism in the Catholic Church

Diffusion in art
Portraits, sometimes with his wife; also in allegorical works about Lutheranism

Influence on art
He considered art to be an excellent teaching aid, provided that it was subordinated to scripture and that there was no danger of idolatry

◄ Lucas Cranach the Elder, *Portrait of Martin Luther as a Young Man*, 1526. Nuremberg, Germanisches Nationalmuseum.

Under the initials M.L. is the motto "In silence and in hope shall be your strength." This tells us that the monastic life and personal inquiry underlie Luther's spiritual development.

Under the name of Luther's wife, "K. von Bora," is the motto "She will be saved through childbearing." She bore Luther six children.

Martin Luther is wearing the hooded black habit of the Augustinians with whom he began his experience of the religious life.

She is no longer wearing the Cistercian habit because she left the order before marrying Martin Luther.

▲ Lucas Cranach the Elder, *Portrait of Martin Luther and Katharina von Bora*, ca. 1520–40. Milan, Museo Poldi Pezzoli.

His best-known official portrait shows him beardless, in a white robe with red camauro and mozzetta, and with an aristocratic, haughty expression on his face.

Clement VII

Giulio, the natural son of Giuliano de' Medici, benefited when Giovanni de' Medici, his cousin, became pope as Leo X. The latter appointed him bishop of Florence and then cardinal in 1513. Ten years later Giulio was elected pope as successor to Hadrian VI and found himself head of the Church at a very difficult time in both the political and religious spheres. On the one hand, there was a conflict between France and Spain, and on the other, Lutheran reforms were spreading across northern Europe. In 1526 he decided, under the pressure of events, to ally himself with France by creating the Holy League of Cognac (joined by Venice, Francis I of France, and Milan), but he later abandoned it when Charles V besieged him in Castel Sant'Angelo. He then made new agreements with the Spanish, the Holy League, and the prince of Naples, but by now German mercenaries in the service of Spain were approaching: the terrible Sack of Rome of 1527 was about to take place. The pope fled the city and vowed never to shave his beard again, so we find him looking different in later portraits. He finally signed an agreement with Charles V and crowned him emperor in Bologna in 1529. In religious affairs, he refused to annul the marriage of Henry VIII to Catherine of Aragon.

Secular name
Giulio de' Medici

Life
1478–1534

Pontificate
1523–1534

Special features of his reign
A diplomat and temporizer in both political and religious affairs. He tried to maintain political equilibrium and managed to avoid convening the council that was so urgently requested on all sides

Diffusion in art
Some official portraits

◀ Sebastiano del Piombo, *Portrait of Clement VII*, 1521. Naples, Capodimonte.

His most famous portrait is in the conventional 16th-century style: three-quarter view, leaning against a parapet with the date on it, and holding a folded piece of paper.

Thomas More

Name
Thomas More

Life
1478–1535

Activities
Lord chancellor of England

Special features of his life
He was condemned to death for refusing to accept the king's supremacy in matters of faith

Diffusion in art
A number of portraits

Thomas More was born in London in 1478, the son of a magistrate. At thirteen he was sent as a page to the home of the lord chancellor of England in order to learn discipline and good manners, and his later humanist studies at Oxford and the study of law at New Inn and Lincoln's Inn in London kept him busy until 1500. He was admitted to the legal profession and taught until 1517. He lodged for a time at the London monastery of the Carthusians but ultimately quit monastic life and married in 1505. He developed a close friendship with Erasmus, for the latter visited London several times, and the two shared a passion for the classics and other literature. After the coronation of Henry VIII, he was a member for the City of London of the first parliament called by the king. After carrying out various diplomatic missions and publishing a number of works, he became the king's lord chancellor in 1529, but resigned in 1532, because he felt he could not support the king over his divorce. After being imprisoned in the Tower of London, in 1535 he was condemned to death for refusing to accept the king's supremacy in matters of faith. Sir Thomas More was beheaded on July 6, 1535. He was beatified by Pope Leo XIII in 1889 and canonized by Pope Pius XI in 1935.

► Peter Paul Rubens, after Hans Holbein the Younger, *Thomas More*, ca. 1630. Madrid, Prado.

The future lord chancellor's intense gaze has been captured by the artist Hans Holbein, who was a guest at the More family home in 1526 and also painted a More family group.

It was only after 1520, when he was knighted, that Thomas More was entitled to wear the gold Collar of the Esses with the heraldic Tudor rose.

It was part of the 16th-century portrait tradition that the subject's hands be visible. More's hands hold a folded piece of paper, his attribute as a man of letters.

▲ Hans Holbein the Younger, *Sir Thomas More*, 1527. New York, Frick collection.

He arranged to be portrayed by great artists, both as a young cardinal and as an elderly pope flanked by his grandsons. Paintings celebrated important moments in his pontificate.

Paul III

Secular name
Alessandro Farnese

Life
1468–1549

Pontificate
1534–1549

Special features of his reign
He convened the Council of Trent and tried to reform the Church

Diffusion in art
Various official portraits as well as paintings celebrating his activities

Alessandro Farnese was born near Viterbo in 1468. He began his ecclesiastical career at the age of fifteen as apostolic secretary and moved into curia circles partly thanks to his humanist studies in Rome under the guidance of Pomponio Leto. Family politics kept him away from the curia for a time, but when Alexander VI became pope he was granted various positions and honors and was involved in securing the inheritance of Ranuccio Farnese the Elder, who had three sons (later legitimized) and a daughter. He was elected pope in 1534, perhaps because it was supposed that, given his advanced age, his reign would be short. Contrary to expectations, it proved long and busy. In spite of continual postponements, for which he was not always responsible, he finally convened the Council of Trent, which was supposed to heal the split between Catholics and Protestants. But when the Protestants declined to attend, it turned its attention to the Counter-Reformation and to redefining the Catholic world. He took steps to reform the Church by encouraging new religious orders. In order to consolidate the power of his family, he indulged in blatant nepotism; he also tried to arrange a truce between France and the Empire.

▶ Sebastiano Ricci, *Paul III among Cardinals*, ca. 1687. Piacenza, Museo Civico.

The red biretta shows that he belonged to the secular clergy. In 1464, Pope Paul II granted the right to wear it solely to cardinals of the secular clergy. It was not until 1591 that Pope Gregory XIV extended its use to the regular clergy.

In the delicate distant landscape we see a town. Its prominent domes and bell towers suggest that it might be Parma, where Alessandro Farnese had been elected bishop.

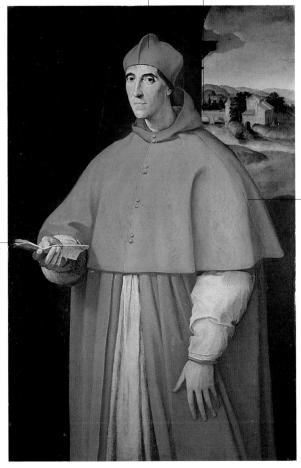

The mozzetta is a short, hooded cloak with buttons down the front. It may be worn only by the pope, cardinals, and bishops. In the case of the pope and cardinals it must be made of silk.

The document held out in his hand acts not only to create the illusion of depth by extending the forearm toward the spectator but also to convey a certain sense of authority.

▲ Raphael, *Portrait of Cardinal Alessandro Farnese, the Future Pope Paul III*, 1509–11. Naples, Capodimonte.

The pope's grandson Ottavio approaches him with
a deferential bow. He was to inherit the task of
maintaining the family prestige when he succeeded
his father as duke of Parma and Piacenza.

Alessandro Farnese,
the pope's grandson,
was appointed cardi-
nal by his grandfather
at the age of fourteen
(1534), and was one of
the most important
men in the ecclesiasti-
cal hierarchy of his
day. Perhaps his
gesture of grasping the
back of the pope's
chair is intended to
convey a strong will
and an ability to
exercise power.

A clock placed on a
side table may have
had a political and
symbolic meaning in
16th-century portrai-
ture. As a symbol of
power and the mastery
of time it often appears
in official portraits of
kings and emperors.

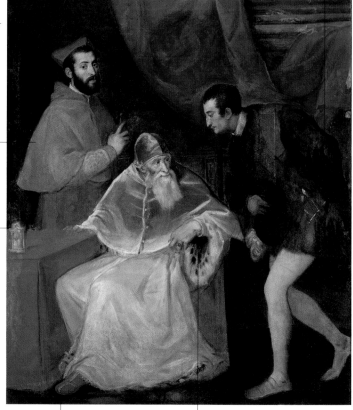

▲ Titian, *Pope Paul III and His
Grandsons*, 1546. Naples,
Capodimonte.

The pope wears red
shoes with a cross on
them. It had been the
custom at least since
the 15th century that
only the pope could
wear shoes decorated
with a cross.

The elderly, seventy-
seven-year-old pope
wears a fur-lined robe.
Titian began this triple
portrait in wintertime,
around December 1545.

His attributes are a heart pierced by thorns, the monogram of Christ (IHS), and the motto Omnia ad maiorem Dei gloriam *(All things for the greater glory of God).*

Ignatius Loyola

Iñigo Lopez de Loyola (he later changed his name to Ignacius) was born in 1491, the eleventh and last child of a Basque nobleman. He trained for a military career and was educated at the court of King Ferdinand of Spain. In May 1521, during the defense of the city of Pamplona against a siege by the French, he was wounded in the leg. Despite surgery, his leg never completely healed, and his military career came to an end. Iñigo's convalescence gave him leisure to read in depth about Christ and the saints and set in motion a conversion that involved a long period spent as a hermit at Manresa, where he began writing his *Spiritual Exercises*, and a visit to the Holy Land. His subsequent study of philosophy took him to Paris from 1528 to 1535. Together with a few companions whom he had met there, he made vows of poverty and chastity and promised to serve the Church by preaching. His new order was given the military title of Company of Jesus and was approved by Pope Paul III in 1540.

Ignatius and his companions devoted themselves to teaching, educating the young, and missionary work. Their order became an important instrument of the Counter-Reformation. Ignatius died in Rome on July 31, 1556.

Name
Of Latin origin but unknown meaning

Life
1491–1556

Activities
He founded the Company of Jesus

Patronage
Patron saint of Jesuits and soldiers

Special features of his cult
Invoked against witchcraft and wolves

Links with other saints
Francis Xavier

Diffusion of his cult
He was beatified in 1609 and canonized in 1622. His cult was originally confined to the Basque provinces and Navarre

Feast day
July 31

◄ Jacopino del Conte, *Portrait of Ignatius of Loyola*, 1556. Rome, Curia Generalizia della Compagnia di Gesù.

God the Father appears in the light of heaven's glory. In front of him is the dove of the Holy Spirit with wings outspread.

Christ appears carrying a heavy cross on his shoulder. He points out the city of Rome to Ignatius.

A companion of Ignatius is admiring the Eternal City. He is probably Pierre Faber, who was traveling from Venice with Ignatius.

Ignatius is wearing the habit of a clerk regular as he falls to his knees before his vision at La Storta, near Rome.

Diego Laynez, one of Ignatius's companions, is watching, half hidden between two columns. He will write an account of the vision.

The words of the motto "Ad maiorem Dei gloriam" (To the greater glory of God) are the opening words of the rule of the Company of Jesus.

▲ Giovanni Battista Gaulli, *The Vision of Saint Ignatius at La Storta*, 1685–90. Houston, Museum of Fine Arts.

Michelangelo's dome on Saint Peter's is an anachronism, since the vision took place in 1537, but it is intended to indicate the strong link that existed between the new order and the papacy.

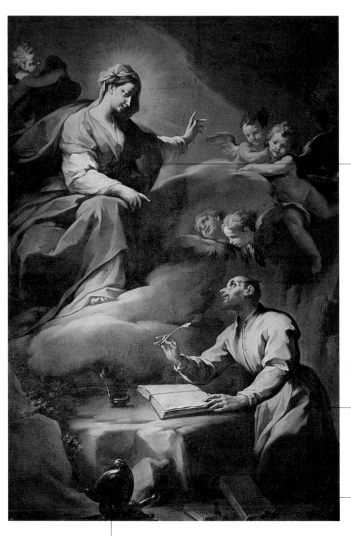

Saint Ignatius has a vision of the Virgin Mary seated on a cloud. Gesturing with her right hand, she dictates the rules of the new order.

Ignatius Loyola is ready with pen in hand as he listens with an expression of awe and inspiration. He is wearing the black habit of clerks regular.

Ignatius is kneeling on a wooden cross made from two planks: this will be the foundation of his new life in the service of Jesus.

A helmet and military insignia are reminders both of the saint's life before his conversion and of the structure of the new order: an army for the Lord.

▲ Giovanni Battista Sassi, *The Virgin Dictating the Rules of the Order of Jesuits to Saint Ignatius Loyola*, 1760. Milan, San Lorenzo.

The future glory of Saint Ignatius (this work was painted before he was canonized) is indicated by cherubs carrying the splendid crown.

Other members of the Company of Jesus are present, wearing the black cassocks of clerks regular.

A dark, shadowy figure is the spirit of evil that had taken possession of the woman below, until the saint performed a miracle.

Ignatius is shown robed as a celebrant and rests one hand on the altar. He gazes upward in a plea for divine intervention.

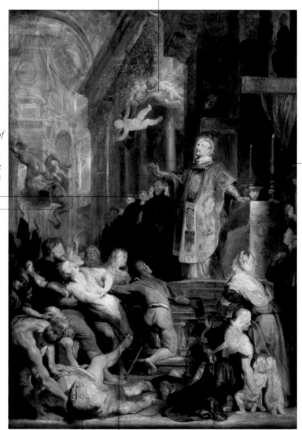

A sick man lying on the ground will be carried to the saint and will recover.

The possessed woman struggles but is restrained by several people.

▲ Peter Paul Rubens, *The Miracle of Saint Ignatius Loyola*, 1617–18. Vienna, Kunsthistorisches Museum.

She is shown wearing the Carmelite habit. Her attributes are an arrow piercing her heart, a heart with IHS (the name of Jesus), and a dove.

Teresa of Avila

Teresa de Cepeda y Ahumada was born on March 28, 1515, at Avila to an aristocratic family. After six years of education with the local Augustinian nuns, she entered the Carmelite convent at Avila at age twenty. She caught malaria and had to leave the convent for treatment; on her return she found it much enlarged and in particular much frequented by the laity. She withdrew into isolation and devoted herself to prayer and reading the works of the Church fathers. In these years she began to experience the mystical and ecstatic visions that are recorded in her writings, and in 1560 she began working toward restoring her order's original rule. In 1562 she founded the convent of Saint Joseph and moved there with thirteen of her sister nuns. In spite of initial opposition to her plan, observance of the rule was approved by the general of the order. In 1568, with the collaboration of John of the Cross, the reform was extended to the order's male branch. She died at Alba de Tormes on October 15, 1582.

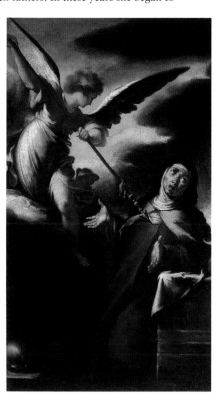

Name
It comes either from a Greek word meaning "huntress" or from a German word meaning "pleasant and strong woman"

Life
1515–1582, Spain

Activities and qualities
A virgin mystic and doctor of the Church. She reformed the Carmelite Order and founded the Discalced Carmelites

Patronage
The Carmelites, Spain

Special cult
Invoked against headaches

Links with other saints
John of the Cross, Peter of Alcántara

Diffusion of her cult
Canonized in 1622

Feast day
October 15

◄ Bernardo Strozzi, *Saint Teresa Pierced by an Angel's Arrow*, ca. 1614. Genoa, Galleria di Palazzo Reale.

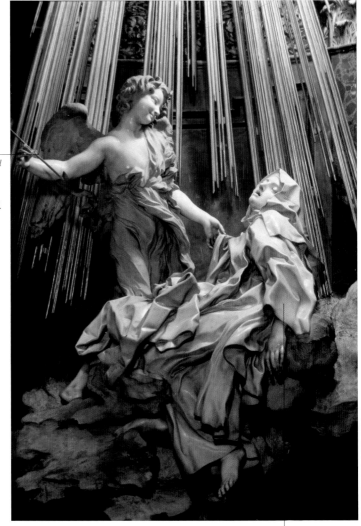

The arrow is a symbol of the wound of love, a visible image of the mystic experience of the soul's love of God.

Saint Teresa is in ecstasy and feels as though she is rising up to heaven, so she is shown on a cloud.

▲ Gian Lorenzo Bernini, *The Ecstasy of Saint Teresa*, 1644–52. Rome, Santa Maria della Vittoria.

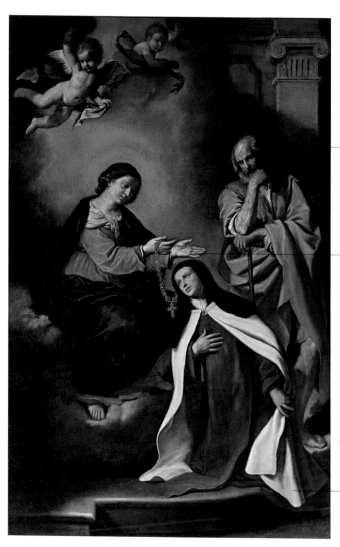

Saint Joseph stands to the side as he observes the scene, as required by traditional iconography, especially in Nativity scenes. Saint Teresa greatly venerated him, affectionately calling him "father and benefactor."

The Virgin has appeared to Saint Teresa on the Feast of the Assumption in 1561, and gives her the chain of her order as a sign of divine goodwill.

We are told that the white cloak worn by Teresa over her habit was given to her by Saint Joseph on the occasion of her Assumption vision in 1561, as a sign of purification from sin.

▲ Guercino, *Saint Teresa Receiving a Chain from the Virgin in the Presence of Saint Joseph*, 1660–61. Bologna, convent of the Discalced Carmelites.

In cardinal's robes and recognizable by his prominent nose, he may have a cord around his neck as a sign of penitence, since he wore one during certain processions. His motto was Humilitas.

Charles Borromeo

Name
Of Germanic origin but Latinized during the Middle Ages. It originally meant simply "man" but later came to mean "free man" and became a title at the Frankish court

Life
1538–1584, Milan

Activities
Cardinal and bishop of Milan. He took steps to have the decisions of the Council of Trent implemented in his diocese

Diffusion of his cult
His cult developed spontaneously after his death on November 3, 1584, and he was canonized in 1610

Influence on art
He took an interest in devotional art and the decoration of churches (*Instructiones Fabricate et Supellectilis Ecclesiasticae*, 1577)

Feast day
November 4

Charles Borromeo was born in 1538 at Arona on Lake Maggiore to an aristocratic Lombard family. He completed his studies at Milan and Pavia, and when his Medici uncle was elected pope as Pius IV, Charles was appointed cardinal in the diocese of Milan and secretary of state at age twenty-two. His duties as secretary of state took him to Rome, and he contributed to the resumption and conclusion of the Council of Trent. In 1564 he was ordained priest and consecrated bishop, and the following year he was given permission by the pope to

reside in his diocese. His important reforms in the diocese of Milan thus began in 1566. He adopted an austere lifestyle and improved the training of clergy by founding seminaries that were much copied elsewhere; he was aided in this work by religious orders such as the Jesuits and Barnabites. His pastoral care extended to all parts of his large diocese and included periodic visits to the alpine valleys. He was active and in close contact with the faithful during the plague of 1576, taking personal care of victims. He died in Milan on November 3, 1584.

▶ Cerano, *Saint Charles*, ca. 1610–20. Geneva, Musée d'Art et d'Histoire.

Saint Charles, in his red
cardinal's robes, is bringing the
Eucharist to plague victims. He
himself looks rather unwell.

The imposing bulk of Milan cathedral can
be seen in the distance. Its construction
received fresh impetus when Cardinal
Borromeo arrived in the diocese.

Cardinal
Borromeo's
insignia as
bishop are
carried by clerks
at the back of the
procession.

The lazaretto stood
outside the city
walls of Milan, near
the Porta Orientale.

The plague victims
welcome the
comfort provided
by the cardinal's
visit and Holy
Communion.

Cardinal
Borromeo can be
seen again in the
background,
among the huts of
the lazaretto. He is
bringing the
sacrament in a
monstrance to
comfort the sick.

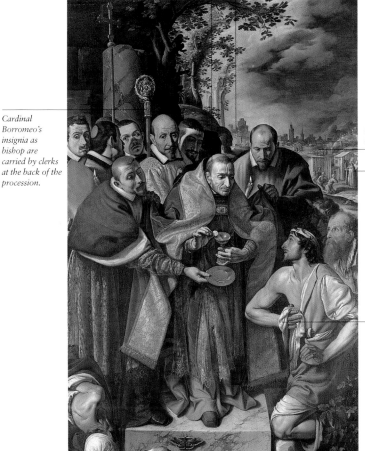

▲ Tanzio da Varallo, *Saint Charles
Borromeo Giving Communion to
Plague Victims*, 1616. Domodossola,
Santi Gervasio e Protaso.

When they heard the arquebus shot, Saint Charles's household came running, but he urged them to continue praying with him.

Brother Farina of the Order of the Humiliati had been paid forty scudi to murder the cardinal, who was trying to restore discipline to the order. Farina managed to slip into the archbishop's palace one evening in October 1567 and fired at the cardinal with his arquebus from a few meters' distance.

The choir accompanying the cardinal's evening prayers was singing a motet by Orlande de Lassus containing the words "It is time for me to return to him who sent me. Let not your heart be troubled."

Saint Charles realized that he had been struck in the back but felt no pain. No more than a dark stain was left on his rochet.

▲ Giovanni Battista della Rovere and Giovanni Mauro della Rovere (called the Fiamminghini), *Farina Attempting to Murder Cardinal Borromeo*, 1602. Milan, cathedral.

One of Saint Charles
Borromeo's commonest
attitudes in art is that of
concentrated study.

Philip is wearing
the black habit of
clerks regular.

Charles's red cardinal's
biretta is on the table. It
is one of his attributes.

Saint Philip Neri shared with
Saint Charles a keen desire to
reform the Church from
within. By creating an oratory
he was able to get closer to the
people, especially children. He
believed that sanctity was a
way of life open to all
Christians.

▲ Giovanni Francesco Guerrieri, *Saint Philip and Saint Charles Borromeo*, first half of the 17th century. Rome, Santa Maria in Vallicella.

He is often represented as an elderly pope with a pointed white beard, wearing a relaxed expression. He appeared in the numerous celebratory prints, monuments, and paintings.

Sixtus V

Secular name
Felice Peretti

Life
1520–1590

Pontificate
1585–1590

Special features of his reign
He restored tranquility to the Papal States and promoted the redevelopment of urban Rome

Diffusion in art
In celebratory portraits

Influence on art
He organized the embellishment of the city of Rome and influenced painting by promoting the depiction of religious subjects that would attract the faithful

Felice Peretti was born in 1520 to a humble family in the Marches. At the age of twelve he entered the Order of Friars Minor (Conventuals), where he was educated until he gained a doctorate in theology at Fermo, a year after being ordained priest. He became apostolic inquisitor for Venice and counselor to the Holy Office and in 1561 was made procurator general of his order. He became a cardinal in 1570 and when Gregory XIII died in 1585, he was elected pope as Sixtus V. He restored order and tranquility to the Papal States by routing brigands and pirates, and embarked on numerous building projects in Rome after improving economic and financial affairs. Thanks to Domenico Fontana, the city underwent a substantial renewal. The Viminal, Esquiline, and Pincian hills were reorganized, many Roman ruins being cleared to provide building materials, and ancient obelisks were erected to decorate squares that were embellished with splendid fountains. Sixtus also promoted a uniformity of style in painting, that he hoped would attract the faithful. He died in 1590.

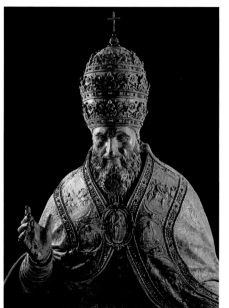

► Antonio Calcagni, *Monument to Sixtus V*, ca. 1586. Loreto, Piazza della Basilica.

Sixtus V, in camauro, rochet, and
mozzetta, is receiving his favorite
architect, from whom he has
commissioned numerous works
for the redevelopment of urban
Rome. The pope drew up a set of
rules governing the use of the new
library and the conservation of its
contents.

The project involved a new
site for the Vatican library,
which was to be totally rebuilt
over the steps separating the
Cortile del Belvedere from
what is now known as the
Cortile della Pigna.

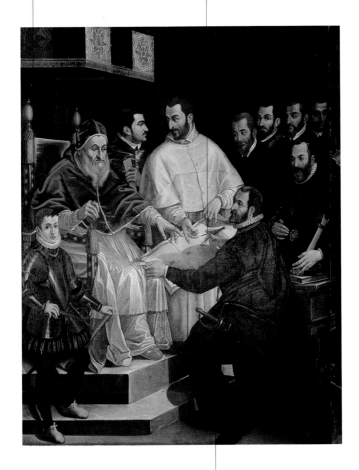

▲ Pietro Facchetti, *Sixtus V Approving
Fontana's Project for the New Vatican
Library*, ca. 1588. Vatican City,
Biblioteca Apostolica Vaticana.

Domenico Fontana
designed and built the
new library between
1587 and 1590.

His official portrait does not respect the tradition that prelates should be painted sitting down. Having himself portrayed standing erect like a king is an explicit sign of his political power.

Cardinal Richelieu

Name
Armand Jean du Plessis de Richelieu

Life
1585–1642

Activities
As chief minister of France he consolidated the position of the French monarchy in Europe

Special features of his career
Once involved in politics, he completely forgot his past as a priest and preacher

Diffusion in art
Various official portraits

Armand Jean du Plessis de Richelieu was born in Paris in 1585, the third son in a prominent family. He had already embarked on a military career when it was decided that the family must not lose its right to a diocese, and so he was appointed bishop of the poor diocese of Luçon in Vendée. A papal dispensation was required because of his youth (he was twenty-two), but in the meantime he showed his abilities by passing all the necessary examinations in Rome. From 1608, he carried out his pastoral duties at Luçon with dedication and energy, and was a fine preacher. His first government posts were given to him by Marie de' Medici. When the Queen Mother was exiled by her son Louis XIII, Richelieu followed her, but he was subsequently reconciled with the king in 1622 and obtained a position of power on his return. In the meantime he had been made cardinal, and now, in 1624, he became chief minister, a post that he retained for eighteen years. His tough stance in both internal and foreign affairs allowed him to consolidate the position of the French monarchy in Europe.

▶ Gian Lorenzo Bernini, *Bust of Cardinal Richelieu*, 1640–41. Paris, Louvre Museum.

The severe expression in this portrait fits his reputation for ruthlessness as chief minister to the king.

The symbol of the supreme French Order of the Holy Spirit is a Maltese cross with pommeled points, enameled white with four gold fleurs-de-lis between the arms of the cross. The blue shield in the center bears the figure of a dove as symbol of the Holy Spirit. It hangs from a blue ribbon, hence the name Cordon Bleu given to knights.

The cardinal is shown full figure and standing in a posture worthy of a king; but the object in his hand is a cardinal's biretta, not a royal crown.

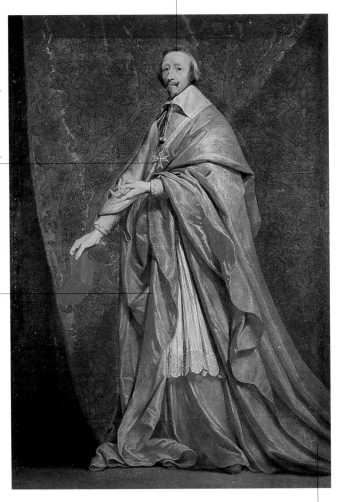

▲ Philippe de Champaigne, *Portrait of Cardinal Richelieu*, ca. 1639. Paris, Louvre Museum.

The cloak that envelops him is reminiscent of the cappa magna *but is worn like a royal robe rather than choir dress.*

Cardinal Richelieu

This triple portrait of Cardinal Richelieu—two profiles and a frontal view—was painted by Philippe de Champaigne to provide a model for the sculptor Francesco Mochi.

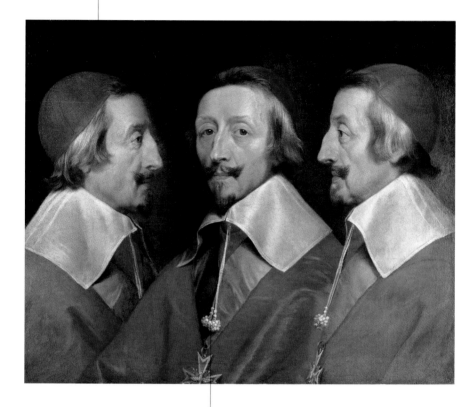

Clearly visible on the cardinal's chest is the blue ribbon from which is suspended the cross of the supreme Order of the Holy Spirit.

▲ Philippe de Champaigne, *Triple Portrait of Cardinal Richelieu*, 1642. London, National Gallery.

Outstanding among official portraits are the splendid busts sculpted by Bernini in which the pope is shown down to his mozzetta, from which the collar of his robe emerges.

Urban VIII

Maffeo Barberini was born in 1568 into an important Florentine family. Thanks to the influence of an uncle, an apostolic protonotary, young Maffeo enjoyed the esteem of several popes. He was appointed protonotary by Clement VIII and then made nuncio to the French court. Later on, Paul V made him a cardinal. He was elected pope after Gregory XV's death. The final stages of the Thirty Years' War took place during his reign, and he tried to bring a balance of power to Europe. He strove not so much to restore Catholicism as to achieve a balance of power that respected his independence and would allow him to consolidate his own position. He made it his task to expand the Papal States, annexing the duchy of Urbino. He fortified the port of Civitavecchia and stripped the tubular bronze beams from the Pantheon in order to make cannons for a renovated Castel Sant'Angelo. So numerous were his projects in the city of Rome that it was said, "What the barbarians didn't do Barberini did." This was above all a reference to his mistreatment of the Pantheon. Nevertheless, thanks to his patronage, artists like Bernini, Poussin, and Claude Lorrain came to Rome. He died in 1644.

Secular name
Maffeo Barberini

Life
1568–1644

Pontificate
1623–1644

Special features of his reign
He was more concerned to establish a political balance of power than to restore Catholicism to northern Europe

Diffusion in art
Numerous official portraits

Influence on art
He issued various documents on the arts (*Sanctissimus*, 1625; *Coelestis*, 1634; *Sacrosancta*, 1642), which suggested that art should be used to promote piety, celebrate the Church, and give moral meaning to the classical revival

◀ Gian Lorenzo Bernini, *Bust of Pope Urban VIII*, 1640–41. Rome, Palazzo Spada.

Following tradition, he is portrayed sitting in an armchair, wearing a white robe and surplice with a red mozzetta and camauro. He is known for his keen gaze and raised eyebrows.

Innocent X

Secular name
Giovanni Battista Pamphilj

Life
1574–1655

Pontificate
1644–1655

Special features of his reign
Political independence from the European powers; interest in the reform of the religious orders, missionary work, and the Jansenist question

Diffusion in art
His finest official portrait, by Velázquez, has been a subject of study for centuries

Influence on art
He was a great patron of the arts and surrounded himself with great artists

▶ Gasparo Morone Mola, *Medal of Innocent X*, 1654. Vienna, Kunsthistoriches Museum, Münzkabinett.

Giovanni Battista Pamphilj was born in Rome in 1574. He studied law and prepared himself for a career in the papal curia. Thanks to influential sponsors, he was sent as papal nuncio to Naples, France, and Spain. In 1629 he was made cardinal by the very pope (Urban VIII) whom he subsequently succeeded, in spite of strong opposition from Cardinal Mazarin, who was a patron of the Barberini family. He maintained political independence from the European powers in his attempt to strengthen the Papal States, but they were clearly in political and administrative decline. In order to lay the foundations for new administrative systems, he enlisted the help of Cardinal Benedetto Odescalchi (later Pope Innocent XI). He supervised the reform of the religious orders and intervened in the "Chinese rites question" (1645–46), rites that the Jesuits wanted to preserve because they were purely civil practices. He attacked Jansenism with a bull (*Cum Occasione*, 1653), with little success. He was a great patron of writers and artists, including Bernini (who had initially objected to his Barberini connections), Algardi, and Borromini.

In accordance with contemporary fashion, his fine white collar emerges from his red mozzetta and contributes to the splendid play of reds between camauro, mozzetta, and the back of the papal armchair.

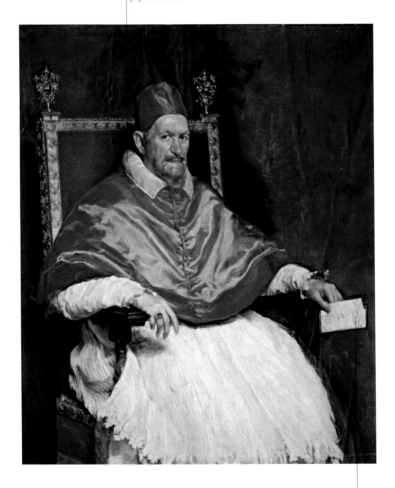

▲ Diego Velázquez, *Portrait of Innocent X*, ca. 1650. Rome, Galleria Doria Pamphilj.

The folded piece of paper in the pope's hand is a credential, signed by the artist. This is one of the rare cases in which Velázquez left his name on a painting, perhaps because it was painted in Italy, where there might be painters who could vie with him.

Innocent X

Innocent X's face has been so thoroughly altered that it is effectively disfigured, though there are a few traits by which he might be identified.

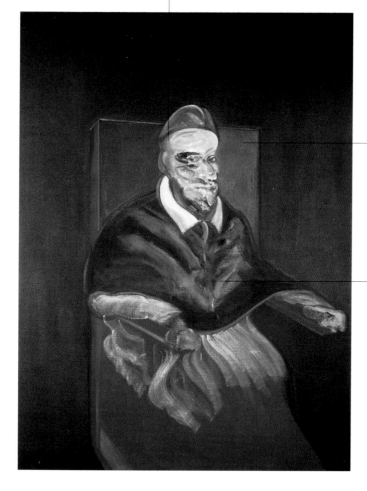

The pope's chair has the same shape as the chair in the original painting.

The fascinating play of reds is still there in this 20th-century study.

▲ Francis Bacon, *Study after the Portrait of Innocent X by Velázquez*, 1959. Private collection.

There are portrait busts in which the papal mozzetta and camauro are accompanied by a careful rendering of the subject's facial features.

Alexander VII

Fabio was born into the Chigi family of Siena in 1599. His election to the papal throne on the death of Innocent X in 1655 was the outcome of a political contest between the cardinals who supported France and its candidate, Cardinal Sacchetti, and those who were for the Habsburgs. The first crisis that the pope had to face was the plague of 1656, which killed fifteen thousand people in Rome. Political relations with France were uneasy, partly because the Papal States were clearly politically weak. The new king of France, Louis XIV, flaunted his power relative to the papacy by seizing Avignon and then restoring it through the Treaty of Pisa (1664), after (it was claimed) receiving papal apologies. Alexander VII's predecessor had already declared himself opposed to the Jansenists, but the problem was unresolved and growing more acute. Alexander repeated the condemnation in a bull (1665), while theologians wrestled urgently with interpretations of Augustinian and Jansenist thought. Alexander, an assiduous patron of the arts, contributed to the embellishment of Rome by restoring "La Sapienza" University, refurbishing the Piazza del Pantheon, and completing Bernini's colonnade in front of Saint Peter's, begun in 1656. He died in 1667.

Secular name
Fabio Chigi

Life
1599–1667

Pontificate
1655–1667

Special features of his reign
He repeated his predecessor's condemnation of Jansenism

Influence on art
He continued his predecessors' program of embellishing Rome. The colonnade in front of Saint Peter's was completed during his reign

◄ Gian Lorenzo Bernini, *Bust of Alexander VII*, 1631–35/before 1667. Rome, Palazzo Barberini.

The pope is kneeling in full
liturgical dress. A beautiful stole
can be seen on his alb, and a
rich cope on his shoulders.

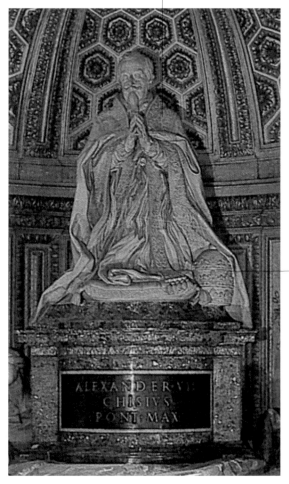

The pope's tiara lies
at his feet, partly
covered by his cope.

▲ Gian Lorenzo Bernini, *Tomb of
Alexander VII*, 1672–78. Vatican City,
Saint Peter's Basilica.

His best-known official portrait follows the traditional rules: he is in papal robes, with surplice, mozzetta, and camauro. He sits in an armchair by a table and holds a book in his right hand.

Clement IX

Giulio Rospigliosi was born at Pistoia in 1600 and it was there that he received his early education, leading to the tonsure and minor orders. In 1614 he was at the Jesuit seminary in Rome to complete his cultural education, and it was here that he came to love the theater, which he considered to be a valuable ally of religion because of its didactic potential. His later studies in theology, philosophy, and law at Pisa were more closely connected to his future ecclesiastical career. In 1624 he was back in Rome, where contacts in the Barberini family (relatives of Pope Urban VIII) introduced him to the life and ways of the curia. Urban VIII gave him his first appointments: in 1644 he was appointed papal nuncio in Spain and consecrated bishop of Tarsus, and fifteen years later he was made cardinal by Alexander VII, who also appointed him secretary of state. His outstanding success at this post left no doubt about the choice of pope at the next conclave. Cardinal Rospigliosi was elected and took the name Clement IX. In his brief two-year reign, he achieved reconciliation with the Jansenists, fought hard, though unsuccessfully, against the Turks, and dealt with matters of ecclesiastical life, the regular clergy, and missionaries.

Secular name
Giulio Rospigliosi

Life
1600–1669

Pontificate
1667–1669

Special features of his reign
He achieved reconciliation with the Jansenists and concerned himself with affairs of the clergy and missionaries

Diffusion in art
Official portraits

◀ Carlo Maratta, *Portrait of Clement IX*, 1669. Rome, Galleria Spada.

He is painted as a cardinal with the attributes of a scholar. The most memorable paintings of him as pope are not the official portraits but scenes celebrating certain moments in his reign.

Benedict XIV

Secular name
Prospero Lambertini

Life
1675–1758

Pontificate
1740–1758

Special features of his reign
The most important pope of the Age of Enlightenment. He was prudent in politics and a rigorous defender of Church doctrine

Diffusion in art
Some portraits as cardinal, and scenes celebrating certain events in the life of Rome

Influence on art
The first pope to become involved with iconography, using an encyclical (*Sollecitudini Nostrae*, 1745) to suggest how God and the Trinity should be represented

Prospero Lambertini was born in Bologna in 1675 and his early education was private. At the age of thirteen he entered the Collegio Clementino in Rome to study rhetoric, philosophy, and theology. He displayed a particular bent for history, especially ecclesiastical history and that of civil law. He completed his studies at nineteen, gaining a doctorate in theology and civil and canon law. His first appointments in the curia were as consistorial advocate, counselor to the Holy Office, and promoter of the faith. His first episcopal post was as titular bishop of Theodosia (1725). Later he was made bishop of Ancona, and then cardinal in 1728 and bishop of Bologna. His election to the papacy as Benedict XIV came at the end of a conclave that lasted six months. He was the most important pope of the Enlightenment: an eminent canon lawyer and a prudent statesman. He rigorously defended Church doctrine but behaved with moderation toward Jansenism; he took an interest in missionary work. He adopted an effective policy to restore the finances of the Papal States, and also devoted himself to the restoration of Rome.

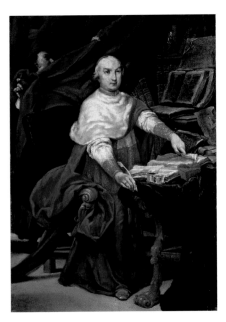

► Giuseppe Maria Crespi, *Cardinal Prospero Lambertini*, 1740. Bologna, Palazzo D'Accursio.

The Trevi Fountain was begun in 1732, following a new design by Nicola Salvi. It was only completed in 1762 under the direction of Giuseppe Pannini.

Various members of the public and visitors to Rome make their way toward the pope.

Swiss guards lead the papal procession.

In 1744, Benedict XIV insisted on a second inauguration of the fountain. The pope can be identified among the train of dignitaries by his processional umbrella.

▲ Giovanni Paolo Panini, *Benedict XIV Visiting the Trevi Fountain in Rome*, 1750–56. Private collection.

In some official portraits he is shown full or three-quarter length. His portrait appeared widely in Italy on medallions and flags at the time of his election to the papacy.

Pius IX

Secular name
Giovanni Maria Mastai
Ferretti

Life
1792–1878

Pontificate
1846–1878

Special features of his reign
The temporal power of the Church came to an end during his reign. He devoted himself to reforming the Papal States. He was beatified in 2000

Diffusion in art
There are various official portraits. His portrait was widely reproduced in Italy during the Risorgimento because he initially embarked on liberal political policies and aroused patriotic hopes among Italians

Giovanni Maria was born at Senigallia in 1792, the ninth child of Count Girolamo Mastai Ferretti. His early studies with the Scolopian fathers were interrupted in 1808 because he had epilepsy. In 1815, he was cured of his epilepsy after a visit to the shrine at Loreto and resumed his studies. He was ordained a priest in 1819. He was appointed archbishop of Spoleto in 1827, became cardinal in 1840, and was elected pope in 1846, taking the name Pius IX. His first act was to grant an amnesty for political offences, and then he concentrated on reforming the Papal States. After the revolutionary turmoil of 1848, he was in exile at Gaeta until 1850. In 1854, he pronounced the doctrine of the Immaculate Conception. Meanwhile, the Papal States had lost Romagna, the Marches, and Umbria, and when Rome was taken in 1870 the pope's temporal power came to an end. Pius IX retreated to the Vatican and failed to conclude

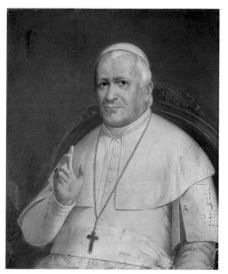

the First Vatican Council, at which the doctrine of papal infallibility had been declared. He died in 1878 still refusing to accept Italy's Law of Guarantees, which acknowledged only his spiritual functions, the inviolability of his person, and diplomatic rights. He was beatified by Pope John Paul II in 2000.

▶ Giovanni Battista Riva, *Portrait of Pius IX*, 1869. Milan, Quadreria Arcivescovile.

His features are well known thanks to photography. His expression of smiling goodwill appears in official portraits, mostly in sculpture.

John XXIII

Giovanni Angelo Roncalli was born in 1881 at Sotto il Monte in the province of Bergamo. He earned a doctorate in theology at Rome at age twenty-two, and was ordained a priest in the same year. For ten years he was secretary to the bishop of Bergamo. At the pope's request, he was put in charge of the Propagation of the Faith in Italy. In 1925, he embarked on a period of diplomatic work, acting as apostolic visitor first to Bulgaria, then Turkey, and finally Greece, where he remained until 1944. After the war he was promoted to papal nuncio in Paris and in 1953 was made patriarch of Venice. In 1958 he was elected pope to succeed Pius XII. Although he was already seventy-seven, this was not a transitional reign. As bishop of Rome he made pastoral care and advice a primary focus, while also increasing the number of cardinals so that more countries were represented. He worked for peace and convened the Second Vatican Council in order to set out traditional doctrine in a manner more suitable to modern sensibilities, and to pay particular attention to ecumenical policies in Christian churches. He died on June 3, 1963. He was beatified by John Paul II in 2000.

Secular name
Giovanni Angelo Roncalli

Life
1881–1963

Pontificate
1958–1963

Special features of his reign
He was known as "the kind pope," winning the hearts of the faithful with his gentleness. He convened the Second Vatican Council in order to set out traditional doctrines in a manner more suited to modern sensibilities

Diffusion in art
There is an official portrait sculpture by Giacomo Manzù

◄ Giacomo Manzù, *Head of Pope John XXIII*, 1963. Ardea, Museo Artistico "G. Manzù."

The inscription *"peace on earth"* alludes to the encyclical Pacem in Terris, *which the pope issued in 1963.*

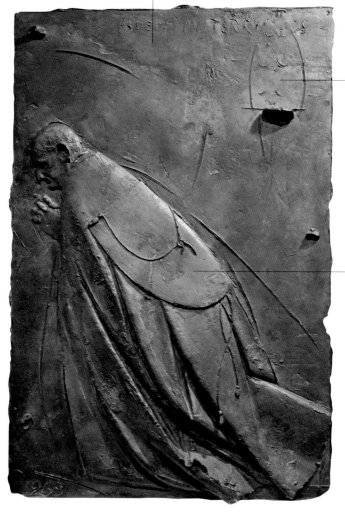

High up on a kind of shelf is a lightly engraved tiara, *the pope's attribute.*

The pope is shown kneeling, leaning forward, and deep in prayer. The only recognizable decoration on his ample cope is the shield, which is a variation on a very ancient type of hood.

▲ Giacomo Manzù, *Pope John*, 1963.
Ardea, Museo Artistico "G. Manzù."

He was a tall, thin man, identifiable by his thin lips and rather prominent ears. He appears in a few monuments and sculptures, and in a widely known official photograph.

Paul VI

Giovanni Battista Montini was born in 1897 into a middle-class family at Concesio in the province of Brescia. He attended a Brescia seminary and was ordained priest in 1920. He began his career in the curia as assistant to the secretary of state and was appointed his deputy in 1937. From 1944 he and Monsignor Tadini were Pope Pius XII's closest collaborators. In 1952 he was appointed archbishop of Milan, and four years later he was made cardinal. He actively contributed to the Second Vatican Council from his diocese by means of a pastoral letter, *Pensiamo al Concilio* (Let us think about the Council), written

during Lent in 1962. He was elected pope on the death of John XXIII and continued the interrupted council, bringing it to a conclusion in December 1965. He also continued with reforms to the code of canon law and with the difficult ecumenical policy. He made important attempts to reach out to the Anglican and Orthodox churches. He went on a number of apostolic visits (the first was to Jerusalem in 1964) and wrote a number of exhortatory encyclicals. He died in 1978.

Secular name
Giovanni Battista Montini

Life
1897–1978

Pontificate
1963–1978

Special features of his reign
He brought the Second Vatican Council to a close, embarked on numerous apostolic visits, and made great progress toward ecumenism

Diffusion in art
There is an official portrait sculpture by Bodini

◄ Floriano Bodini, *Monument to Pope Paul VI* (detail), 1968. Vatican City, Musei Vaticani.

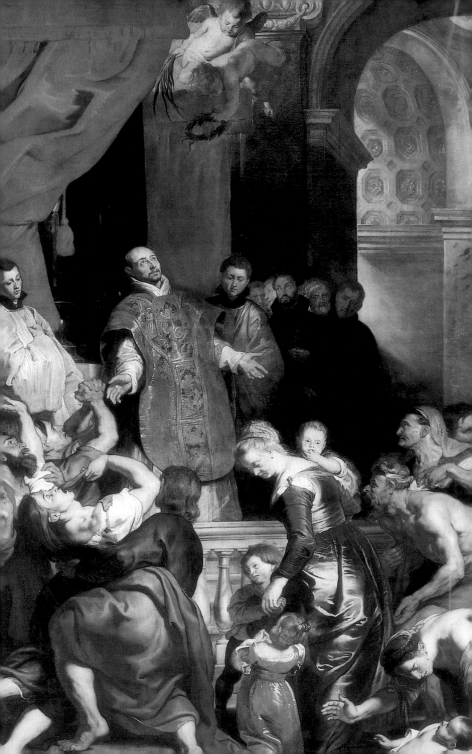